**P■CKET**
Visual Encyclopedia

# Art in the 19ᵗʰ Century
# Kunst des 19. Jahrhunderts
# Negentiende-eeuwse kunst
# Arte en el Siglo XIX

SCALA

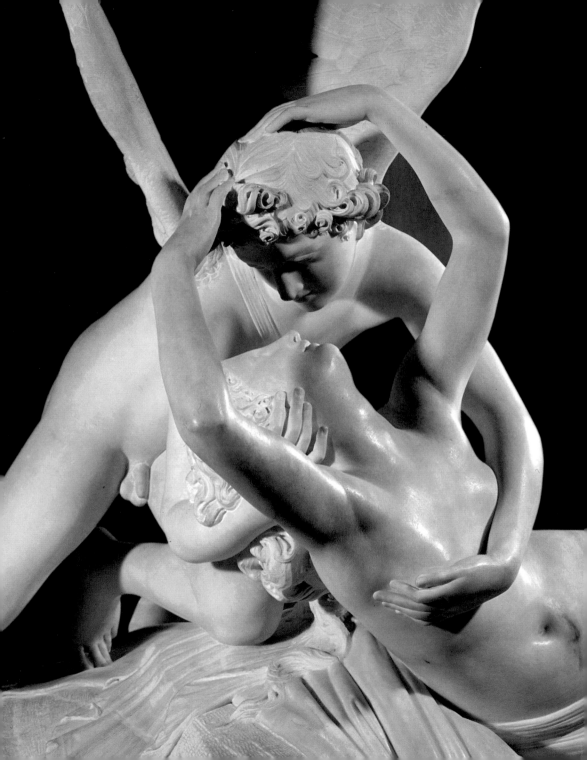

# Contents

# Inhalt

# Inhoudsopgave

# Índice

# Introduction

The 19th century was a pivotal period in Western history, marked by a revolutionary phase involving not only politics but art and, more broadly speaking, taste. The roots of this change date back to the 1740s, when there was a call for a new kind of art, one that would be useful and educational, both aesthetically and morally, in contrast to the frivolous and "uncommitted" tendency of the Rococo. The new model identified with ancient Greece and Rome; it was believed that through the imitation of antiquity, art could aspire to the ideal beauty of true nature.

The outcomes of such a revolution were unforeseeable and historical events soon came to jeopardise the very system of thought that had given rise to them. Artists' attention shifted towards a more emotional and personal sphere, Neoclassical "conventions" came to be seen as outworn, while the focus turned to the more intimate aspects of the human soul: phantasy, the unconscious, the relation between man and nature and between man and the divine.

These were the earliest, but not the only manifestations of Romanticism: sharp anti-Classical polemics, together with the rise of nationalist movements in Europe, led to the spread of new models, derived mainly from the Middle Ages, which in turn gave rise to various revival movements and above all to historical genre painting. This was the soil from which realism was to spring in the mid-19th century.

The superseding of academic conventions, history and war as the theatre of action for man, represented as-it-is in the here and now, so much so that a preference developed for low-life subject matter, these are just a few of the pivots of a movement which was to elevate ordinary men and women to the status of new "heroes of modern life".

# Einleitung

In der westlichen Geschichte war das 19. Jahrhundert von Umwälzungen geprägt und wurde von einer revolutionären Phase durchzogen, die sich nicht nur in der Politik, sondern auch in der Kunst oder allgemein im Geschmack niedergeschlagen hat. Die Wurzeln dieser Veränderungen gehen bereits auf die 40er Jahre des 18. Jahrhunderts zurück, als das Bedürfnis nach einer neuen, nützlichen und erzieherischen Kunst im Gegenzug zur Frivolität und Nutzlosigkeit des Rokoko wuchs. Als Vorbild galt sowohl ästhetisch als auch moralisch die griechisch-römische Antike, durch deren Imitation man glaubte, die Schönheit der wahren Natur erreichen zu können. Die Folgen einer solchen Revolution waren unvorhersehbar und die geschichtlichen Ereignisse stürzten sehr schnell eben diese Denkweise, die sie hervorgerufen hat, in die Krise. Die Künstler verlagerten ihre Aufmerksamkeit auf eine persönlichere und emotionalere Ebene. Die "Konventionen" des Neoklassizismus schienen überwunden und die Aufmerksamkeit richtete sich auf die intimeren Aspekte der menschlichen Seele: der Fantasie, dem Unterbewusstsein, der Beziehung zwischen Mensch und Natur und zwischen Mensch und Gottheit. Dies waren die ersten, aber nicht einzigen Anzeichen der Romantik: Die starke antiklassizistische Kontroverse, in Verbindung mit dem Entstehen der europäischen Nationalismen, bestimmte auch die Verbreitung von neuen Modellen, die ihren Ursprung vor allem in der mittelalterlichen Vergangenheit hatten und die auf die Revival-Bewegungen und vor allem auf die Geschichtsmalerei Einfluss hatten. Genau hier heraus entsteht in der Mitte des 19. Jahrhundert der Realismus.

Das Überwinden der akademischen Konventionen, die Geschichte und der Krieg als Schauplatz des Menschen, der in seiner gegenwärtigen Lage und seiner Wahrheit gezeigt wird, nämlich, dass er die niederen Themen bevorzugt, sind nur einige Umwälzungen innerhalb der Bewegung, in der Männer und Frauen des Volkes auf die Ebene der neuen "Helden des modernen Lebens" erhoben wurden.

# Introductie

De 19$^e$ eeuw was voor de westerse geschiedenis
een cruciale tijd, vanwege een revolutionaire fase
die niet alleen het politieke klimaat,
maar ook de kunst en meer in het algemeen de
smaak beïnvloedde. De basis voor deze verandering
werd al in de jaren veertig van de achttiende eeuw
gelegd, toen de behoefte aan een nieuwe, nuttige
en leerzame kunst ontstond, in tegenstelling tot het
frivole en "luchthartige" van het rococo.
Als voorbeeld gold, zowel in esthetisch als
moralistisch opzicht, de Grieks-Romeinse Oudheid,
waarvan werd gedacht dat door die te imiteren de
ware schoonheid van de natuur kon worden bereikt.
De resultaten van een dergelijke revolutie waren
onvoorspelbaar en de historische gebeurtenissen
stortten al snel de denkwijzen die eraan ten
grondslag hadden gelegen in een crisis.
De kunstenaars verlegden hun aandacht naar
een meer emotionele en persoonlijke sfeer, de
neoklassieke "conventies" bleken verouderd, en
er kwam meer belangstelling voor de intiemere
aspecten van de menselijke geest: de fantasie, het
onderbewustzijn, de relatie tussen mens en natuur
en tussen mens en goddelijkheid.
Dit waren de eerste maar niet enige manifestaties
van de romantiek: de sterke anticlassicistische
controverse, samen met de opkomst van het
Europees nationalisme, bepaalde de verspreiding
van nieuwe modellen, die hun oorsprong in de
Middeleeuwen hadden en die de revivalbewegingen
en vooral de historieschilderkunst beïnvloedden.
Hieruit ontstond halverwege de negentiende eeuw
het realisme. Het overwinnen van academische
conventies, de geschiedenis en de oorlog als theater
van het menselijk handelen, weergegeven in een
moderne context met een zodanige nadruk op de
waarheid dat nederige thema's de voorkeur hadden,
zijn enkele van de hoekstenen van de beweging
waarbinnen mannen en vrouwen van het volk
werden verheven tot de nieuwe "helden van het
moderne leven".

# Introducción

El siglo XIX ha marcado un período clave para
la historia occidental, atravesado por una fase
revolucionaria que involucró no sólo el ámbito
político, sino también el arte y, de forma más
generalizada, el gusto. Las raíces de este cambio
se remontan ya a los años '40 del siglo XVIII,
cuando se comenzó a difundir la exigencia
de un nuevo arte que fuera útil y educativo,
y antítesis a la tendencia frívola y carente
de compromiso del rococó. El nuevo modelo,
tanto estético como moral, fue identificado en
la antigüedad grecorromana, a través de cuya
imitación se creía poder aspirar a la belleza de
la verdadera naturaleza. Los resultados de una
revolución tal eran imprevisibles, y los eventos
históricos pusieron rápidamente en crisis el
mismo sistema de pensamiento desde el que
habían sido generados. Los artistas trasladaron
su propia atención hacia una esfera más emotiva
y personal, las "convenciones" del neoclasicismo
les parecieron superadas, mientras la atención
se dirigió hacia aspectos más íntimos del espíritu
humano: la fantasía, el inconsciente, la relación
entre hombre y naturaleza, y entre hombre y
divinidad. Fueron éstas las primeras, pero no las
únicas, manifestaciones del romanticismo: la fuerte
polémica anticlasicista, unida al resurgimiento de
los nacionalismos europeos, determinó también la
difusión de nuevos modelos, provenientes sobre
todo del pasado, que confluyeron en movimientos
de revival y, sobre todo, en la pintura histórica.
Precisamente debido a estas necesidades, a
mediados del siglo XIX nació el realismo. La
superación de las convenciones académicas, la
historia y la guerra como escenario de acción del
hombre, representado en su contemporaneidad,
en su verdad, a tal punto de privilegiar sujetos
populares, son sólo algunos de los fundamentos
del movimiento, en el cual hombres y mujeres del
pueblo fueron elevados a nivel de nuevos "héroes
de la vida moderna".

# Chronology
# Chronologie
# Cronología

**1738**

■ First archaeological excavations in Herculaneum.

■ Erste archäologische Ausgrabungen in Herculaneum.

■ Eerste archeologische opgravingen in Herculaneum.

■ Primeras excavaciones arqueológicas en Herculano.

**1748**

■ First archaeological excavations in Pompeii.

■ Erste archäologische Ausgrabungen in Pompeji.

■ Eerste archeologische opgravingen in Pompei.

■ Primeras excavaciones arqueológicas en Pompeya.

**1751**

■ First volume of Diderot and D'Alembert's *Encyclopédie* published in France.

■ In Frankreich erscheint das erste Band der *Encyclopédie* von Diderot und D'Alembert.

■ In Frankrijk wordt de eerste uitgave van de *Encyclopédie* van Diderot en D'Alembert uitgegeven.

■ Se publica en Francia el primer volumen de la *Encyclopédie* de Diderot y D'Alembert.

**1753**

■ Founding of the British Museum in London.

■ Gründung des British Museum in London.

■ Het British Museum in Londen wordt geopend.

■ Nace el British Museum de Londres.

**1755**

■ Winckelmann publishes *Thoughts on the Imitation of Greek Works* in Dresden.

■ Winckelmann veröffentlicht in Dresden *Gedanken über die Nachahmung der Griechischen Werke in der Malerei und Bildhauer-Kunst.*

■ Winckelmann publiceert in Dresden *Gedachten over de imitatie van de Griekse kunst.*

■ Winckelmann publica en Dresde las *Reflexiones sobre el arte griego en la pintura y la escultura.*

**1761**

■ Mengs completes *Parnassus* fresco for the Villa Albani.

■ Mengs beendet das Fresko *Der Parnass* in der Villa Albani.

■ Mengs voltooit de fresco *Der Parnass* voor Villa Albani.

■ Mengs termina el fresco del *Parnaso* para Villa Albani.

**1762**

■ Mengs publishes *Thoughts concerning Beauty.*
Catherine II, known as Catherine the Great, the enlightened monarch, becomes Empress of Russia.

■ Mengs veröffentlicht die *Gedanken über die Schönheit.*
In Russland wird Katharina II. die Große aufgeklärte Herrscherin, zur Kaiserin ausgerufen.

■ Mengs publiceert de *Gedanken über die Schönheit.*
In Rusland wordt Catharina de Grote, de verlichte soeverein, keizerin.

■ Mengs publica las *Reflexiones sobre la belleza y el gusto en la pintura.*
En Rusia es coronada emperatriz Catalina II la Grande, soberana iluminada.

**1768**

■ Josiah Wedgwood begins to produce Etruscan-style pottery in England.

■ Josiah Wedgwood beginnt in England mit dem Etruskischen Stil in der Keramikproduktion.

■ Josiah Wedgwood begint in Engeland zijn productie van neo-Etruskisch keramiek.

■ Josiah Wedgwood comienza en Inglaterra su producción de cerámica neoetrusca.

**1770-1775**

■ Conventional date for the birth of the *Sturm und Drang* movement.
In 1774 Goethe publishes *The Sorrows of Young Werther.*

■ Konventionelles Datum für das Entstehen der *Sturm und Drang-Bewegung.*
1774 veröffentlicht Goethe *Die Leiden des jungen Werther.*

■ Verondersteld tijdvlak waarin de *Sturm und Drang*-beweging opkomt.
In 1774 publiceert Goethe *Die Leiden des jungen Werthe.*

■ Fechas con las que se indica convencionalmente el nacimiento del movimiento *Sturm und Drang.*
En 1774 Goethe publica *Las desventuras del joven Werther.*

| | | | |
|---|---|---|---|
| **1776-1783** | ▮ American Revolutionary War. | ▮ Amerikanischer Unabhängigkeitskrieg. | ▮ Amerikaanse onafhankelijkheidsoorlog. |
| | | | ▮ Guerra de la Independencia de los Estados Unidos. |

**1785**

▮ Jefferson designs Virginia State Capitol in Richmond.
At the Paris Salon, David successfully exhibits *The Oath of the Horatii*, completed in Rome the previous year.

▮ Jefferson entwirft das Virginia State Capitol in Richmond (Virginia). David stellt erfolgreich im Salon de Paris den *Schwur der Horatier* aus, den er im vorigen Jahr in Rom gefertigt hat.

▮ Jefferson ontwerpt het Capitool in Richmond (Virginia). David stelt met succes *Het oordeel van de Horatiërs* op de Salon van Parijs tentoon, dat hij het jaar daarvoor in Rome heeft voltooid.

▮ Jefferson proyecta el Capitolio de Richmond (Virginia). David expone con éxito en el Salón de París *El juramento de los Horacios*, realizado en Roma el año anterior.

**1789-1799**  ▮ French Revolution.  ▮ Französische Revolution.  ▮ Franse revolutie.  ▮ Revolución francesa.

**1791**  ▮ Brandenburg Gate in Berlin completed.  ▮ Das Brandenburger Tor in Berlin wird fertig gestellt.  ▮ De Brandenburger Poort in Berlijn wordt voltooid.  ▮ Finaliza la construcción de la Puerta de Brandeburgo en Berlín.

**1793**  ▮ The Louvre in Paris opens.  ▮ Das Musée du Louvre in Paris wird eingeweiht.  ▮ Het Musée du Louvre in Parijs wordt geopend.  ▮ Se inaugura el Museo del Louvre en París.

**1796**  ▮ Napoleon appointed commander-in-chief of the French Army in Italy  ▮ Napoleon wird zum höchsten Befehlshaber der französischen Armee in Italien ernannt.  ▮ Napoleon wordt tot opperbevelhebber benoemd van de Franse troepen in Italië.  ▮ Napoleón es nombrado comandante supremo de la armada francesa en Italia.

**1797**

▮ Peace of Campo Formio between France and Austria.
Treaty of Tolentino between France and the Papal States, which stipulated the transfer of masterpieces kept in Rome to Paris.

▮ Frieden von Campo Formio zwischen Frankreich und Österreich. Der Vertrag von Tolentino zwischen Frankreich und der Römischen Kurie, der die Übersendung von in Rom aufbewahrten Meisterwerken nach Paris vorsieht.

▮ Vrede van Campo Formio tussen Frankrijk en Oostenrijk. Verdrag van Tolentino tussen Frankrijk en de paus voorziet erin dat de in Rome bewaarde meesterwerken worden overgebracht naar Parijs.

▮ Paz de Campoformio entre Francia y Austria. Tratado de Tolentino entre Francia y el papado, que prevé el traslado a París de las obras maestras conservadas en Roma.

**1801**  ▮ Lord Elgin removes Phidias' sculptures from the Parthenon to display them at the British Museum in London.  ▮ Lord Elgin demontiert die Parthenon-Skulpturen und stellt sie im British Museum von London aus.  ▮ Lord Elgin verwijdert de Fidiussculpturen van het Parthenon en verscheept ze naar het British Museum in Londen.  ▮ Lord Elgin quita las esculturas de Fidia del Partenón para exponerlas en el British Museum de Londres.

**1804**  ▮ Napoleon crowned emperor.  ▮ Napoleon wird zum Kaiser gekrönt.  ▮ Napoleon wordt tot keizer gekroond.  ▮ Napoleón es coronado emperador.

**1808**

▌ Canova completes *Pauline Bonaparte as Venus Victrix*. Friedrich exhibits the *Tetschen Altar* in Dresden, sparking controversy with his bold anti-academic depiction of a symbolic and mysterious landscape.

▌ Canova beendet die *Paolina Borghese als siegreiche Venus*. Friedrich stellt in Dresden den *Tetschener Altar* aus und löst mit dem antiakademischen Wagemut in der symbolischen und mysteriösen Landschaftsdarstellung, Polemiken aus.

▌ Canova voltooit de *Paolina Borghese als Venus Vintrix*. Friedrich stelt in Dresden de *Drieluik van Tetschen* tentoon en veroorzaakt controverse door de antiacademische schilderwijze van een symbolisch en mysterieus landschap.

▌ Canova termina la *Paulina Borghese como Venus vencedora*. Friedrich expone en Dresde el *Altar de Tetschen*, despertando polémicas por la audacia antiacadémica en la representación del paisaje en clave simbólica y misteriosa.

**1809-1810**

▌ Several students of the Vienna Academy gather in Rome led by Overbeck and Pforr in the Brotherhood of St. Luke, which gave rise to the Nazarene movement.

▌ Einige Studenten der Wiener Kunstakademie tun sich in Rom unter der Leitung von Overbeck und Pforr als Bruderschaft von San Luca zusammen und rufen die Nazarener ins Leben.

▌ Enkele leerlingen van de Academie van Wenen organiseren zich in Rome onder leiding van Overbeck en Pforr in de Sint Lucasbond, waaruit de Nazareners voorkomen.

▌ Algunos alumnos de la Academia de Viena se reúnen en Roma, bajo la guía de Overbeck y Pforr, en la Compañía de San Lucas, dando vida al grupo de los Nazarenos.

**1814-1815**

▌ The fall of Napoleon. The Congress of Vienna leads to the restoration of the powers of the *Ancien Régime*. Goya paints *The Third of May 1808* in the year 1814, a work that celebrated Spanish resistance against the French. In 1814 Géricault displays *Wounded Officer of the Imperial Guard Leaving the Battlefield* at the Paris Salon.

▌ Fall Napoleons. Der Wiener Kongress beschließt die Restauration der Mächte des *Ancien Régime*. Goya malt 1814 *Die Erschießung der Aufständischen am 8.Mai 1808*, feierliches Werk zur spanischen Resistenz gegen die Franzosen. Géricault stellt 1814 *Verwundeter Kürassier verlässt das Schlachtfeld* im Pariser Salon aus.

▌ Val van Napoleon. Het Congres van Wenen besluit tot de restauratie van de de bevoegdheden van de *Ancien Régime*. Goya schildert in 1814 *3 mei 1808: executie van prins Pius op de heuvel*, een werk dat het verzet van de Spanjaarden tegen de Fransen eert. Géricault stelt in 1814 *Gewonde kurassier verlaat het strijdveld* op de Salon tentoon.

▌ Caída de Napoleón. El congreso de Viena marca el inicio de la Restauración de los poderes del *Ancien Régime*. Goya pinta en 1814 *El tres de mayo de 1808*, o *Los fusilamientos en la montaña del Príncipe Pío*, obra que celebra la resistencia española contra los franceses. Géricault expone en el Salón de París en 1814 *Coracero herido*.

**1819**

▌ Géricault exhibits *The Raft of Medusa* at the Paris Salon.

▌ Géricault stellt im Pariser Salon *Das Floß der Medusa* aus.

▌ Géricault stelt op de Salon *Het vlot van Medusa* tentoon.

▌ Géricault expone en el Salón *La balsa de la Medusa*.

**1820**

▌ Hayez exhibits *Pietro Rossi Prisoner of the Scaligeri* at the Brera Gallery, hailed as the first Italian romantic painting.

▌ Hayez stellt in Brera *Pietro Rossi Gefangener der Scaligeri*, das als erstes romantisches Bild der italienischen Malerei gilt.

▌ Hayez stelt in Brera *Pietro Rossi gevangene van de Scala* tentoon, dat wordt gezien als het eerste romantische stuk van de Italiaanse schilderkunst.

▌ Hayez expone en Brera *Pietro Rossi prisionero de los Scaligeri*, aclamado como primer cuadro romántico de la pintura italiana.

**1824**

▌ Ingres' *The Vow of Louis XIII* and Delacroix's *The Massacre at Chios* are exhibited at the Salon in Paris: an encounter won by Ingres' classicism yet again.

▌ Austellung der Werke *Das Gelübde Ludwigs XIII.* von Ingres und *Das Massaker von Chios* von Delacroix im Pariser Salon: Ein Aufeinandertreffen, bei dem der Klassizismus von Ingres als Sieger hervorgeht.

▌ Op de Salon van Parijs worden de *Stem van Louis XIII* van Ingres en *Het bloedbad van Chios* van Delacroix tentoongesteld: een confrontatie waaruit Ingres' classicisme als winnaar naar voren komt.

▌ En el Salón de París se exponen *Voto de Luis XIII* de Ingres y *La matanza de Quíos* de Delacroix: un enfrentamiento del cual el clasicismo de Ingres saldrá de nuevo victorioso.

**1830**

▌ Proletariat and bourgeoisie unite in Paris in a revolt against King Charles X: revolutionary movements spread throughout Europe. Delacroix paints *Liberty Leading the People*.

▌ Proletariat und Bürgertum vereinen sich in Paris in einem Aufstand gegen König Karl X.: die revolutionären Bewegungen breiten sich in ganz Europa aus. Delacroix malt *Die Freiheit führt das Volk*.

▌ Proletariaat en bourgeoisie komen samen in Parijs in opstand tegen koning Charles X: de revolutionaire bewegingen verspreiden zich door heel Europa. Delacroix schildert *Vrijheid leidt het volk*.

▌ Proletariado y burguesía se unen en París en una insurrección contra el rey Carlos X: los motines revolucionarios se difunden en toda Europa. Delacroix pinta *La libertad guiando al pueblo*.

**1848**

▌ New revolutionary movements spread throughout Europe starting in France. Rossetti, Hunt, Millais, Woolner, Collins, Stephens and W.M. Rossetti found the Pre-Raphaelite Brotherhood.

▌ Neue Bewegungen der Revolution durchziehen Europa und gehen von Frankreich aus. Rossetti, Hunt, Millais, Woolner, Collins, Stephens und W.M. Rossetti gründen die Bruderschaft der Präraffaeliten.

▌ Vanuit Frankrijk verspreiden zich nieuwe revolutionaire bewegingen door Europa. Rossetti, Hunt, Millais, Woolner, Collins, Stephens en W.M. Rossetti vormen de prerafaëlieten.

▌ Nuevos motines revolucionarios se propagan por toda Europa, partiendo desde Francia. Rossetti, Hunt, Millais, Woolner, Collins, Stephens y W.M. Rossetti fundan la Hermandad Prerrafaelita.

**1849**

▌ Courbet paints *The Stone Breakers*, which was later destroyed.

▌ Courbet malt das heute verschollene Bild *Die Steinhauer*.

▌ Courbet schildert het inmiddels verloren gewaande *De steenhouwers*.

▌ Courbet pinta *Los picapedreros*, hoy extraviado.

**1852**

▌ Napoleon III comes to power in France: the Second Empire begins.

▌ Napoleon der III. kommt in Frankreich an die Macht: das Zweite Kaiserreich beginnt.

▌ Napoleon III komt aan de macht in Frankrijk: het Tweede Keizerrijk begint.

▌ Napoleón III sube al poder en Francia, dando comienzo al Segundo Imperio.

**1855**

▌ Courbet sets up the *Pavillon du Réalisme* near the Paris Universal Exhibition, writing a manifesto for the occasion explaining his philosophy. An Ingres retrospective is organized at the Universal Exhibition.

▌ Courbet organisiert in der Nähe der Pariser Weltausstellung den *Pavillon du Réalisme* und definiert in der für diesen Zweck verfassten Broschüre die Prinzipien seiner Poetik. Innerhalb der Weltausstellung wird eine retrospektive Ausstellung zur Tätigkeit Ingres organisiert.

▌ Courbet organiseert nabij de Wereldtentoonstelling van Parijs het *Pavillon du Réalisme* en in zijn voor de gelegenheid geschreven boekje beschrijft hij de beginselen van zijn poëzie. Binnen de Wereldtentoonstelling wordt een retrospectieve tentoonstelling georganiseerd over de activiteiten van Ingres.

▌ Courbet organiza, en vistas de la proximidad de la Exposición Universal de París el *Pabellón del Realismo* y en el opúsculo escrito para la ocasión define los principios de su poética. Dentro de la Exposición Universal se organiza una muestra retrospectiva de la actividad de Ingres.

**1870-1871**

▌ Following the Franco-Prussian War and the fall of the Second Empire, the Third Republic is born in France. Courbet plays an active part in the Paris Commune.

▌ In Folge des französisch-preußischen Krieges und dem Fall des Zweiten Kaiserreichs entsteht in Frankreich die Dritte Republik. Courbet nimmt aktiv an der Pariser Kommune teil.

▌ Als gevolg van de Frans-Pruisische oorlog en de val van het Tweede Keizerrijk ontstaat in Frankrijk de Derde Republiek. Courbet is actief betrokken bij de Commune van Parijs.

▌ Luego de la guerra franco-prusiana y de la caída del Segundo Imperio nace en Francia la Tercera República. Courbet participa activamente en la Comuna de París.

# Style chart
# Stilschaubild
# Stijlkaart
# Tabla de estilos

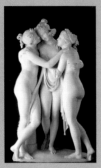

c. 1750 - c.1820

### Neoclassicism

Artistic movement which developed in Europe between the mid 18th and early 19th Century, inspired by archaeological discoveries and the thinkers of the Enlightenment. Neoclassical theories were a reaction to the excesses of the Baroque and the Rococo and their greatest proponent was J.J. Winckelmann. The art of Antiquity is the model to be imitated, in order to achieve the "beauty" which comes of simplicity, harmony, proportion and decorum.

### Neoklassizismus

Künstlerische Bewegung, die sich in Europa Mitte des 18. und Beginn des 19. Jahrhunderts entwickelte und von archäologischen Entdeckungen und der Aufklärung beeinflusst wurde. Die neoklassizistischen Theorien widersetzen sich den Exzessen des Barock und Rokoko. J. J. Winckelmann galt als größter Theoretiker. Die antike Kunst ist das nachgeahmte Vorbild, um die "Schönheit" aus Einfachheit, Harmonie, Proportionen und Zierde zu erreichen.

### Neoclassicisme

Artistieke beweging die tussen het midden van de achttiende en het begin van negentiende eeuw in Europa ontstond en werd beïnvloed door archeologische vondsten en de Verlichting. De neoklassieke theorieën zijn een reactie op de excessen van het barok en het rococo en de voornaamste theoreticus is J. J. Winckelmann. Kunst uit de Oudheid geldt als voorbeeld om de door eenvoud, harmonie, verhouding en omgeving gecreëerde "schoonheid" te bereiken.

### Neoclasicismo

Movimiento artístico que se desarrolló en Europa, entre mediados del siglo XVIII y principios del siglo XIX, alimentado por descubrimientos arqueológicos y por el pensamiento iluminista. Las teorías neoclásicas se oponen a los excesos del Barroco y del Rococó, y tienen en J. J. Winckelmann a su teórico más importante. El arte antiguo es el modelo a imitar, para alcanzar la "belleza" dada por la simplicidad, la armonía, la proporción y el decoro.

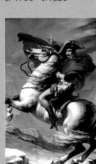

1804 - 1815

### Empire Style

Style that becomes established first in France and spreads throughout Europe during the Napoleonic Empire; it coincides with the final stage of Neoclassicism and follows its forms. Art is seen as a celebration of authority, exalted by a décor of grandiose architecture, furnishings and minor arts, based on Roman, Egyptian and Pompeian models (sphinxes, lyres, Greek fret designs, torches).

### Imperialstil

Der sich zuerst in Frankreich und dann in ganz Europa während des napoleonischen Reichs durchsetzt. Dieser kreuzt sich mit der abschließenden Neoklassizismus-Phase, deren Formen er folgt. Die Kunst wird als Form des Ehrens einer Autorität angesehen, die sich durch großartige Architekturen, Ausstattungen und niedere Kunst, nach dem Vorbild der Römer, Ägypter und Pompejaner (Sphinxe, Leiern, Griechinnen und Fackeln) auszeichnet.

### Empirestijl

Stijl die tijdens het napoleontische tijdperk in Frankrijk ontstaat en zich vervolgens in Europa verbreidt; hij valt samen met de laatste fase van het neoclassicisme, waarvan de stijl wordt voortgezet. De kunst wordt gezien als een eerbetoon aan autoriteit, geaccentueerd door de grandeur van architectuur, meubels, kunst en kunstnijverheid naar Romeins, Egyptisch en Pompejaans voorbeeld (sfinxen, lieren, Grieksen, fakkels).

### Estilo Imperio

Estilo que se afirma primero en Francia y luego en toda Europa en los años del imperio napoleónico; coincide con la fase final del neoclasicismo, del que sigue sus tendencias. El arte es visto como forma de celebración de la autoridad, exaltada por la grandiosidad de la arquitectura, del mobiliario y de las artes menores, y el uso de decoraciones que seguían modelos romanos, egipcios y pompeyanos (esfinges, liras, grecas, antorchas).

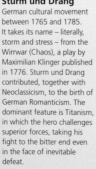

1765 - 1785

### Sturm und Drang

German cultural movement between 1765 and 1785. It takes its name – literally, storm and stress – from the Wirrwar (Chaos), a play by Maximilian Klinger published in 1776. Sturm und Drang contributed, together with Neoclassicism, to the birth of German Romanticism. The dominant feature is Titanism, in which the hero challenges superior forces, taking his fight to the bitter end even in the face of inevitable defeat.

### Sturm und Drang

Deutsche Literaturbewegung (1765 - 1785) deren Name dem Drama Wirrwarr (1776) von M. Klinger, entlehnt wurde. Sturm und Drang trägt mit dem Neoklassizismus zur Entstehung der deutschen Romantik bei. Die dominierende Eigenschaft ist der Titanismus, d. h. der Held, der höheren Mächten trotzt, seinen Kampf bis zum Ende führt, auch wenn er sich bewusst ist, dass er mit einer Niederlage endet.

### Sturm und Drang

Duitse culturele beweging die zich ontwikkelt tussen 1765 en 1785. Is vernoemd naar het drama Wirrwar (Chaos), dat in 1776 door Maximilian Klinger werd gepubliceerd, en letterlijk storm en impuls betekent. Sturm und Drang draagt, et het neoclassicisme, bij tot het ontstaan van de Duitse romantiek. Het leidmotief is de Titaan, de held die bovennatuurlijke krachten trotseert en doorvecht tot het einde, zelfs wanneer hij weet dat hem slechts een nederlaag wacht.

### Sturm und Drang

Movimiento cultural alemán que se desarrolla entre 1765 y 1785. Toma el nombre del drama Wirrwar (Caos), publicado en 1776 por Maximilian Klinger y literalmente significa "tormenta e impulso". El Sturm und Drang contribuye, con el Neoclasicismo, al nacimiento del Romanticismo alemán. Su característica dominante es el titanismo, o sea, el héroe que desafía a fuerzas superiores llevando hasta las últimas consecuencias su lucha, incluso cuando es consciente de que lo único que le espera es la derrota.

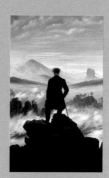

c. 1790 - 1850

### Romanticism

Term expressing a spiritual attitude widespread throughout Europe between the late 18<sup>th</sup> Century and the first half of the 19<sup>th</sup> Century. In the figurative arts, this is reflected in a new sensibility which exalts the artist's individuality and creativity, freed from neoclassical academicism. With the Romantic movement, Art ceases to imitate nature in search of ideal beauty, turning to the expression of individual feelings and aspiring to the sublime.

### Romantik

Der Begriff umschreibt eine in Europa zwischen Ende des 18. Jahrhunderts und der ersten Hälfte des 19. Jahrhunderts verbreitete Geisteshaltung. In den figurativen Künsten Hebt sich die Kreativität des Künstlers hervor, der nun von den akademischen Vorgaben des Neoklassizismus befreit ist. Mit der Romantik ist die Kunst nicht mehr Nachahmung der Natur und Suche nach dem Schönheitsideal, sondern Ausdruck eines individuellen und nach dem Erhabenen strebenden Gefühls.

### Romantiek

Term voor een spirituele houding, die aan het eind van de achttiende en begin negentiende eeuw wijdverbreid is in Europa en in de beeldende kunst tot uiting komt in een nieuw bewustzijn dat is gericht op de individualiteit en creativiteit van de kunstenaar, die nu bevrijd is van de neoklassieke conventies. Nabootsing van de natuur en het bereiken van het schoonheidsideaal worden niet langer nagestreefd maar wel expressie van het individuele gevoel en het verlangen naar het sublieme.

### Romanticismo

Término que indica una postura espiritual, difundida en Europa entre fines del siglo XVIII y la primera mitad del siglo XIX, y que en las artes figurativas se refleja en una nueva sensibilidad tendiente a exaltar la individualidad y la creatividad del artista, liberado de los academicismos neoclásicos. Con el Romanticismo, el arte ya no es imitación de la naturaleza y búsqueda de la belleza ideal, sino expresión del sentimiento individual y anhelo de lo sublime.

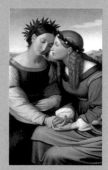

1806 - 1830

### Nazarenes

Group of German artists active in Rome in the early 19<sup>th</sup> Century. Theirs was an art inspired by religious and patriotic values, rejecting the canons of classicist academicism for a return to the simpler forms of the Italian Quattrocento and German models (Dürer). This group's art was to influence both German 19<sup>th</sup> Century religious painting and the Italian purists.

### Die Nazarener

Eine Gruppe deutscher Künstler, die zu Beginn des 19. Jahrhunderts in Rom aktiv sind. Sie bieten eine Kunst, die von den religiösen und patriotischen Werten inspiriert ist, wobei sie die Maßstäbe des klassischen Akademiemus ablehnen, um zu den einfachen Formen des italienischen 15. Jahrhundert und der deutschen Vorbilder (Dürer) zurückzukehren. Die Kunst dieser Gruppe beeinflusst die deutsche Malerei des 19. Jahrhunderts mit heiligen Sujets, sowie die italienischen Puristen.

### Nazareners

Groep Duitse schilders die actief is in Rome aan het begin van de negentiende eeuw. Zijn kunst is geïnspireerd op de religieuze en patriottische waarden en wijst de normen van de klassieke academie af om tot de eenvoudige vormen van vijftiende-eeuwse Italiaanse en Duitse voorbeelden (Dürer) te kunnen terugkeren. Hij beïnvloedt de negentiende-eeuwse Duitse schilderkunst van religieuze onderwerpen en de Italiaanse puristen.

### Nazarenos

Grupo de artistas alemanes activos en Roma a comienzos del siglo XIX. Proponen un arte inspirado en los valores religiosos y patrióticos, rechazando los cánones del academicismo clasicista para volver a las formas clásicas del Quattrocento italiano y de los modelos alemanes (Durero). El arte de este grupo influye en la pintura sagrada alemana del siglo XIX y en los puristas italianos.

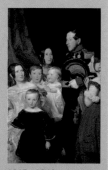

1815 - 1848

### Biedermeier

Style widespread in Germany and Austria during the Restoration, mainly involving furniture and painting. The furniture is simpler than in the neoclassical period and is characterized by its graceful slender lines and striped or floral upholstery fabric patterns. Biedermeier painting is characterized by picturesque views and bourgeois portraits.

### Biedermeier

Ein während der Restauration in Deutschland und Österreich verbreiteter Stil, der sich vor allem in der Einrichtung und in der Malerei niederschlägt. Die Möbel sind gegenüber der vorhergehenden Phase des Neoklassizismus vereinfacht und haben verdünnte Linien; in der Polsterarbeit werden Bezüge aus gestreiften oder geblümten Stoffen verwendet. Die Biedermaier-Malerei ist von malerischen Ansichten und bürgerlichen Bildnissen gekennzeichnet.

### Biedermeier

Tijdens de Restauratie in Duitsland en Oostenrijk populaire stijl die vooral meubels en schilderkunst betreft. Het meubilair is ten opzichte van de vorige, neoklassieke periode eenvoudiger en slanker van lijn; meubelstoffen hebben streep- of bloempatronen. De schilderkunst wordt gekenmerkt door schilderachtige uitzichten en portretten van de bourgeoisie.

### Biedermeier

Estilo difundido en Alemania y en Austria durante la Restauración, concerniendo sobre todo al mobiliario y la pintura. Los muebles se simplifican respecto al precedente período neoclásico y sus líneas son estilizadas; en las tapicerías se usan fundas de telas a rayas o floreadas. La pintura Biedermaier está caracterizada por escorzos pintorescos y retratos burgueses.

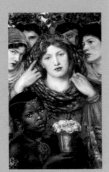

1848 - c. 1880

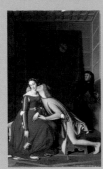

1800 - c. 1850

### Pre-Raphaelites

Movement founded in London in 1848 in reaction to official painting, calling for a return to art before Raphael (hence the name) in order to recover something of the lost ideals of purity, piety, spontaneity and contact with nature. The Brotherhood officially dissolved in 1853, but the style and influence survived until the 1880s.

### Die Präraffaeliten

Die Bewegung wurde 1848 in London als Reaktion auf die offizielle Malerei gegründet. Sie fordert eine Rückkehr zur Kunst vor Raffael (daher stammt der Name), um sich besser den Idealen der Reinheit, religiosität, Spontaneität und Verbindung mit der Natur zu nähern. Die Gruppe wird sich offiziell im Jahr 1853 auflösen, aber der Stil und die Einflüsse werden bis in die 80er Jahre des Jahrhunderts überleben.

### De prerafaëlieten

In 1848 in Londen opgerichte beweging, in reactie op de officiële schilderkunst, die oproept tot een terugkeer van de kunst van voor Raphaël (vandaar de naam), om dichter bij de idealen van zuiverheid, vroomheid, spontaniteit, en in contact met de natuur te komen. De groep wordt officieel in 1853 ontbonden, maar de stijl en de invloeden overleven tot de jaren tachtig van die eeuw.

### Prerrafaelitas

Movimiento fundado en Londres en 1848 como reacción a la pintura oficial, que exhorta a un retorno al arte anterior a Rafael (de aquí el nombre) para acercarse principalmente a los ideales de pureza, religiosidad, espontaneidad y contacto con la naturaleza. El grupo se disolverá oficialmente en 1853, pero su estilo y sus influencias sobrevivirán hasta los años '80 de dicho siglo.

### Primitivism

Term that covers the tendency to flee the restrictions of contemporary society, finding refuge in an idealised past and adapting content and style accordingly. In the first half of the 19ᵗʰ Century, the term referred to the return to models deriving from the works of the Primitives: Tuscan artists of the 14ᵗʰ and 15ᵗʰ Centuries who were regarded as exemplars of purity.

### Primitivismus

Umfasst, im Gegensatz zu den Zwängen der gegenwärtigen Gesellschaft, die Tendenz, in eine idealisierte Vergangenheit zu flüchten. In der ersten Hälfte des 19. Jahrhunderts bedeutete dieser Begriff die Wiederaufnahme von Modellen aus Arbeiten der Primitiven: toskanische Künstler des 14. und 15. Jahrhunderts, die als Vorbilder für Reinheit galten.

### Primitivisme

Term voor de trend, in tegenstelling tot de beperkingen van de hedendaagse samenleving, een toevlucht te nemen in een geïdealiseerd verleden, met aanpassing van inhoud en stijl. In de eerste helft van de negentiende eeuw wordt met deze term een hervatting van de originele modellen uit de werken van Primitivisten aangeduid: veertiende- en vijftiende-eeuwse Toscaanse kunstenaars, die worden beschouwd als voorbeelden van zuiverheid.

### Primitivismo

Término que indica la tendencia, en oposición a las coerciones de la sociedad moderna, a refugiarse en un pasado idealizado, adecuando a éste sus contenidos y estilo. En la primera mitad del siglo XIX se indica con este término una recuperación de los modelos originados en las obras de los Primitivos: artistas toscanos de los siglos XIV y XV, considerados ejemplos de pureza.

1720 - c. 1880

### Gothic revival

Artistic trend that spread in England from c. 1720 onwards and, from the end of the 18th century, throughout the rest of Europe. The aim was to bring about a reevaluation of the art and civilization of the Middle Ages (in particular Gothic architecture) in contrast to the classic taste then prevalent. In England, it coincides with the return of Gothic forms which then spread, above all to the Nordic countries. John Ruskin was one of the movement's principal champions.

### Neugothic

In England seit ungefähr 1720 und im restlichen Europa seit Ende des Jahrhunderts verbreitete künstlerische Strömung. Sie zielt auf die Neubewertung der mittelalterlichen Kunst und Kultur (vor allem der gotischen Architektur) im Gegensatz zur Klassik. In England trifft sie mit der Rückkehr von gotischen Formen zusammen, die sich dann vor allem auf die nordischen Länder ausbreiten. Zu den Hauptvertretern gehört J. Ruskin.

### Neogotiek

Artistieke trend die rond 1720 in Engeland ontstaat en zich vanaf het einde van de eeuw in de rest van Europa vestigt. Hij streeft naar de herwaardering van middeleeuwse kunst en cultuur (met name van de gotische architectuur) in tegenstelling tot de klassieke smaak. In Engeland valt hij samen met de terugkeer van de gotische vormen, die vervolgens ook en vooral in de Scandinavische landen plaatsvindt. Een van de belangrijkste exponenten is J. Ruskin.

### Neogótico

Tendencia artística que se difundió en Inglaterra desde 1720 aproximadamente, y desde fin de siglo en el resto de Europa. Aspira a la revalorización del arte y de la civilizaciones medievales (en particular de la arquitectura gótica) en contraposición al gusto clásico. En Inglaterra coincide con el retorno de los módulos góticos que se propagarán sobre todo en los países nórdicos. Entre sus principales exponentes, J. Ruskin.

c. 1850 - c. 1890

### Realism

Term that implies keeping artistic expression as close as possible to real data and refers to a specific trend which began in France from 1850 onwards with the work of Gustave Courbet. In 1855 the French painter expounded his theories in a treatise entitled Realism in which he asserted the right of artists to create works capable of representing contemporary social problems, while rejecting academic canons and romantic escapism.

### Realismus

Der Begriff umschreibt eine enge Verbindung des künstlerischen Ausdrucks mit der Wirklichkeit. Er bezieht sich auf eine bestimmte Strömung, die sich seit 1850 in Frankreich mit G. Coubert durchgesetzt hat. Der französische Maler stellt 1855 seine eignen Theorien in dem Traktat Der Realismus vor, in dem er das Recht der Künstler einfordert, Werke zu schaffen, die in der Lage sind die aktuellen gesellschaftlichen Probleme darzustellen und dabei auf die akademischen Vorlagen und romantischen Ausbrüche verzichten.

### Realisme

Term die een nauwe samenhang tussen de artistieke expressie en de realiteit aanduidt en verwijst naar een stroming die zich in 1850 in Frankrijk vestigt met G. Coubert. De Franse schilder presenteert zijn theorieën in 1855 in het tractaat Het realisme, waarin het recht van kunstenaars uitgesproken wordt om werken in maken waarin hedendaagse sociale kwesties worden weergegeven, en waarbij de academische waarden en het romantische ontwijken worden afgewezen.

### Realismo

Término que indica una estricta adhesión de la expresión artística a la realidad, y se refiere a una precisa corriente que se afirmó en Francia a partir de 1850 con G. Coubert. En 1855, el pintor francés expone sus propias teorías en el tratado El realismo, en el cual reivindica el derecho de los artistas a realizar obras capaces de representar las problemáticas sociales contemporáneas, rechazando los cánones académicos y las evasiones románticas.

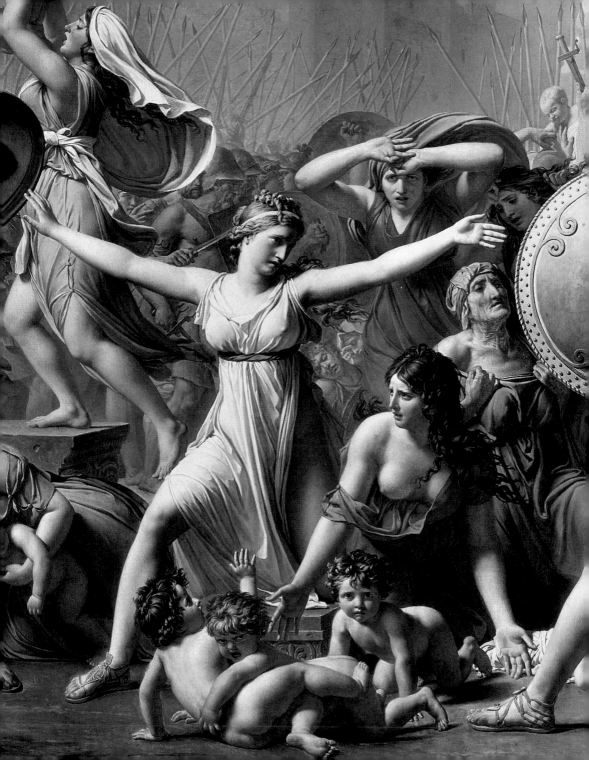

# The example
# of the ancient world

*Half way through the 18th century,
in Italy, and above all in Rome,
neoclassical culture was born.
Increasingly, the Grand Tour drew
travelers; new archaeological digs at
Pompeii, Herculaneum and Paestum
encouraged an intermingling of
merchants, artists, and international
scholars, who together laid the
theoretical and methodological
foundations for the new taste.
However, while Italy was the
main centre from which the new
language spread, England and France
also played a decisive role in its
development.*

# Das antike Vorbild

*Seit Mitte des 18. Jahrhunderts wurde
Italien und vor allem Rom zum Schauplatz
für die entstehende neoklassizistische
Kultur. Die Kavalierreise oder auch die
Grand Tour, die immer mehr Reisende
unternahmen, und die neuesten
archäologischen Ausgrabungen in Pompeji,
Herkulaneum und Paestum begünstigten
die Begegnung von internationalen
Händlern, Künstlern und Gelehrten, die
hier die theoretischen und methodischen
Fundamente des neuen Geschmacks
gossen. Auch wenn Italien die zentrale
Geburtsstätte der neuen Sprache
war, spielten bei deren Ausarbeitung
auch Frankreich und England eine
entscheidende Rolle.*

# 1

# De Oudheid als voorbeeld

*Halverwege de achttiende eeuw werd
Italië en met name Rome het toneel van
de opkomende neoklassieke cultuur.
De praktijk van de Grand Tour raakte
steeds populairder onder reizigers en
de nieuwe opgravingen in Pompeji,
Herculaneum en Paestum werkten
ontmoetingen tussen kooplieden,
kunstenaars en internationale geleerden
in de hand, die hier de theoretische en
methodologische bases legden voor het
nieuwe concept van smaak.
Maar al was Italië het absolute centrum
van de nieuwe taal, ook Engeland en
Frankrijk speelden een beslissende rol in
de ontwikkeling ervan.*

# El ejemplo de la Antigüedad

*Desde la mitad del siglo XVIII, Italia,
y sobre todo Roma, se convierten en
escenario de discusión para la naciente
cultura neoclásica. La práctica del Grand
Tour, cada vez más difundida entre
los viajeros, y las nuevas excavaciones
arqueológicas en Pompeya, Herculano
y Paestum favorecen el encuentro de
comerciantes, artistas y estudiosos
internacionales que asentaron aquí
las bases teóricas y metodológicas del
nuevo gusto. Pero si bien Italia fue el
centro de propagación fundamental
del nuevo lenguaje, también Francia e
Inglaterra jugaron un rol decisivo en su
elaboración.*

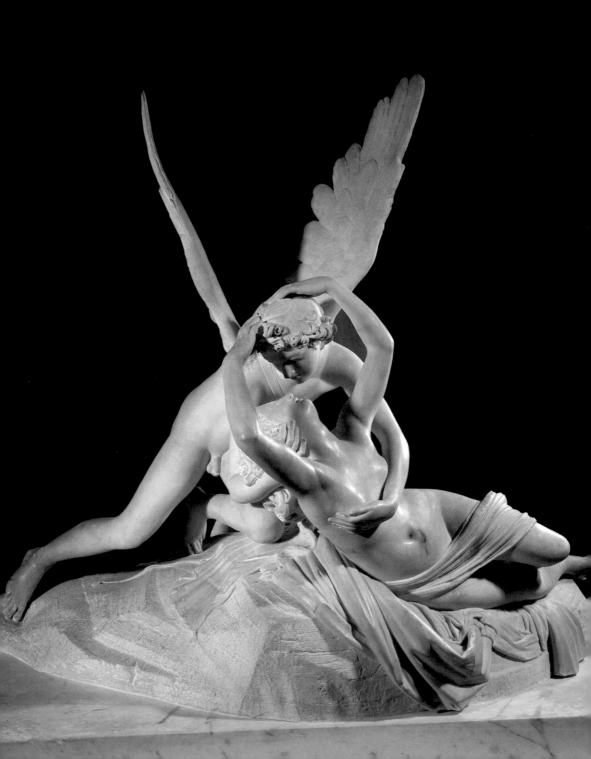

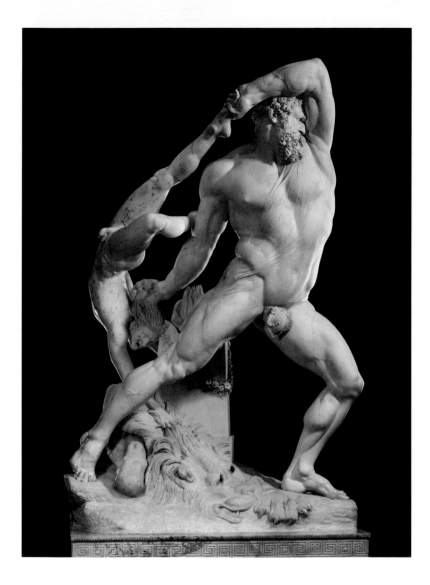

◄ **Antonio Canova**
(Possagno, Treviso 1757 - Venezia 1822)
*Cupid and Psyche,* marble
*Amor und Psyche,* Marmor
*Amor en Psyche,* marmer
*Psique reanimada por el beso del amor,* mármol
1787-1793
155 x 168 cm / 61 x 66.2 in.
Musée du Louvre, Paris

**Antonio Canova**
(Possagno, Treviso 1757 - Venezia 1822)
*Hercules and Lica,* marble
*Herkules und Lica,* Marmor
*Hercules en Lica,* marmer
*Hércules y Lichas,* mármol
1795-1815
h. 335 cm / 131.9 in.
Galleria Nazionale di Arte Moderna, Roma

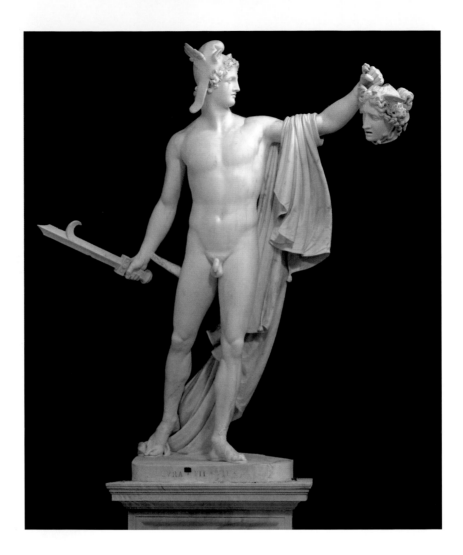

**Antonio Canova**
(Possagno, Treviso 1757 - Venezia 1822)
*Perseus*, marble
*Perseus*, Marmor
*Perseus*, marmer
*Perseo con la cabeza de Medusa*, mármol
1797-1801
235 x 190 cm / 92.5 x 74.8 in.
Museo Pio-Clementino, Città del Vaticano

▌ *In Canova's sculpture, fluid and continuous lines enfold the bodies and outline limbs captured in mid- movement.*
▌ *In den Skulpturen von Canova umhüllen fließende und ununterbrochene Linien die Körper und schließen die Glieder ein, die im Bruchteil einer Bewegung eingefangen werden.*
▌ *In de sculpturen van Canova omhullen continue en vloeiende lijnen het lichaam en omsluiten de ledematen, die zijn gevangen in een fractie van de beweging.*
▌ *En las esculturas de Canova, las líneas fluidas y continuas envuelven a los cuerpos, capturando los miembros detenidos en una fracción de movimiento.*

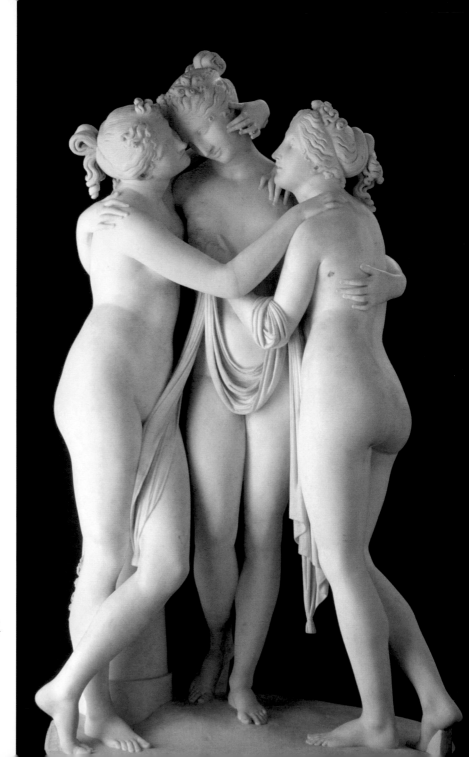

**Antonio Canova**
(Possagno, Treviso 1757
- Venezia 1822)
*The Three Graces,* marble
*Die drei Grazien,* Marmor
*De drie gratiën,* marmer
*Las tres gracias,* mármol
1814-1817
173 x 97 x 75 cm
68 x 38 x 29.5 in.
Victoria & Albert
Museum, London

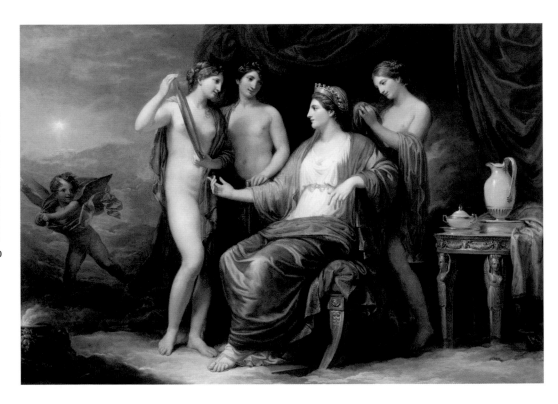

**Andrea Appiani**
(Milano 1754 - 1817)
*The Toilet of Juno*, oil on canvas
*Die Toilette der Juno*, Öl auf Leinwand
*Toilet van Juno*, olieverf op doek
*La toilette de Juno*, óleo sobre lienzo
c. 1811
100 x 142 cm / 39 x 56 in.
Pinacoteca Civica, Brescia

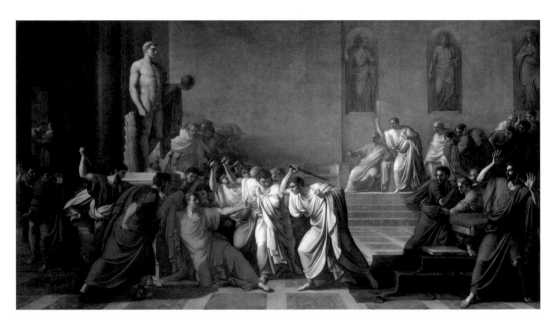

**Vincenzo Camuccini**
(Roma 1771 - 1844)
*The Death of Julius Caesar*, oil on canvas
*Der Tod des Caesar*, Öl auf Leinwand
*Dood van Julius Caesar*, olieverf op doek
*La muerte de César*, óleo sobre lienzo
1798
400 x 707 cm / 157.4 x 278.3 in.
Galleria Nazionale di Capodimonte, Napoli

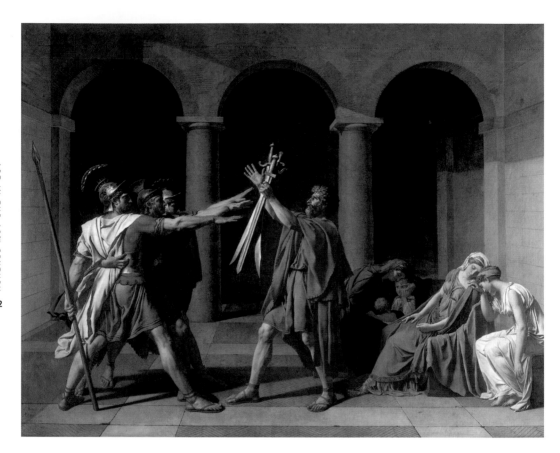

**Jacques-Louis David**
(Paris 1748 - Bruxelles 1825)
*The Oath of the Horatii*, oil on canvas
*Schwur der Horatier*, Öl auf Leinwand
*De eed van de Horatiërs*, olieverf op doek
*El juramento de los Horacios*, óleo sobre lienzo
1784
330 x 425 cm / 130 x 167.3 in.
Musée du Louvre, Paris

▌ *The austere perspectives of David's scenic settings accompany the eye across the dramatic turning points of historical and human events.*
▌ *Die strenge Ansicht der Szenerie bei David begleitet das Auge zum dramatischen Mittelpunkt der historischen und menschlichen Geschehnisse.*
▌ *De sobere perspectieven in de compositie van David begeleiden het oog naar het dramatische middelpunt van historische en menselijke gebeurtenissen.*
▌ *Las austeras perspectivas de la construcción del espacio en David guían la mirada hacia los ejes dramáticos del acontecimiento histórico y humano.*

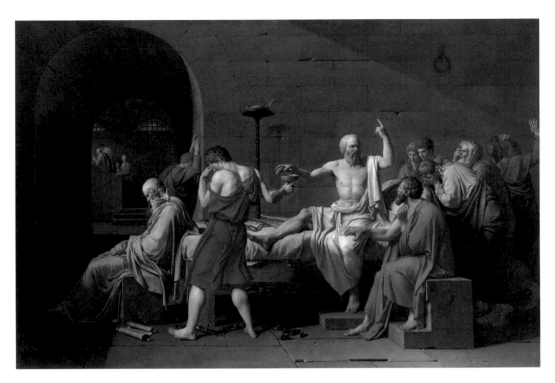

**Jacques-Louis David**
(Paris 1748 - Bruxelles 1825)
*The Death of Socrates,* oil on canvas
*Der Tod des Sokrates,* Öl auf Leinwand
*De dood van Socrates,* olieverf op doek
*La muerte de Sócrates,* óleo sobre lienzo
1787
129,5 x 196,2 cm / 50.8 x 77.2 in.
The Metropolitan Museum of Art, New York

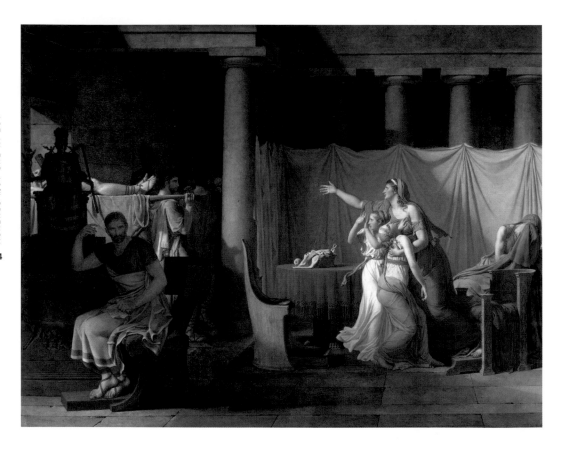

**Jacques-Louis David**
(Paris 1748 - Bruxelles 1825)
*Lictors Bearing to Brutus the Bodies of His Sons*, oil on canvas
*Die Liktoren bringen Brutus die Leichen seiner Söhne*, Öl auf Leinwand
*De lectoren brengen Brutus de lichamen van zijn zonen*, olieverf op doek
*Los lictores llevan a Bruto el cuerpo de sus hijos*, óleo sobre lienzo
1789
323 x 422 cm / 127 x 166.2 in.
Musée du Louvre, Paris

▶ **Jacques-Louis David**
(Paris 1748 - Bruxelles 1825)
*The Death of Marat*, oil on canvas
*Der Tod des Marat*, Öl auf Leinwand
*De dood van Marat*, olieverf op doek
*La muerte de Marat*, óleo sobre lienzo
1793
165 x 128 cm / 65 x 50.4 in.
Musées royaux des Beaux-Arts de Belgique, Bruxelles

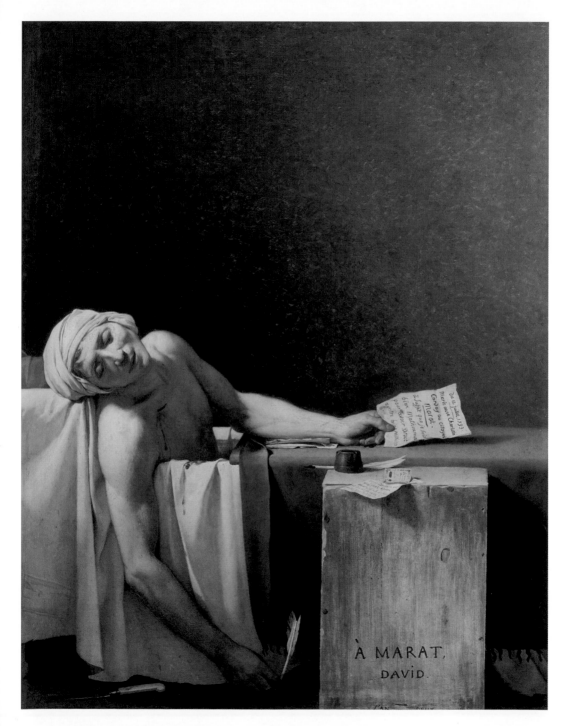

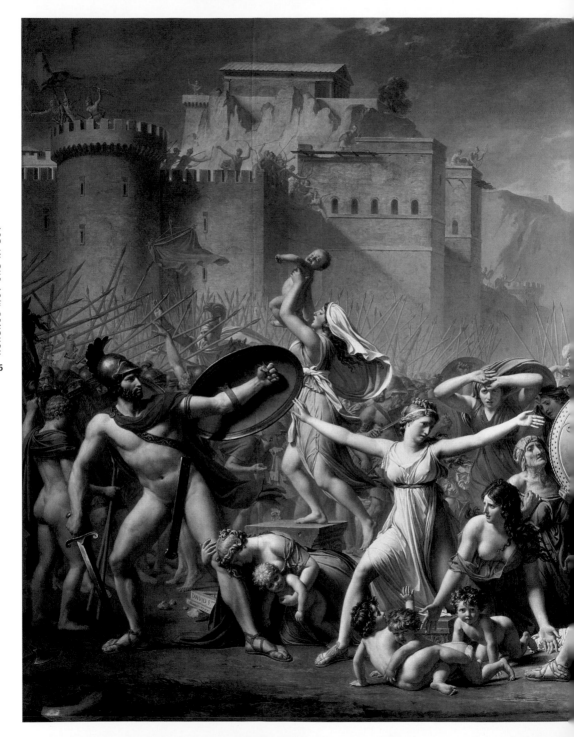

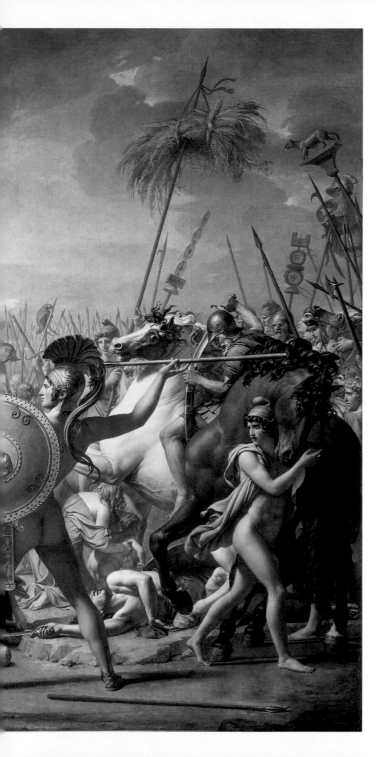

**Jacques-Louis David**
(Paris 1748 - Bruxelles 1825)
*The Sabine Women Halt the Fight between
the Romans and Sabines*, oil on canvas
*Raub der Sabinerinnen*, Öl auf Leinwand
*De Sabijnse vrouwen stoppen de strijd
tussen de Romeinen en de Sabijnen*,
olieverf op doek
*El rapto de las Sabinas*, óleo sobre lienzo
1799
385 x 522 cm / 151.5 x 205.5 in.
Musée du Louvre, Paris

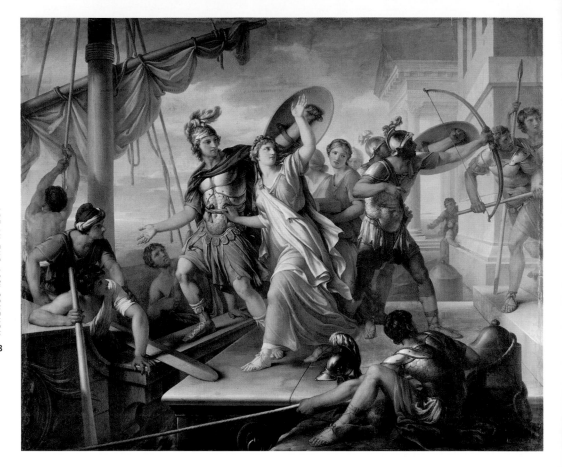

■ *Collector and painter who chose to live in Rome, Hamilton's predilection was for mythological subjects, enriched by infinite details thanks to his antiquarian's passion.*
■ *Als Sammler und Maler, der Rom zu seiner Wahlheimat machte, sticht Hamilton mit seinen mythologischen Sujets, die mit unzähligen Details dank seiner Leidenschaft für Antiquitäten bereichert sind, hervor.*
■ *Als verzamelaar en schilder, die heeft gekozen voor Rome als zijn thuisstad, geeft Hamilton in zijn werk de voorkeur aan mythologische onderwerpen, verrijkt met oneindig veel details, dankzij zijn passie voor oudheden.*
■ *Coleccionista y pintor que ha elegido Roma como ciudad de residencia, Hamilton tiene predilección en sus obras por los temas mitológicos, enriquecidos con infinitos detalles gracias a su pasión por las antigüedades.*

**Gavin Hamilton**
(Lanark 1723 - Roma 1798)
*The Abduction of Helen*, oil on canvas
*Die Entführung der Helena*, Öl auf Leinwand
*De ontvoering van Helena*, olieverf op doek
*El rapto de Helena*, óleo sobre lienzo
1784
306 x 367 cm / 120.5 x 144.5 in.
Museo di Roma, Roma

▶ **Gavin Hamilton**
(Lanark 1723 - Roma 1798)
*Venus Presenting Helen to Paris*, oil on canvas
*Venus verspricht Paris Helena zur Frau*, Öl auf Leinwand
*Venus presenteert Helena aan Paris*, olieverf op doek
*Venus dando a Paris Helena como esposa*, óleo sobre lienzo
1785
306 x 259 cm / 120.5 x 102 in.
Museo di Roma, Roma

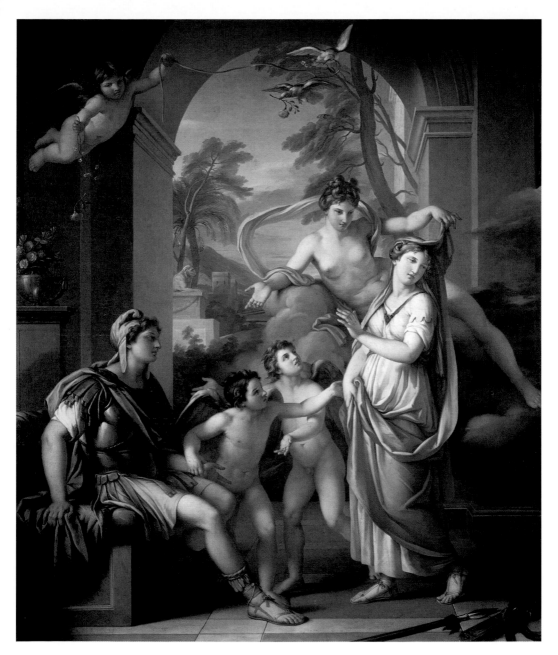

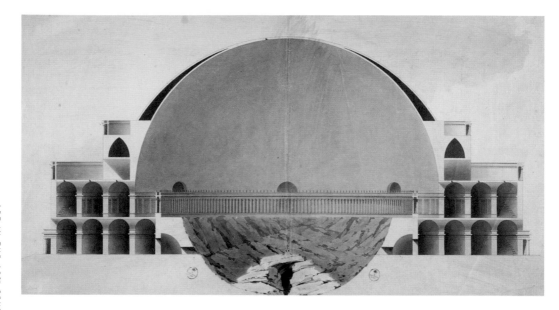

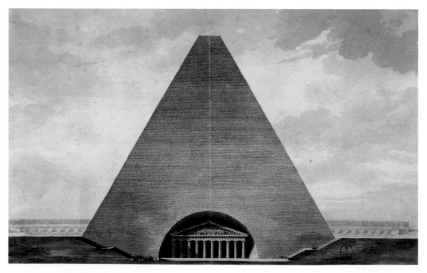

**Étienne-Louis Boullée**
(Paris 1728 - 1799)
*Design for a Temple of Reason or Nature*, vertical section
*Projekt für einen Tempel der Vernunft oder der Natur*, Querschnitt
*Project voor een tempel voor de Rede of de Natuur*, split
*Proyecto para un templo de la Razón o de la Naturaleza*, corte vertical
c. 1780
Gabinetto dei Disegni e delle Stampe degli Uffizi, Firenze

**Étienne-Louis Boullée**
(Paris 1728 - 1799)
*Pyramid no. 6591*, drawing
*Pyramide*, Zeichnung
*Piramide*, tekening
*Cenotafio piramidal*, dibujo
c. 1780
Gabinetto dei Disegni e delle Stampe degli Uffizi, Firenze

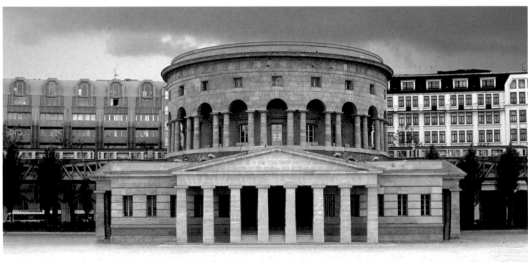

**Giuseppe Piermarini**
(Foligno 1734 - 1808)
The Scala Theater
Teatro alla Scala
Teatro de la Scala
1776-1778
Milano

**Claude-Nicolas Ledoux**
(Dormans-sur-Marne 1736 - Paris 1806)
View of the Rotonde de la Villette
Blick auf die Rotonde de la Villette (Rotunde Ledoux)
Zicht op de Rotonda della Villette (Rotonde Ledoux)
Vista de la rotonda de la Villette (Rotonde Ledoux)
1784-1789
Paris

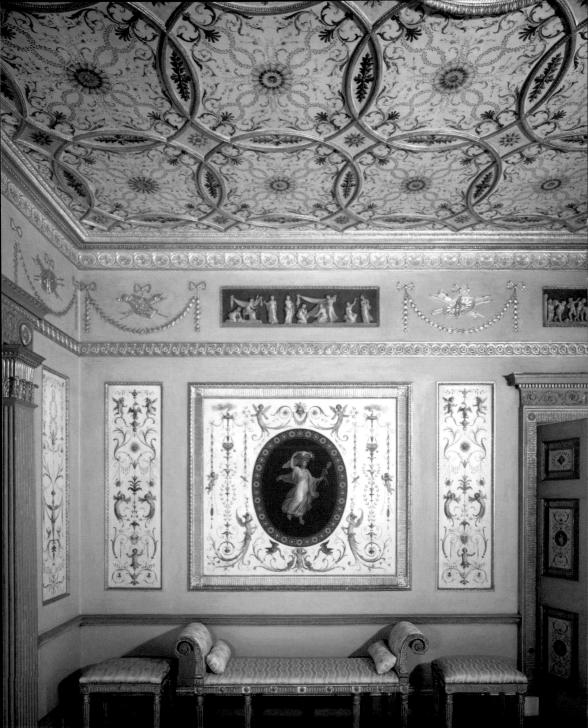

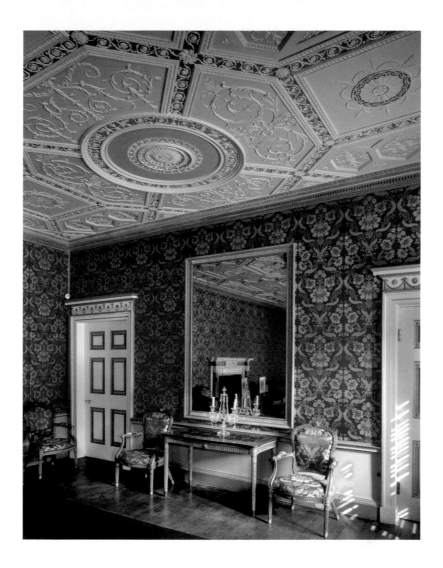

◀ **Robert Adam**
(Kirkcaldy 1728 - London 1792)
The Little Drawing Room
Kleiner Salon
De kleine salon
La sala pequeña
*post* 1762
Audley End House, Saffron Walden (Essex)

**Robert Adam**
(Kirkcaldy 1728 - London 1792)
The Great Drawing Room
Großer Salon
De grote salon
La sala grande
*post* 1762
Audley End House, Saffron Walden (Essex)

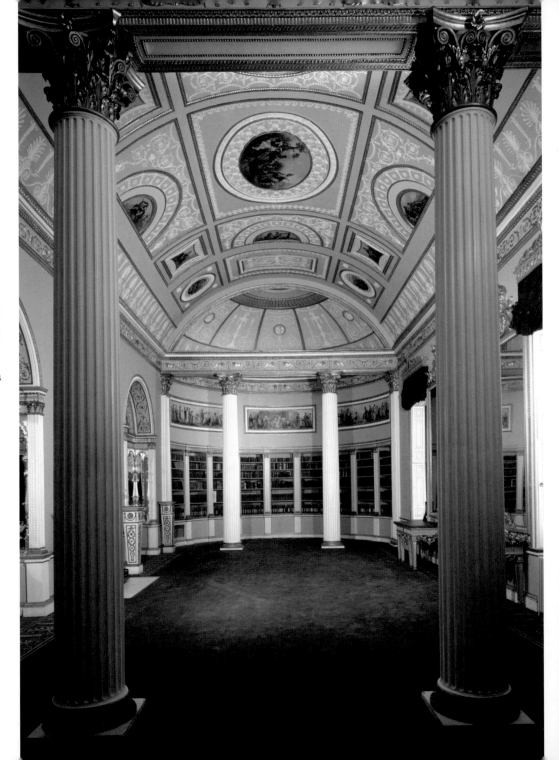

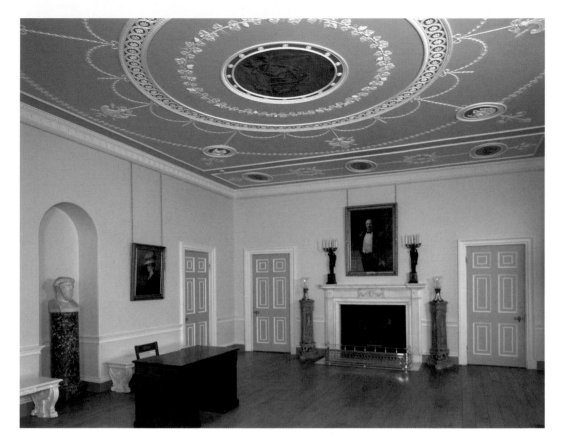

▌ *Adam's cultivated interpretation of antiquity blends graceful decorative detail with the severity of neoclassical architectural forms.*
▌ *Die gebildete Deutung der Antike durch Adam verbindet die Anmut der dekorativen Einzelheiten mit der Strenge der architektonischen Formen im Neoklassizismus.*
▌ *De verfijnde interpretatie in de Oudheid van Adam combineert de charme van decoratieve details met de rigiditeit van de neoklassieke architectonische vormen.*
▌ *La culta interpretación de la antigüedad de Adam funde la armonía de los detalles decorativos con el rigor de las formas arquitectónicas neoclásicas.*

◄ **Robert Adam**
(Kirkcaldy 1728 - London 1792)
The Library
Bibliothek
Bibliotheek
Biblioteca
1764-1779
Kenwood House, Hampstead (London)

**Robert Adam**
(Kirkcaldy 1728 - London 1792)
The Entrance Hall
Eingang
Ingang
Vestíbulo
1764-1779
Kenwood House, Hampstead (London)

# The spread
of Neoclassicism

A deep cultural change and the ethical
message underlying Neoclassicism did
much to contribute to its widespread
international dissemination. The
part played by Northern Europe was
particularly important, with artists
in Italy and in their home countries
decisively developing theoretical and
formal thinking, and Mengs leading
the way. The Russia of Catherine the
Great and the United States brought
much original and significant work into
the world. A landmark contribution
was the Virginia State Capitol building
in Richmond, by future US President
Thomas Jefferson.

# Die Verbreitung
des Neoklassizismus

Die tiefe kulturelle Erneuerung und die
ethische Botschaft, als Grundlage des
Neoklassizismus, unterstützten darüber
hinaus dessen weite internationale
Verbreitung. Besonders erfolgreich
war der Beitrag Nordeuropas durch
Künstler, die in Italien und der Heimat
einen entscheidenden theoretischen
und formalen Gedanken entwickelten:
besonders Mengs. Auch das Russland
von Katharina der Großen und die
Vereinigten Staaten boten echte und
bedeutsame Werke: ein wichtiges Zeugnis
war mit Sicherheit das Virginia State
Capitol in Richmond des zukünftigen
Präsidenten Thomas Jefferson.

2

# De verspreiding
van het neoclassicisme

De diepgaande culturele vernieuwing en
ethische boodschap, die aan de basis van
het neoclassicisme lagen, vormden ook
de motor achter de brede internationale
verspreiding ervan. Bijzonder succesvol
was de bijdrage van Noord-Europa met
kunstenaars, met name Mengs, die in
Italië en in hun vaderland een cruciale
theoretische en formele denkwijze
ontwikkelden. Zelfs het Rusland van
Catharina de Grote en de Verenigde
Staten leverden originele en bijzondere
werken: een sterk bewijs hiervan was
zonder twijfel het Capitool in Richmond
van de toekomstige president Jefferson.

# La expansión
del neoclasicismo

La profunda renovación cultural y el
mensaje ético, bases del neoclasicismo,
fueron en gran parte responsables
de su amplia difusión internacional.
Particularmente fructífera fue la
contribución del norte de Europa
con artistas que en Italia y en su país
desarrollaron una decisiva reflexión
teórica y formal: sobre todo Mengs.
También la Rusia de Catalina la Grande
y los Estados Unidos contribuyeron
con obras originales y significativas: un
fuerte testimonio fue, sin lugar a dudas,
el que dio el futuro presidente Jefferson
con el Capitolio de Richmond.

**Anton Raphael Mengs**
(Aussig 1728 - Roma 1779)
*Judgement of Paris*, oil on canvas
*Das Urteil des Paris*, Öl auf Leinwand
*Het oordeel van Paris*, olieverf op doek
*El juicio de Paris*, óleo sobre lienzo
c. 1756
226 x 295,5 cm / 89 x 116.14 in.
State Hermitage Museum, St. Petersburg

▌ *The beauty of the goddesses painted by Mengs is emphasized by the solemn calm and nobility of their figures, while their eyes reveal the passions that move them.*
▌ *Die Schönheit der von Mengs gemalten Gottheiten wird von der feierlichen Gelassenheit und Vorzüglichkeit ihrer Figuren unterstrichen, während aus ihren Augen die Leiden, die sie bewegen, dringen.*
▌ *De schoonheid van de door Mengs geschilderde godinnen, wordt benadrukt door de plechtige kalmte en de edelheid van de figuren, terwijl hun ogen de passie uitdrukken, die hen beweegt.*
▌ *La belleza de las deidades pintadas por Mengs es resaltada por la solemne calma y la nobleza de sus figuras, mientras que sus ojos desvelan las pasiones que las mueven.*

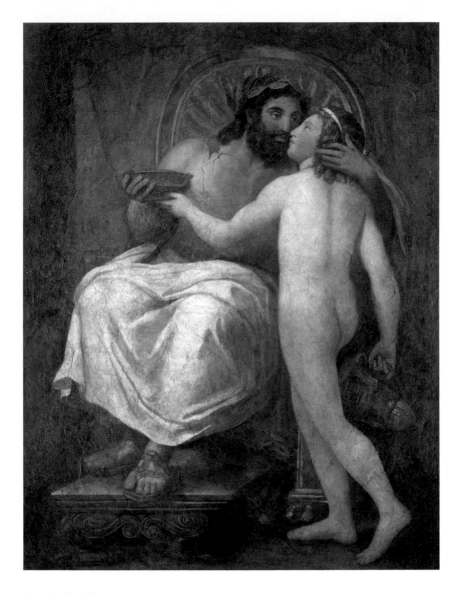

**Anton Raphael Mengs**
(Aussig 1728 - Roma 1779)
*Jupiter and Ganymede*, fresco transferred to canvas
*Jupiter und Ganymed*, auf Leinwand aufgetragenes Fresko
*Jupiter en Ganymedes*, fresco op doek
*El rapto de Ganímedes,* fresco transportado a lienzo
1758-1759
180 x 140 cm / 70.9 x 55 in.
Galleria Nazionale d'Arte Antica, Roma

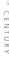

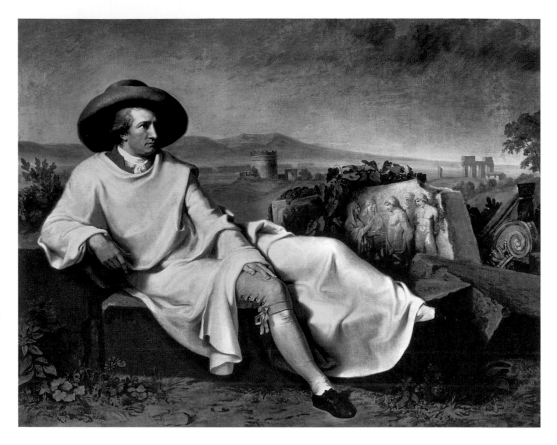

▌ *Goethe in his monumental portrait is the symbol of all the travelers who for generations saw their trip to Italy as a fundamental stage in their life and education.*

▌ *Goethe ist in seinem monumentalen Bildnis das Symbol aller Reisenden, die über Generationen hinweg in ihrer Italienreise eine grundlegende Phase ihres Lebens und ihrer Bildung sahen.*

▌ *In dit monumentale portret is Goethe het symbool van alle reizigers, die generaties lang de reis naar Italië als een cruciale fase in hun leven en opleiding zagen.*

▌ *En su monumental retrato, Goethe es el símbolo de todos los viajeros que por generaciones y generaciones vieron en el viaje a Italia una etapa fundamental de su vida y de su formación.*

**Johann H. W. Tischbein**
(Haina 1751 - Eutin 1829)
*Goethe in the Roman Campagna*, oil on canvas
*Goethe in der Campagna*, Öl auf Leinwand
*Goethe in het Romeinse platteland*, olieverf op doek
*Goethe en la campaña romana*, óleo sobre lienzo
1786-1787
164 x 206 cm / 64.5 x 81 in.
Städelsches Kunstinstitut, Frankfurt

▶ **Johann H. W. Tischbein**
(Haina 1751 - Eutin 1829)
*Girl with Flowers*, oil on canvas
*Mädchen mit Blumen*, Öl auf Leinwand
*Meisje met bloemen*, olieverf op doek
*Muchacha con flores*, óleo sobre lienzo
c. 1825
91,5 x 76,2 cm / 35.8 x 30 in.
Hamburger Kunsthalle, Hamburg

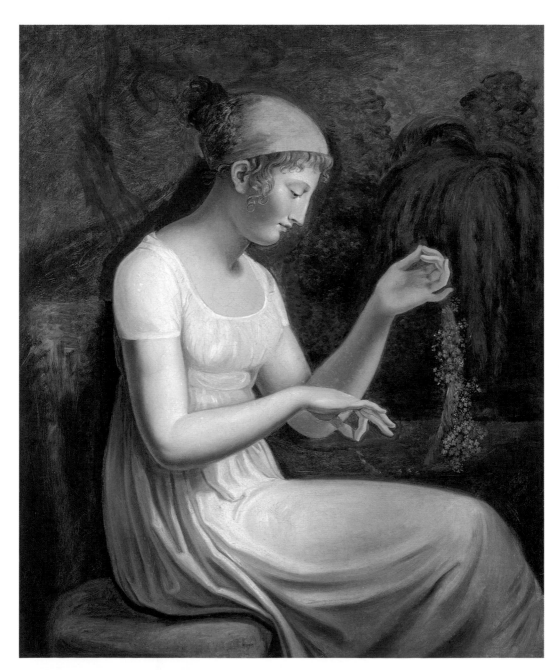

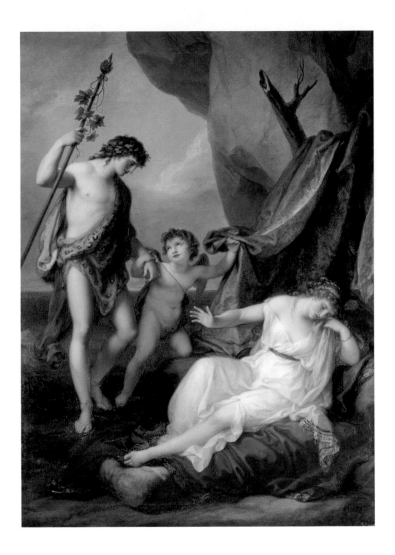

◀ **Angelica Kauffmann**
(Chur 1741 - Roma 1807)
*Ariadne Abandoned by Theseus on Naxos*, oil on canvas
*Die verlassene Ariadne*, Öl auf Leinwand
*Ariadne verlaten*, olieverf op doek
*Ariadna abandonada por Teseo*, óleo sobre lienzo
*ante* 1782
Gemäldegalerie Alte Meister, Staatliche Kunstsammlungen

**Angelica Kauffmann**
(Chur 1741 - Roma 1807)
*Bacchus and Ariadne*, oil on canvas
*Bacchus und Ariadne*, Öl auf Leinwand
*Bacchus en Ariadne*, olieverf op doek
*Baco y Ariadna*, óleo sobre lienzo
Attingham Park, Shrewsbury

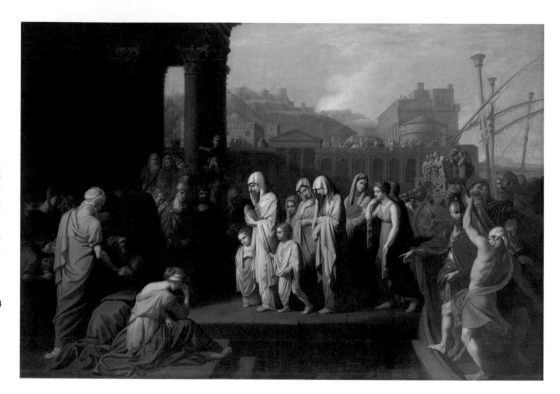

**Benjamin West**
(Springfield, Pennsylvania 1738 - London 1820)
*Agrippina Landing at Brindisium with the Ashes
of Germanicus*, oil on canvas
*Agrippina trifft in Brindisi mit der Asche des Germanicus ein,*
Öl auf Leinwand
*Agrippina komt in Brindisi aan wal met
de as van Germanicus,* olieverf op doek
*Agripina desembarcando en Brindisi con las cenizas
de Germánico,* óleo sobre lienzo
1768
163,8 x 240 cm / 64.5 x 94.5 in.
Yale University Art Gallery, New Haven (CT)

▌ *The mournful procession that accompanies the ashes of Germanicus
culminates in the figure of his wife, Agrippina, model of dignity and
courage, virtues that West wanted to inspire in the viewers.*
▌ *Der schmerzerfüllte Zug, der die Asche von Germanicus begleitet findet
ihren Höhepunkt in der Figur der Frau Agrippina, dem Vorbild an Würde
und Mut: Tugenden, zu denen West die Betrachter bewegen wollte.*
▌ *De rouwende stoet, die de as van Germanicus begeleidt, culmineert in
de figuur van zijn vrouw Agrippina, een voorbeeld van waardigheid en
moed, een deugd waarmee West kijkers wilde inspireren.*
▌ *El dolorido cortejo que acompaña las cenizas de Germánico culmina
en la figura de su mujer, Agripina, ejemplo de dignidad y coraje, virtudes
con las cuales West quiso inspirar a los observadores.*

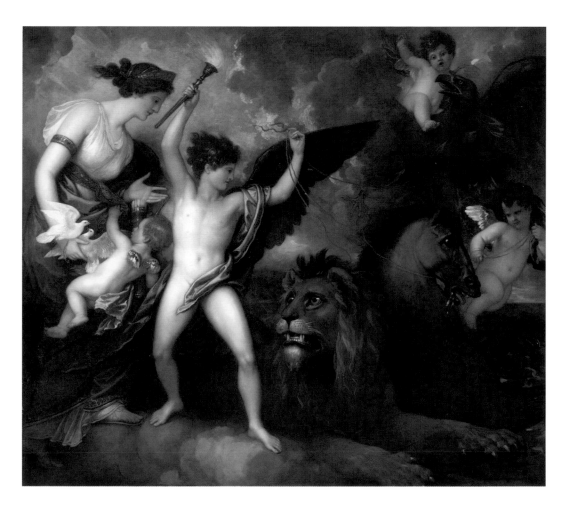

**Benjamin West**
(Springfield, Pennsylvania 1738 - London 1820)
*Omnia Vincit Amor*, or *The Power of Love in the Three Elements*, oil on canvas
*Omnia Vincit Amor*, oder *Die Kraft der Liebe in den drei Elementen*, Öl auf Leinwand
*Omnia Vincit Amor*, *Liefde overwint alles* of *De kracht van de liefde in de drie elementen*, olieverf op doek
*Omnia Vincit Amor* o *El poder del Amor sobre los Tres Elementos*, óleo sobre lienzo
1809
178,8 x 204,5 cm / 70.5 x 80 in.
The Metropolitan Museum of Art, New York

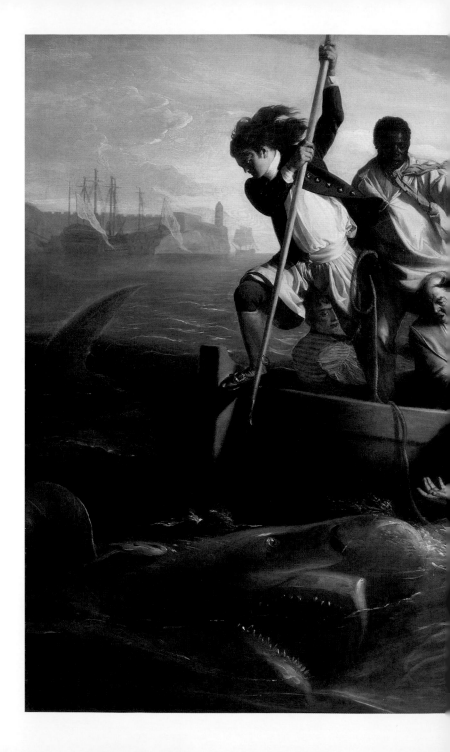

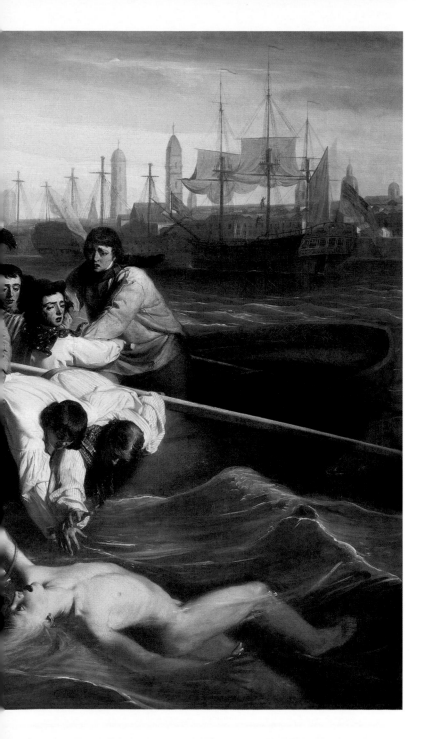

**John Singleton Copley**
(Boston 1738 - London 1815)
*Watson and the Shark,*
oil on canvas
*Watson und der Hai,*
Öl auf Leinwand
*Watson en de haai,*
olieverf op doek
*Watson y el tiburón,*
óleo sobre lienzo
1778
182 x 229 cm / 71.6 x 90 in.
National Gallery of Art,
Washington DC

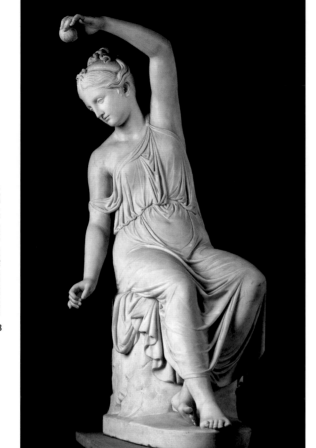

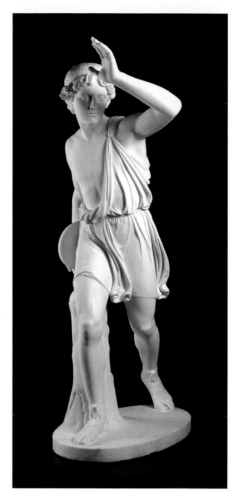

**Rudolf Schadow**
(Roma 1786 - 1822)
*Woman Spinning*, marble
*Die Spinnerin*, Marmor
*Vrouw die spint*, marmer
*La hilandera*, mármol
1816
h. 125 cm / 49.2 in.
Nationalgalerie, Staatliche Museen, Berlin

**Rudolf Schadow**
(Roma 1786 - 1822)
*Discobolus*, marble
*Diskuswerfer*, Marmor
*Discuswerper*, marmer
*Discóbolo*, mármol
1820-1821
h. 149 cm / 58.6 in.
Nationalgalerie, Staatliche Museen, Berlin

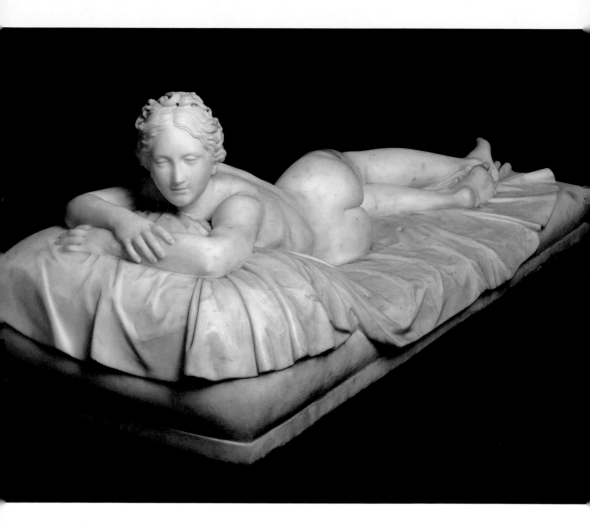

**Johann Gottfried Schadow**
(Berlin 1764 - 1850)
*Girl Resting*, marble
*Das ruhende Mädchen*, Marmor
*Meisje dat rust*, marmer
*Muchacha descansando*, mármol
1826
34 x 95 cm / 13.3 x 37.4 in.
Nationalgalerie, Staatliche Museen, Berlin

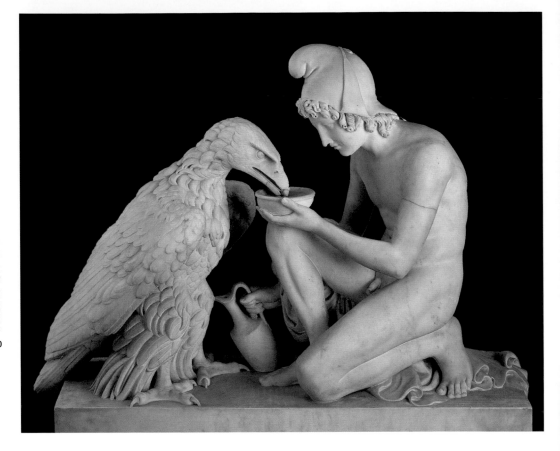

**Bertel Thorvaldsen**
(Copenhagen 1770 - 1844)
*Ganymede and the Eagle*, marble
*Ganymed den Adler des Zeus tränkend*,
Marmor
*Ganymedes en de adelaar*, marmer
*Ganímedes y el águila*, mármol
1817
Museum der bildenden Künste, Leipzig

▌ *Direct student of Canova, Thorvaldsen over the years grows away from him, lifting his own figures out of materiality to move them towards an ideal of unchangeable beauty devoid of temporal references.*
▌ *Thorvaldson, obwohl direkter Schüler von Canova, hebt sich im Lauf der Jahre ab und befreit seine eigenen Figuren von der Materialität, um sie in die Richtung eines unveränderlichen Schönheitsideal, frei von zeitlichen Bezügen, zu führen.*
▌ *Hoewel Thorvaldsen een leerling van Canova was, ontgroeit hij hem in de loop der tijd en bevrijdt zijn figuren van de stoffelijkheid om ze te leiden naar een onveranderlijk, tijdloos schoonheidsideaal.*
▌ *Discípulo directo de Canova, Thorvaldsen se aleja de éste con el pasar de los años, despojando de materialidad sus figuras para llevarlas hacia un ideal de belleza inmutable y carente de referencias temporales.*

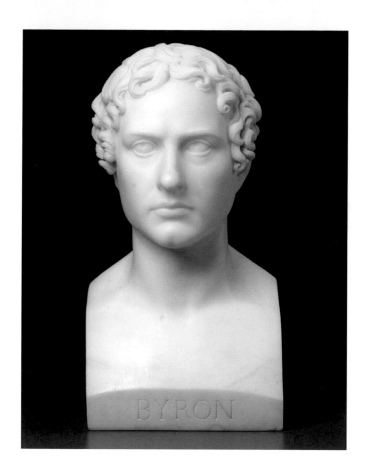

**Bertel Thorvaldsen**
(Copenhagen 1770 - 1844)
*Bust of Lord Byron*, marble
*Büste des Lord Byron*, Marmor
*Buste van Lord Byron*, marmer
*Busto de Lord Byron*, mármol
1821
45,1 x 23 x 17,5 cm / 17.8 x 9.1 x 6.9 in.
Museum of Fine Arts, Boston

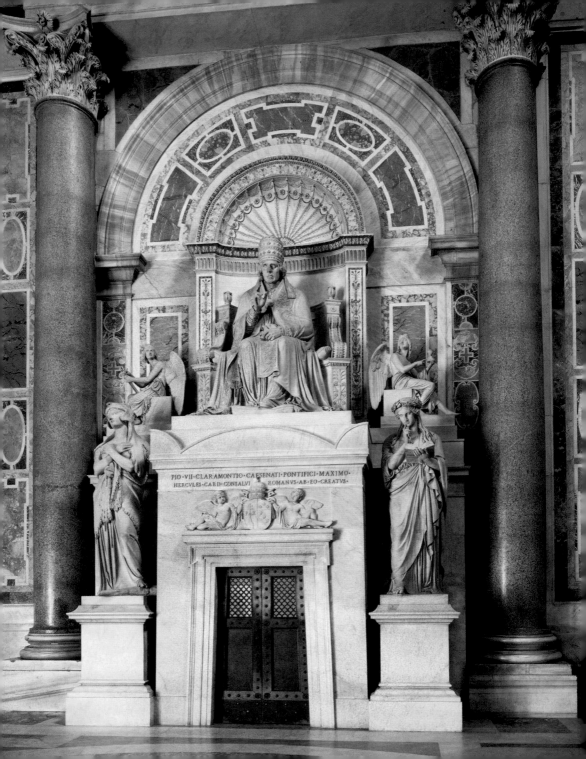

◀ **Bertel Thorvaldsen**
(Copenhagen 1770 - 1844)
*Tomb of Pius VII,* marble
*Grabmal des Pius VII.,* Marmor
*Tombe van Pius VII,* marmer
*Tumba de Pío VII,* mármol
1823-1831
Basílica di San Pietro, Città del Vaticano

**Bertel Thorvaldsen**
(Copenhagen 1770 - 1844)
*Allegory of the Night,* marble
*Die Nacht,* Marmor
*De nacht,* marmer
*La Noche,* mármol
1815
Museo Nazionale di Capodimonte, Napoli

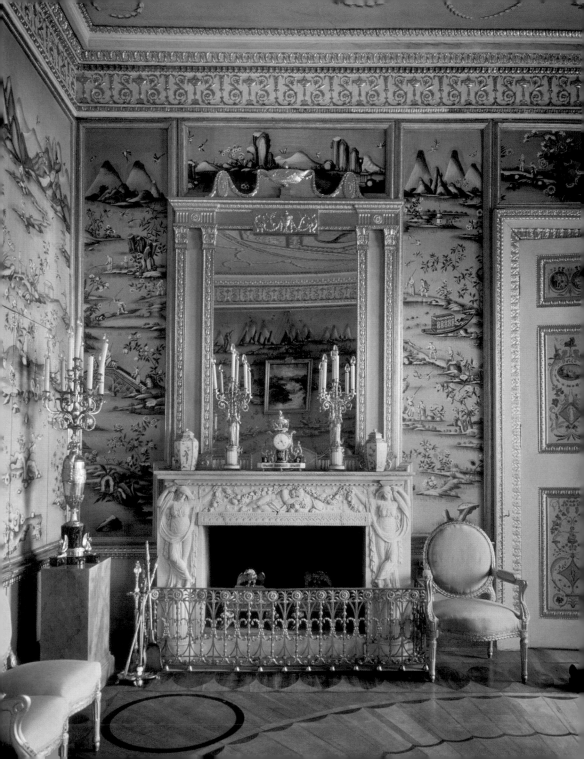

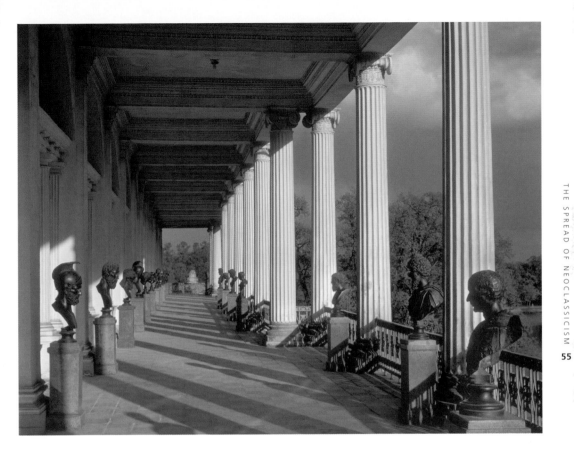

▐ *The spacious, airy Cameron Gallery, dominating the park of Tsarskoye Selo, was one of the places best loved by Catherine the Great.*
▐ *Die weiträumige und luftige Galerie Cameron, von wo aus man den Park von Tsarskoye Selo überblickt, gehörte zu den beliebtesten Orten von Katharina der Großen.*
▐ *De grote en luchtige Camerongalerij, die over het Tsarskoje Selopark uitkijkt, was een van de favoriete plekken van Catharina de Grote.*
▐ *La amplia y aireada Galería Cameron, desde la cual se goza una magnífica vista general del parque de Tsarskoye Selo, era uno de los lugares favoritos de Catalina la Grande.*

◀ **Charles Cameron**
(? c. 1740 - ? 1812)
Imperial Palace, Blue Drawing Room
Katharinenpalast, blauer Salon
Keizerlijk paleis, blauwe salon
Palacio de Catalina, sala azul
c. 1785
Tsarskoye Selo, St. Petersburg

**Charles Cameron**
(? c. 1740 - ? 1812)
Imperial Palace, Open Colonnade
Katharinenpalast, Blick auf offenen Säulengang (Cameron-Gallerie)
Keizerlijk paleis, uitzicht op de open zuilengalerij (Camerongalerij)
Palacio de Catalina, vista de la galería con columnas (Galería Cameron)
c. 1785
Tsarskoye Selo, St. Petersburg

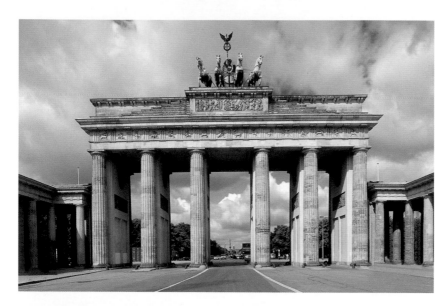

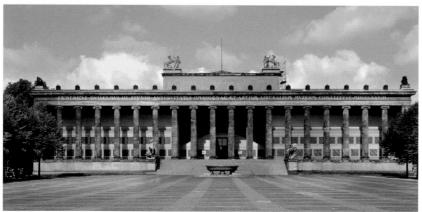

**Carl Gotthard Langhans**
(Landshut 1732 - Grüneiche 1808)
View of the Brandenburg Gate
Brandenburger Tor
Brandenburger Poort
Puerta de Brandeburgo
1789-1794
Berlin

**Karl Friedrich Schinkel**
(Neuruppin 1781 - Berlin 1841)
Exterior of the Altes Museum with granite fountain
Äußeres des Alten Museums mit dem Granitbrunnen
Exterieur van het Altes Museum met de granieten fontein
Exterior del Altes Museum con la fuente de granito
1824-1828
Berlin

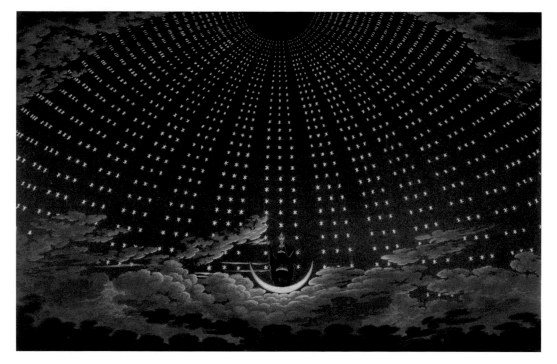

**Karl Friedrich Schinkel**
(Neuruppin 1781 - Berlin 1841)
Backdrop for Mozart's *The Magic Flute*, engraving
Bühnenbild zu Mozarts *Zauberflöte*, Stich
Decor van *De Toverfluit* van Mozart, gravure
Decorados para *La flauta mágica* de Mozart, grabado
1816
Bibliothèque-Musée de l'Opéra, Paris

▌ *Visionary and romantic both in his paintings and works on paper, Schinkel developed the neoclassical language in his architectural work, creating a new image for the city of Berlin.*
▌ *Als Visionär und Romantiker in den Malereien und den Werken auf Papier entwickelte Schinkel eine neoklassizistische Sprache in seinen architektonischen Arbeiten und bestimmte so ein neues Bild der Stadt Berlin.*
▌ *Als visionair en romanticus in zijn schilderijen en zijn werken op papier, ontwikkelde Schinkel een neoklassieke taal in zijn architectuur, en gaf de stad Berlijn zo een nieuwe uitstraling.*
▌ *Visionario y romántico en sus pinturas y en sus obras sobre papel, Schinkel desarrolló el lenguaje neoclásico en sus obras arquitectónicas, definiendo una nueva imagen de la ciudad de Berlín.*

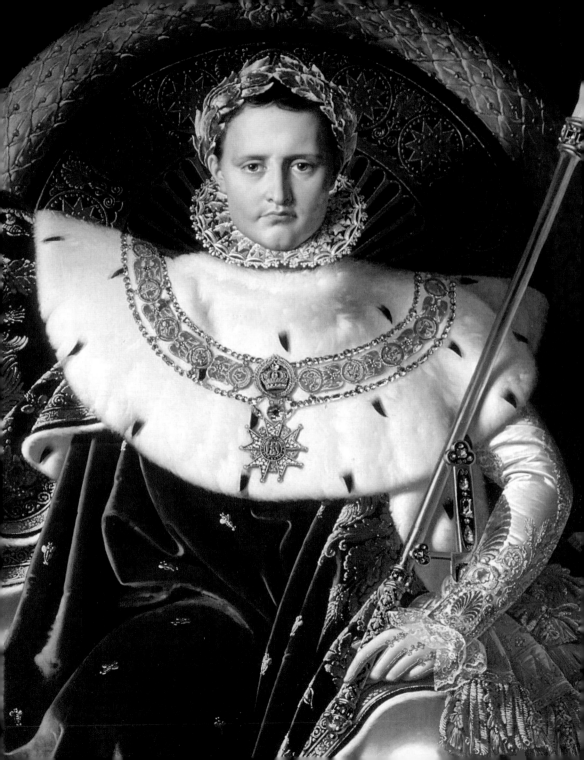

# The Napoleonic age and the decline of Neoclassicism

*Napoleon's lightning rise to power marked a profound change in the course of European history. If the French Revolution drew inspiration from the Roman Republic, in the Napoleonic era, Imperial Rome became the new guiding light. The purpose of art shifted from education to pomp and propaganda; neoclassicism became Empire style. Meanwhile, in the rest of Europe and finally in France, feeling, emotion, and "phantasy" entered the scene as the Neoclassical era and the Age of Reason gave way at last to the age of doubt and introspection.*

# Die Napoleonische Ära und der Niedergang des neoklassizistischen Stils

*Das umwerfende politische Gleichnis des Napoleon gab der europäischen Geschichte einen deutlichen Richtungswechsel vor. Wenn man während der Französischen Revolution auf die römische Republik blickte, so orientierte man sich in der Napoleonischen Ära am kaiserlichen Rom. Die erzieherische Absicht der Kunst zeigte sich propagandistisch und feierlich: der Neoklassizismus nahm einen kaiserlichen Stil an. Gleichzeitig begannen sich im restlichen Europa und dann in Frankreich der Sinn, das Gefühl und die "Fantasie" ganz hinten im neoklassizistischen Stil einzureihen und das Zeitalter der Aufklärung wich schließlich dem Zeitalter des Zweifels und der Selbstbeobachtung.*

# 3

# Het napoleontische tijdperk en de neergang van de neoklassieke stijl

*De bliksemsnelle politieke carrière van Napoleon had een ingrijpende verandering in de Europese geschiedenis tot gevolg. Was tijdens de Franse Revolutie het republikeinse Rome het voorbeeld, zo gold tijdens de Napoleontische periode het keizerlijke Rome als maatstaf. Het pedagogische aspect van de kunst werd propagandistisch en plechtig, het neoclassicisme kreeg een keizerlijke stijl. Tegelijkertijd drong in de rest van Europa en vervolgens in Frankrijk het gevoel, de emotie en de "fantasie" door tot de laatste fase van de neoklassieke periode en uiteindelijk moest het tijdperk van de rede wijken voor een periode van twijfel en introspectie.*

# La era napoleónica y el ocaso del estilo neoclásico

*La brillante trayectoria política de Napoleón marcó un profundo cambio de dirección en la historia europea. Si durante la Revolución Francesa se miraba hacia la Roma republicana, en la era napoleónica la Roma imperial se convirtió en el ejemplo a seguir. La intención del arte mutó de educativa a propagandística y celebratoria: el neoclasicismo tomó la forma del estilo imperio. Contemporáneamente, en el resto de Europa, y luego en Francia, el sentimiento, la emoción, la fantasía, comenzaron a entreverse entre las últimas filas del estilo neoclásico, y la edad de la razón cedió paso finalmente a la edad de la duda y la introspección.*

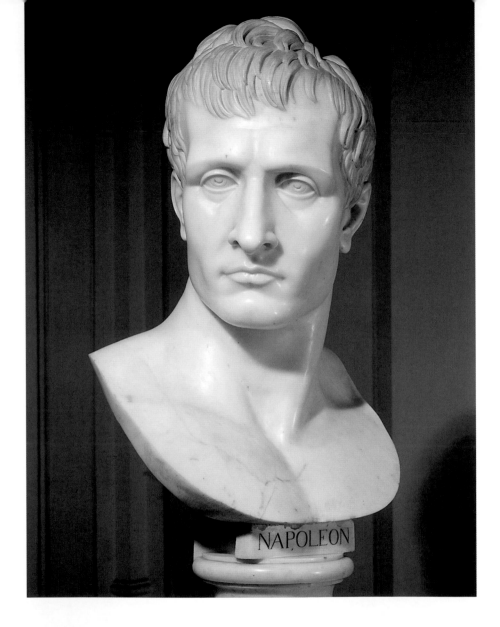

**Antonio Canova**
(Possagno, Treviso 1757 - Venezia 1822)
*Bust of Napoleon Bonaparte*, marble
*Büste von Napoleon Bonaparte*, Marmor
*Buste van Napoleone Bonaparte*, marmer
*Busto de Napoleón*, mármol
1803
Galleria d'Arte Moderna, Firenze

▌ *Napoleon and the cult of his image: real personage and hero, at once contemporary and classical.*
▌ *Napoleon und das Zelebrieren seiner Person anhand des Bildes: wirkliche Persönlichkeit und Held, aktuell und klassisch zur gleichen Zeit.*
▌ *De verering van Napoleon in een beeld: een echte persoon en held, zowel modern als klassiek.*
▌ *Napoleón y su celebración a través de la imagen: personaje real y héroe, contemporáneo y clásico a la vez.*

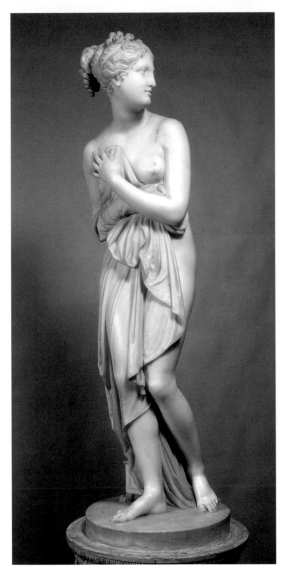
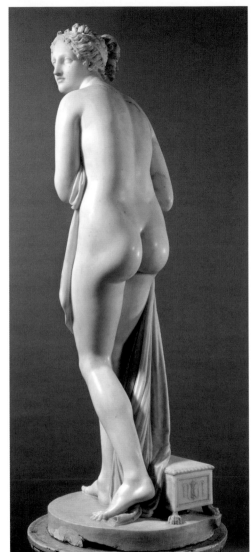

**Antonio Canova**
(Possagno, Treviso 1757 - Venezia 1822)
*Venus Italica*, marble
*Venus Italica*, Marmor
*Venus Italica*, marmer
*Venus Itálica*, mármol
1804-1812
172 x 52 x 55 cm / 67.7 x 20.4 x 21.6 in.
Galleria Palatina, Firenze

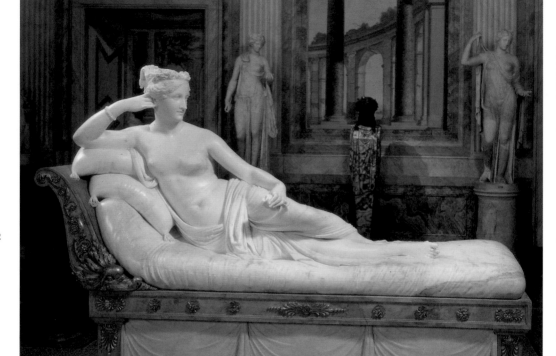

**Antonio Canova**
(Possagno, Treviso 1757 - Venezia 1822)
*Pauline Bonaparte Borghese as Venus* and detail, marble
*Paolina Borghese, Venus victrix (Siegreiche Venus)* und Detail, Marmor
*Paolina Borghese als Venus Vintrix* en detail, marmer
*Paulina Borghese como Venus vencedora* y detalle, mármol
1804-1808
l. 200 cm / 78.7 in.
Galleria Borghese, Roma

▌ *Pauline, representation of the neoclassical feminine ideal,*
*holds in her hand the apple symbolising*
*the acknowledgement of her divine beauty.*
▌ *Paolina, die Darstellung des weiblichen Ideals i*
*m Neoklassizismus, hält in der Hand einen Apfel*
*als Symbol der Anerkennung ihrer göttlichen Schönheit.*
▌ *Paolina, de neoklassieke uitbeelding van het vrouwelijke*
*ideaal, houdt in haar hand een appel, het symbool*
*van de erkenning van haar goddelijke schoonheid, vast.*
▌ *Paulina, representación del ideal femenino neoclásico,*
*sostiene en sus manos una manzana,*
*símbolo del reconocimiento de su divina belleza.*

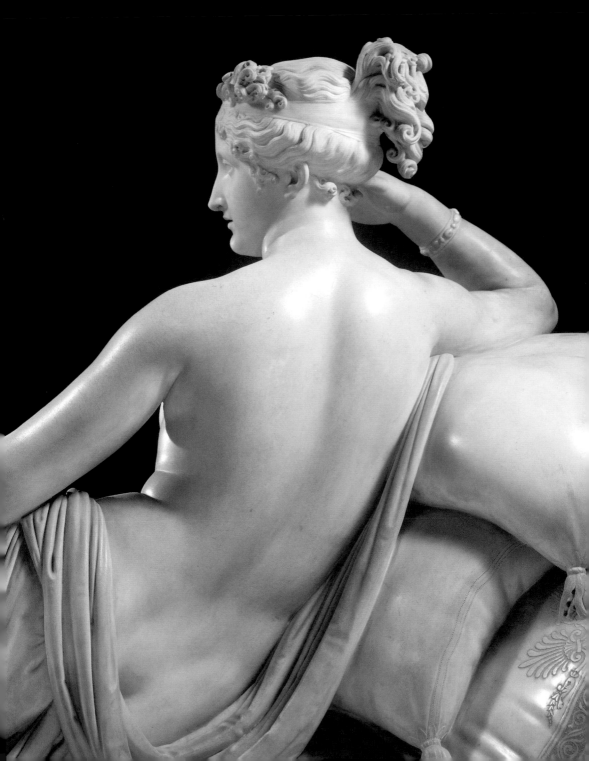

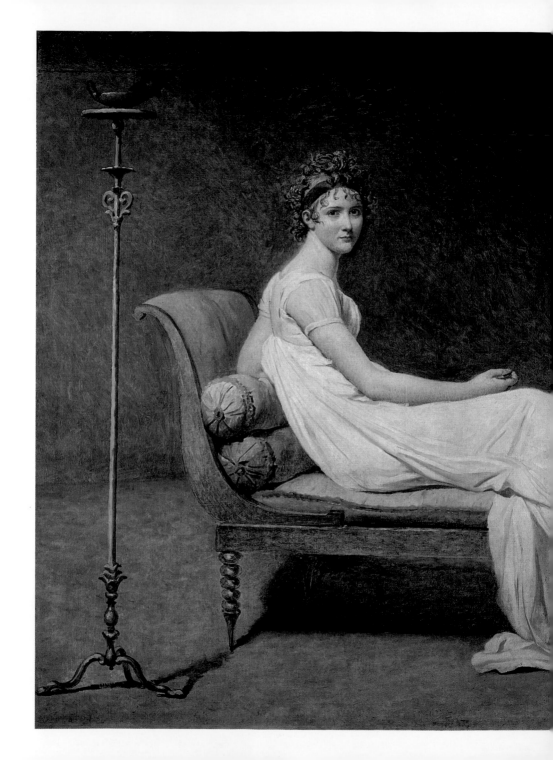

**Jacques-Louis David**
(Paris 1748 - Bruxelles 1825)
*Portrait of Madame Récamier,*
oil on canvas
*Porträt der Madame Récamier,*
Öl auf Leinwand
*Portret van Madame Récamier,*
olieverf op doek
*Retrato de Madame Récamier,*
óleo sobre lienzo
1800
174 x 244 cm / 68.5 x 96 in.
Musée du Louvre, Paris

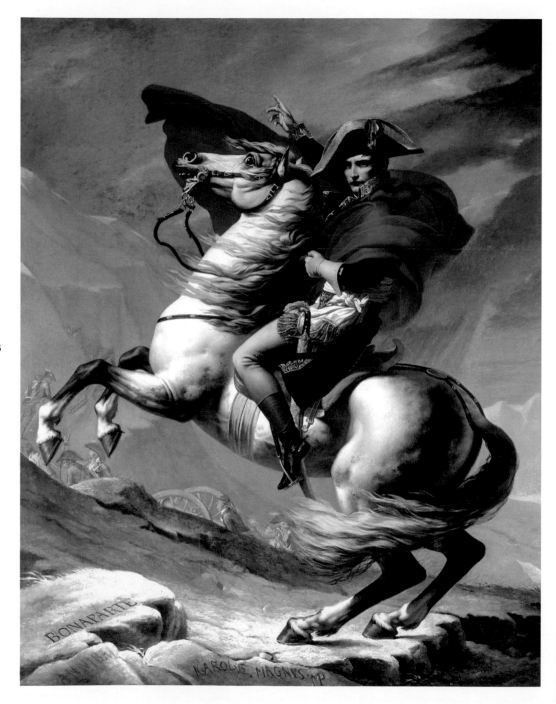

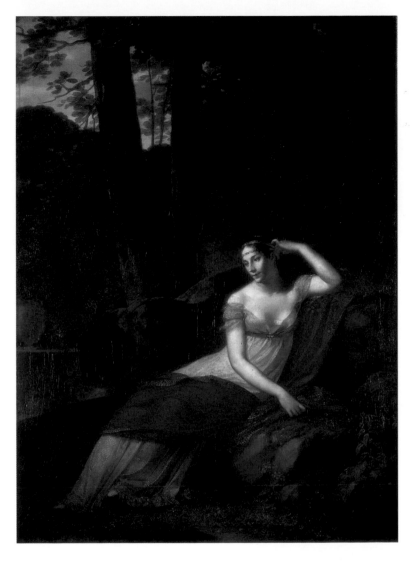

◀ **Jacques-Louis David**
(Paris 1748 - Bruxelles 1825)
*Napoleon Bonaparte, First Consul, Crossing the Alps*, oil on canvas
*Napoleon Bonaparte als Erster Konsul den großen Sankt Bernhard
überquerend*, Öl auf Leinwand
*Eerste consul, Napoleon, te paard bij de grote Sint Bernardpas*,
olieverf op doek
*Napoleón, Primer Cónsul, cruzando los Alpes*, óleo sobre lienzo
*post* 1801
259 x 221 cm / 102 x 87 in.
Musée National du Château de Malmaison, Rueil-Malmaison

**Pierre-Paul Prud'hon**
(Cluny 1758 - Paris 1823)
*Portrait of Empress Josephine Bonaparte*, oil on canvas
*Porträt der Kaiserin Josephine Beauharnais im Park
von Malmaison*, Öl auf Leinwand
*Portret van keizerin Josephine Beauharnais in het park
van Malmaison*, olieverf op doek
*Retrato de la emperatriz Josefina*, óleo sobre lienzo
1805
244 x 179 cm / 96 x 70 in.
Musée du Louvre, Paris

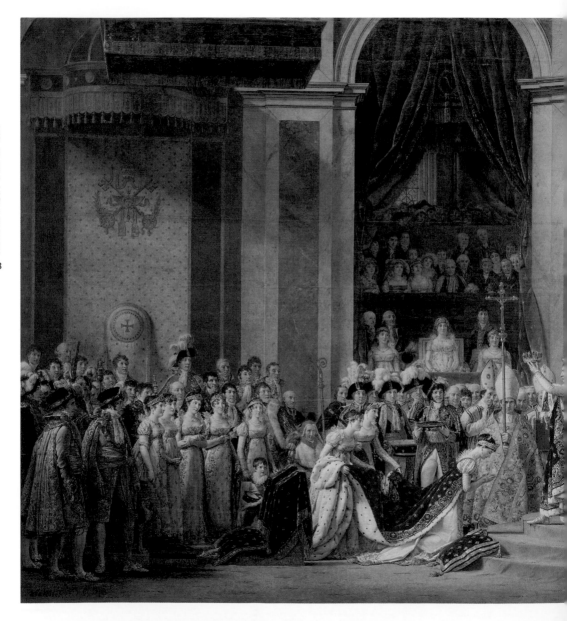

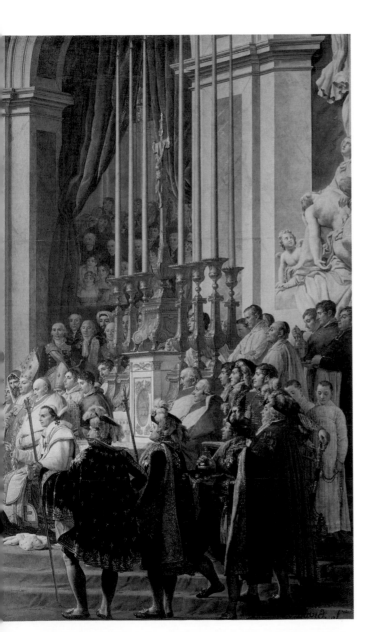

**Jacques-Louis David**
(Paris 1748 - Bruxelles 1825)
*The Coronation of Napoleon I*, oil on canvas
*Die Krönung Napoleons I. am 2. Dezember 1804*,
Öl auf Leinwand
*De kroning van Napoleon I op 2 december 1804*,
olieverf op doek
*La consagración del emperador Napoleón
el 2 de diciembre de 1804*, óleo sobre lienzo
1804-1807
621 x 979 cm / 244.5 x 385.5 in.
Musée du Louvre, Paris

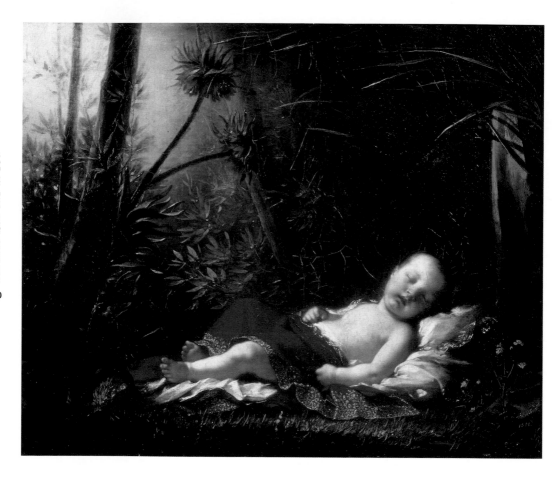

**Pierre- Paul Prud'hon**
(Cluny 1758 - Paris 1823)
*Portrait of the King of Rome*, oil on canvas
*Der eingeschlafene König von Rom*, Öl auf Leinwand
*De koning van Rome in slaap*, olieverf op doek
*Rey de Roma*, óleo sobre lienzo
1811
46 x 56 cm / 18 x 22 in.
Musée du Louvre, Paris

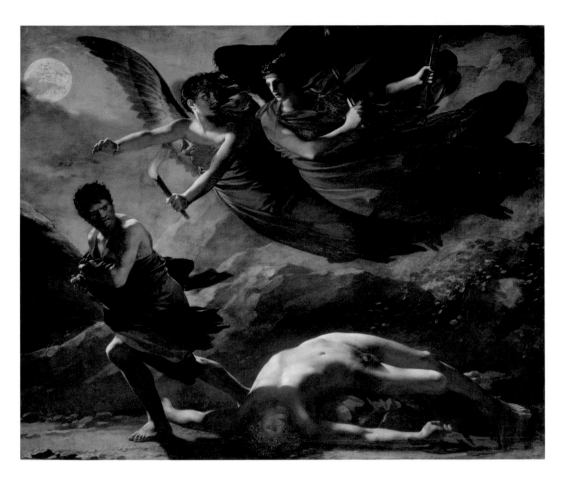

**Pierre-Paul Prud'hon**
(Cluny 1758 - Paris 1823)
*Justice and Divine Vengeance pursue Crime,*
oil on canvas
*Göttliche Gerechtigkeit und Rache verfolgen das Verbrechen,*
Öl auf Leinwand
*Goddelijke gerechtigheid en wraak vervolgen de misdaad,*
olieverf op doek
*La Justicia y la Venganza divina persiguen el crimen,*
óleo sobre lienzo
1808
244 x 294 cm / 96 x 115.7 in.
Musée du Louvre, Paris

▌ *Classical references in a dark, lunar atmosphere:*
*in Prud'hon we sense the first signs of a romantic sensibility.*
▌ *Klassische Bezüge in einer dunklen Athmosphäre*
*im Mondschein: bei Prud'hon zeigen sich die ersten Signale*
*einer romantischen Sensibilität.*
▌ *Klassieke verwijzingen in een duistere en maanverlichte sfeer:*
*bij Prud'hon worden de eerste tekenen*
*van een romantische gevoeligheid waargenomen.*
▌ *Referencias clásicas en una atmósfera oscura y lunar:*
*en Prud'hon se advierten las primeras huellas*
*de una sensibilidad romántica.*

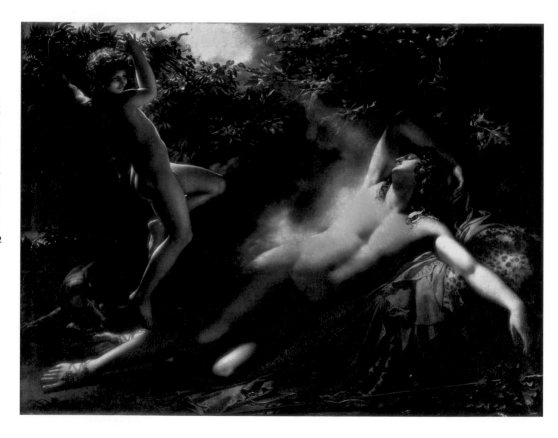

**Anne-Louis Girodet-Trioson**
(Montargis 1767 - Paris 1824)
*The Sleep of Endymion*, oil on canvas
*Der Traum des Endymion*, Öl auf Leinwand
*De slaap van Endymmion*, olieverf op doek
*El sueño de Endimión*, óleo sobre lienzo
1791
198 x 261 cm / 78 x 102 in.
Musée du Louvre, Paris

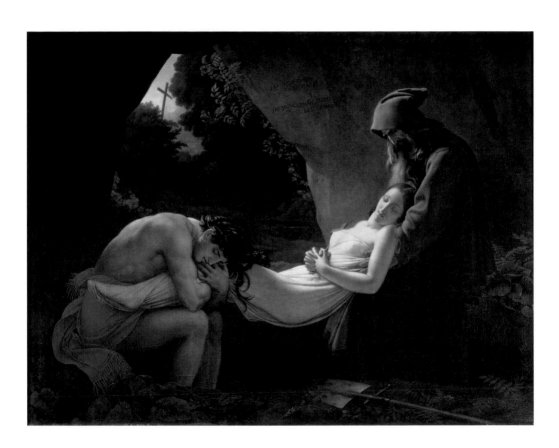

**Anne-Louis Girodet-Trioson**
(Montargis 1767 - Paris 1824)
*The Entombment of Atala*, oil on canvas
*Das Begräbnis der Atala*, Öl auf Leinwand
*De begrafenis van Atala*, olieverf op doek
*El entierro de Atala*, óleo sobre lienzo
1808
207 x 267 cm / 81.5 x 105 in.
Musée du Louvre, Paris

▌ *Atala, lying in her tomb, holds the cross in her hand: renewed religious sentiment, inspired by the writings of Chateaubriand, pervades the work of Girodet.*
▌ *Atala in ihrem Grab hält in ihrer Hand das Kreuz: ein aufgefrischtes religiöses Gefühl, inspiriert von der Novelle von Chateaubriand, durchdringt das Werk von Girodet.*
▌ *Atala, in haar graf, omklemt in haar handen het kruis: een hernieuwd religieus gevoel, geïnspireerd op de geschriften van Chateaubriand doordringt het werk van Girodet.*
▌ *Atala, depositada en el sepulcro, aprieta en su mano la cruz: un renovado sentimiento religioso, inspirado en los escritos de Chateaubriand, invade la obra de Girodet.*

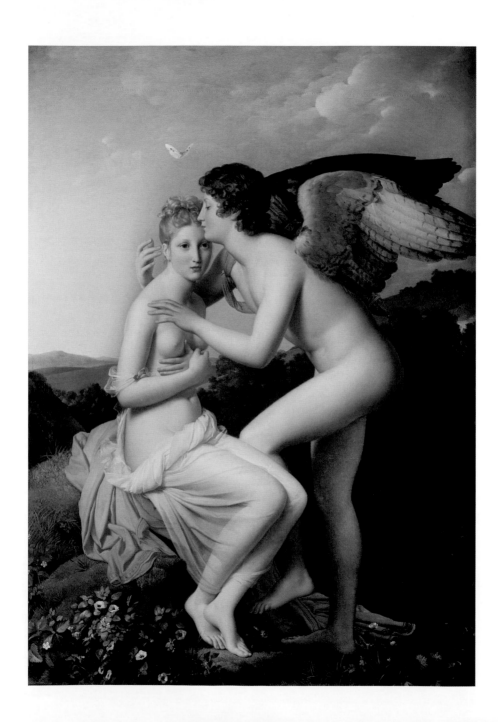

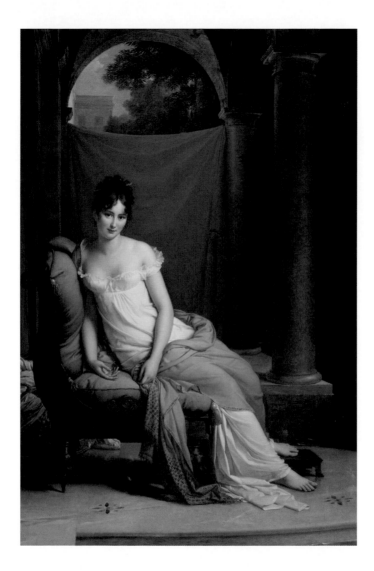

**◀ François Gérard**
(Roma 1770 - Paris 1837)
*Cupid and Psyche*, oil on canvas
*Amor und Psyche*, Öl auf Leinwand
*Amor en Psyche*, olieverf op doek
*Eros y Psique*, óleo sobre lienzo
1798
186 x 132 cm / 73 x 52 in.
Musée du Louvre, Paris

**François Gérard**
(Roma 1770 - Paris 1837)
*Portrait of Juliette Récamier,* oil on canvas
*Porträt der Juliette Récamier*, Öl auf Leinwand
*Portret van Juliette Récamier*, olieverf op doek
*Madame Récamier*, óleo sobre lienzo
1805
225 x 148 cm / 88.5 x 58.2 in.
Musée Carnavalet, Paris

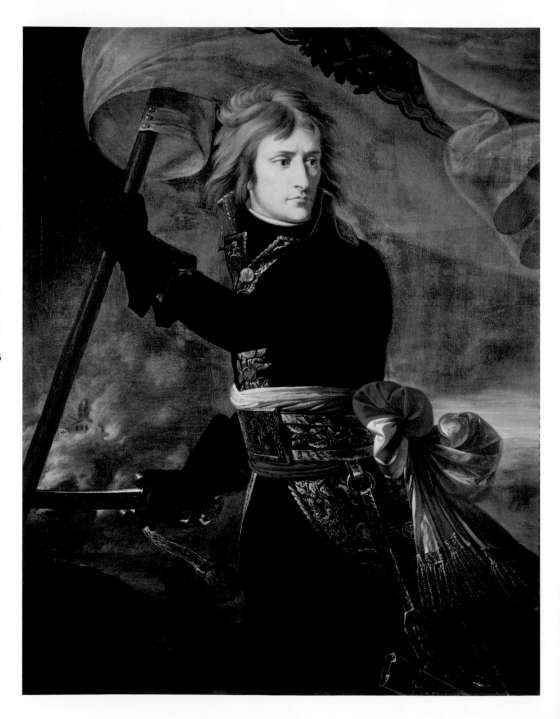

◄ **Antoine-Jean Gros**
(Paris 1771 - Meudon 1835)
*Napoleon on the Bridge at Arcole*, oil on canvas
*Bonaparte auf der Brücke von Arcole*, Öl auf Leinwand
*Generaal Bonaparte op de brug van Arcole*, olieverf op doek
*El general Bonaparte en el puente de Arcole*, óleo sobre lienzo
1796-1797
134 x 104 cm / 52.7 x 40.9 in.
State Hermitage Museum, St. Petersburg

**Antoine-Jean Gros**
(Paris 1771 - Meudon 1835)
*Napoleon Visiting the Plague Victims at Jaffa*, oil on canvas
*Bonaparte bei den Pestkranken von Jaffa*, Öl auf Leinwand
*Napoleon bezoekt de pestlijders in Jaffa*, olieverf op doek
*Napoleón visitando a los apestados de Jaffa*, óleo sobre lienzo
1804
523 x 715 cm / 206 x 281.5 in.
Musée du Louvre, Paris

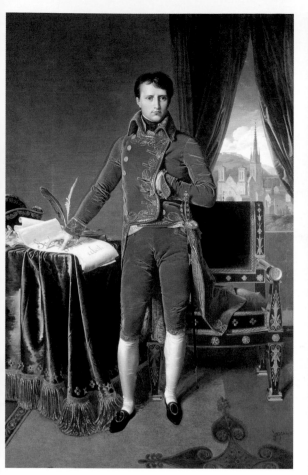

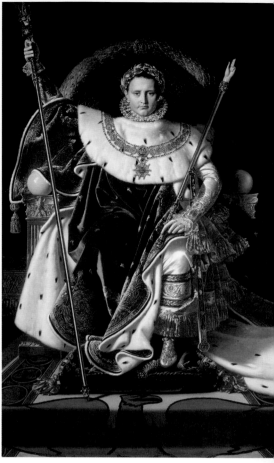

**Jean-Auguste-Dominique Ingres**
(Montauban 1780 - Paris 1867)
*Portrait of Napoleon Bonaparte, First Consul*, oil on canvas
*Porträt Bonapartes als Erster Konsul*, Öl auf Leinwand
*Portret van Napoleon Bonaparte de consul*, olieverf op doek
*Napoleón Bonaparte, Primer Cónsul*, óleo sobre lienzo
1804
227 x 147 cm / 89.3 x 57.8 in.
Musée des Beaux-Arts, Liège

**Jean-Auguste-Dominique Ingres**
(Montauban 1780 - Paris 1867)
*Portrait of Napoleon on the Imperial Throne*, oil on canvas
*Napoleon auf dem Thron*, Öl auf Leinwand
*Portret van Napoleon Bonaparte, de consul*, olieverf op doek
*Napoleón en su trono imperial*, óleo sobre lienzo
1806
250 x 160 cm / 98.4 x 63 in.
Musée de l'Armée, Paris

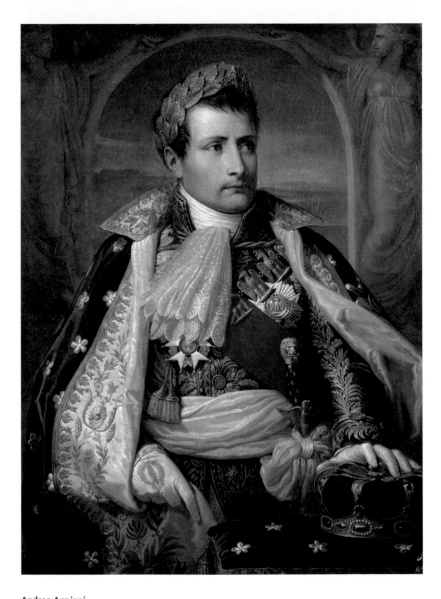

**Andrea Appiani**
(Milano 1754 - 1817)
*Portrait of Napoleon King of Italy*, oil on canvas
*Bildnis Napoleons als König von Italien*, Öl auf Leinwand
*Portret van Napoleon, koning van Italië*, olieverf op doek
*Napoleón Rey de Italia*, óleo sobre lienzo
c. 1805
98 x 74 cm / 38.5 x 29 in.
Musée Napoléonien, Île-d'Aix

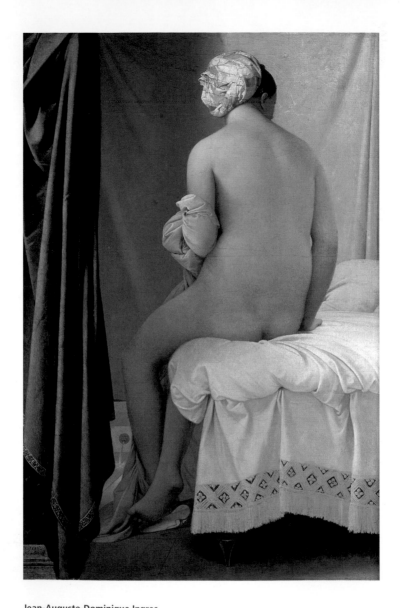

**Jean-Auguste-Dominique Ingres**
(Montauban 1780 - Paris 1867)
*The Valpinçon Bather*, oil on canvas
*Die Badende von Valpinçon*, Öl auf Leinwand
*De baadster van Valpinçon*, olieverf op doek
*La bañista de Valpinçon*, óleo sobre lienzo
1808
146 x 97 cm / 57.4 x 38 in.
Musée du Louvre, Paris

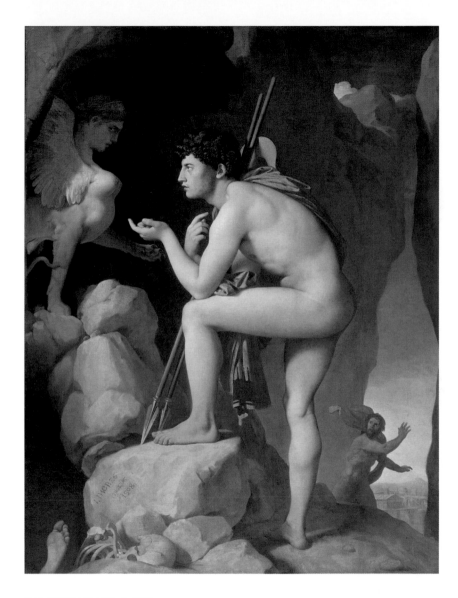

**Jean-Auguste-Dominique Ingres**
(Montauban 1780 - Paris 1867)
*Oedipus and the Sphinx*, oil on canvas
*Ödipus und die Sfinx*, Öl auf Leinwand
*Oedipus en de sfinx*, olieverf op doek
*Edipo y la Esfinge*, óleo sobre lienzo
1808
189 x 144 cm / 74.4 x 56.6 in.
Musée du Louvre, Paris

▮ *Reason against the obscurity of the unknown: Ingres represents Oedipus secure and stationary, struck by the light, at the moment of his victory.*
▮ *Die Vernunft gegen die Dunkelheit des Unbekannten: Ingres stellt Ödipus sicher und standhaft von einem Lichtstrahl getroffen im Moment seines Sieges dar.*
▮ *De ratio versus de duisternis van het onbekende: Ingres beeldt Oedipus veilig en standvastig af, gepakt door het licht, op het moment van zijn overwinning.*
▮ *La razón contra la oscuridad de lo desconocido: Ingres representa a Edipo seguro e inmóvil, con su figura esculpida por la luz, en el momento de su victoria.*

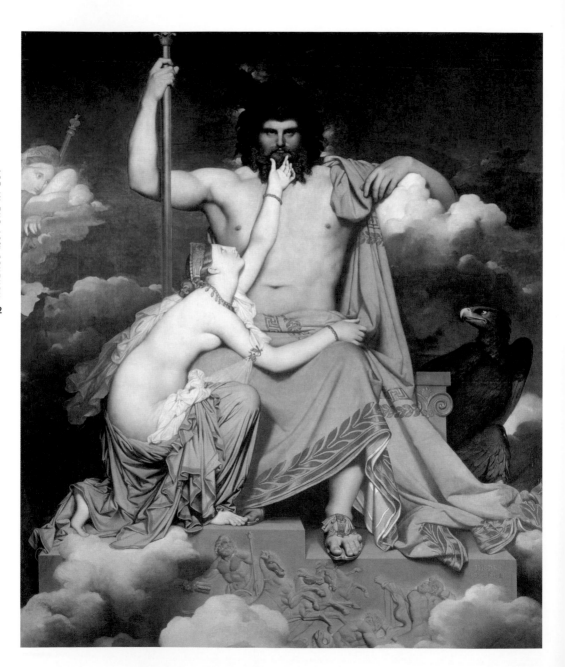

◄ **Jean-Auguste-Dominique Ingres**
(Montauban 1780 - Paris 1867)
*Jupiter and Thetis*, oil on canvas
*Jupiter und Thetis*, Öl auf Leinwand
*Jupiter en Thetis*, olieverf op doek
*Júpiter y Tetis*, óleo sobre lienzo
1811
320 x 260 cm / 126 x 102 in.
Musée Granet, Aix-en-Provence

**Jean-Auguste-Dominique Ingres**
(Montauban 1780 - Paris 1867)
*The Dream of Ossian*, oil on canvas
*Der Traum des Ossian*, Öl auf Leinwand
*De droom van Ossian*, olieverf op doek
*El sueño de Ossian*, óleo sobre lienzo
1813
348 x 275 cm / 137 x 108 in.
Musée des Beaux-Arts, Montauban

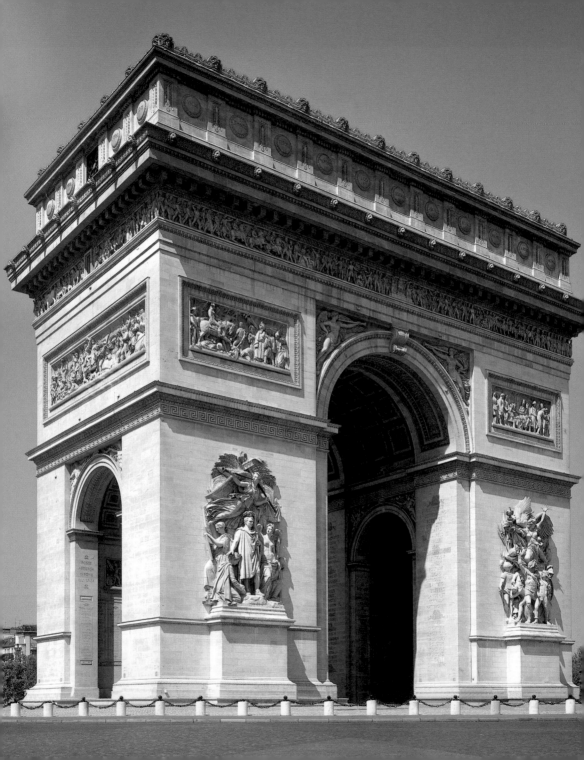

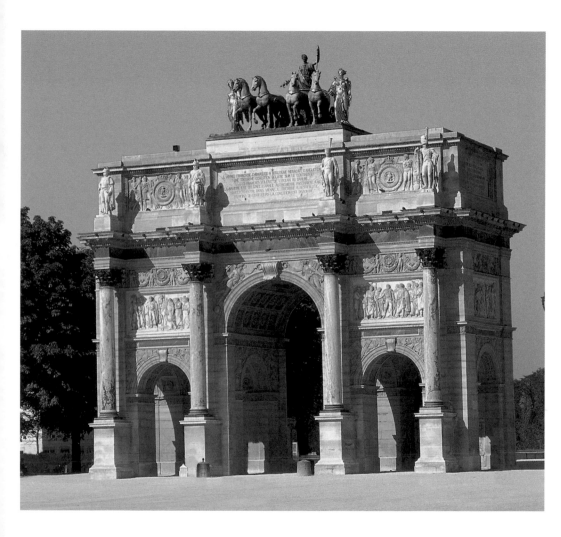

◀ **Jean Chalgrin**
(Paris 1739 - 1811)
Arc de Triomphe
Arc de Triomphe de l'Étoile
Arco de Triunfo de la Place de L'Étoile
1806-1836
Paris

**Charles Percier**
(Paris 1764 - 1838)
**François Fontaine**
(Pontoise 1762 - Paris 1853)
Arc de Triomphe du Carousel
Arco de Triunfo del Carrusel
1806-1808
Paris

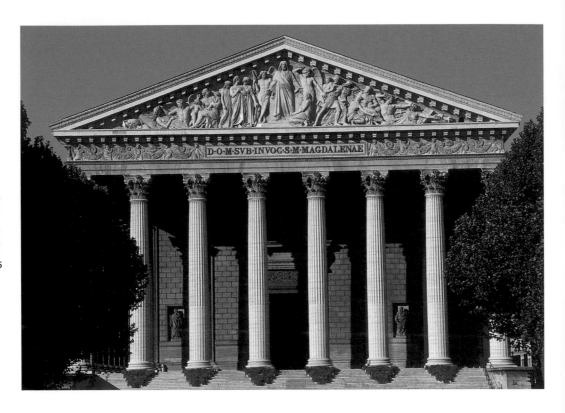

**Paris**
Madeleine Church
Kirche La Madeleine
De kerk La Madeleine
La iglesia de la Madeleine
c. 1764-1845

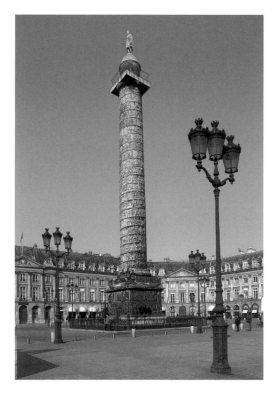

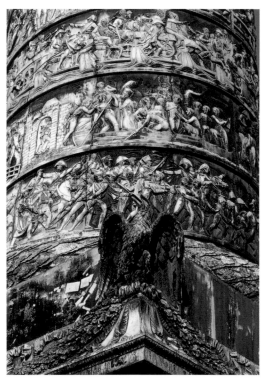

**Paris**
Place Vendôme
The Austerlitz column and detail
Die Säule von Austerlitz und Detail
De zuil van Austerlitz en detail
La columna de Austerlitz y detalle
1806-1810

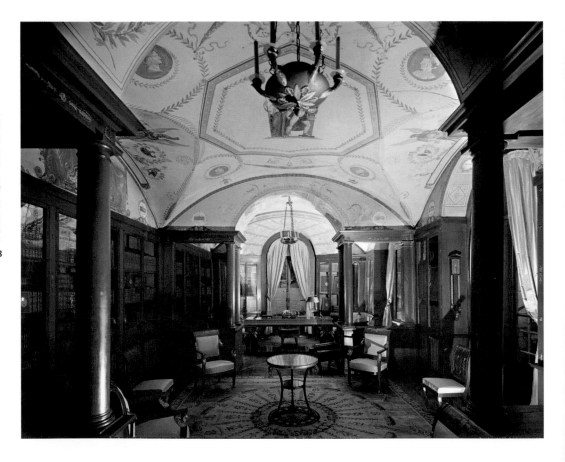

**Charles Percier**
(Paris 1764 - 1838)
**François Fontaine**
(Pontoise 1762 - Paris 1853)
Interior of Napoleon's library
Innenansicht der Bibliothek Napoleons
Interieur van de bibliotheek van Napoleon
Interior de la biblioteca de Napoleón
c. 1810
Musée National du Château de Malmaison,
Rueil-Malmaison

▌ *Grandeur in both public buildings and private spaces, the Empire Style is the mirror of a ruling caste drawn from the military.*
▌ *Mit der Monumentalität der öffentlichen Gebäude und privaten Räume ist der Imperialstil der Spiegel einer Führungsriege mit militärischer Herkunft.*
▌ *De monumentaliteit van de empirestijl in openbare gebouwen en privéruimtes, is een afspiegeling van een heersende klasse van militaire afkomst.*
▌ *Monumentalidad en los edificios públicos y en los espacios privados, el estilo Imperio es el reflejo de una casta dirigente de origen militar.*

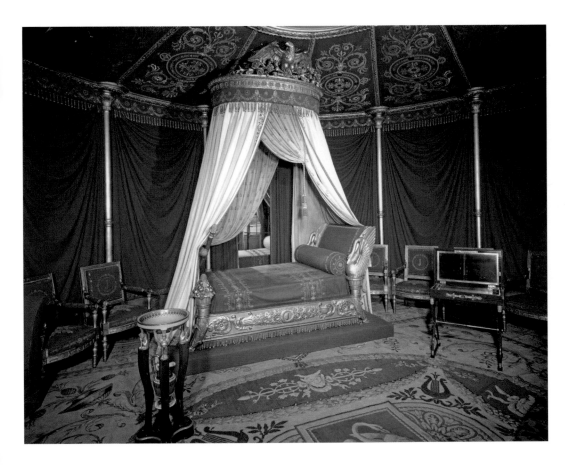

**Charles Percier**
(Paris 1764 - 1838)
**François Fontaine**
(Pontoise 1762 - Paris 1853)
The interior of Empress Josephine Beauharnais' room
Innenansicht der Kammer der Kaiserin Josephine Beauharnais
Interieur van de kamer van keizerin Josephine Beauharnais
Interior del dormitorio de la emperatriz Josefina Beauharnais
c. 1810
Musée National du Château de Malmaison, Rueil-Malmaison

## Visionary painters

While historical developments and political affairs at the beginning of the 19th century did much to spread a general sense of doubt and unease, which paved the way for Romanticism, even in the second half of the 18th century, the characteristics of the new poetics already stood side by side with Neoclassicism. The concept of the "sublime" and the attention already paid by Diderot to the dark and irrational side of the human soul, the allure of the occult and the unconscious were all signs of how artists were increasingly drawn to exploring in their work the fear of the unknown.

## Die visionären Maler

Wenn die geschichtlichen und politischen Ereignisse des 19. Jahrhunderts zur Verbreitung eines allgemeinen Gefühls von Unruhe und Zweifel beigetragen haben, die der Romantik den Weg bereitet haben, hatten sich die Merkmale der neuen Poesie schon seit der zweiten Hälfte des 18. Jahrhunderts zum Neoklassizismus gesellt. Der Begriff "Sublime", die bereits von Diderot geäußerte Aufmerksamkeit auf die dunkleren und irrationalen Aspekte der menschlichen Seele und die Faszination des Verborgenen und des Unbewussten waren alles Aspekte eines Interesses, das die Künstler dazu brachten, immer mehr - über das eigene Werk - die Furcht vor dem Unbekannten zu vertiefen.

## 4

## Visionaire schilders

Hoewel de historische en politieke gebeurtenissen in het begin van de negentiende eeuw bijdroegen aan de verspreiding van een algemeen gevoel van onbehagen en twijfel die de weg effende voor de romantiek, waren de kenmerken van de nieuwe poëzie reeds in de tweede helft van de achttiende eeuw aan het neoclassicisme verbonden.
Het begrip "sublime", de reeds door Diderot geuite belangstelling voor de duistere en irrationele aspecten van de menselijke geest en de fascinatie van het onbewuste en het onbekende, waren allemaal aspecten van een interesse die de kunstenaars ertoe brachten zich in hun werk steeds verder te verdiepen in de angst voor het onbekende.

## Los pintores visionarios

Si los acontecimientos históricos y políticos de comienzos del siglo XIX contribuyeron a la difusión de un sentimiento general de inquietud y de duda que abrieron camino al romanticismo, las características de la nueva poética ya habían acompañado al neoclasicismo desde la segunda mitad del siglo XVIII. El concepto de "lo sublime", el interés ya expresado por Diderot por los aspectos más oscuros e irracionales del alma humana, la fascinación por lo oculto y por el inconsciente, fueron todos aspectos de un interés que llevó a los artistas a profundizar cada vez más, a través de su propia obra, el temor por lo desconocido.

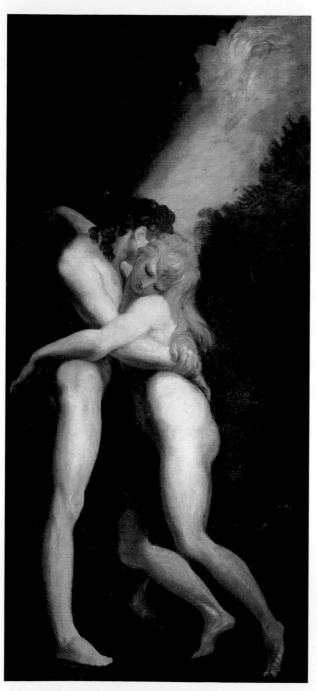

**Heinrich Füssli**
(Zürich 1741 - Putney Hill, London 1825)
*Adam and Eve,* oil
*Adam und Eva,* Öl
*Adam en Eva,* olieverf
*Adán y Eva,* óleo
c. 1780-1790
Moss Stanley Collection,
Riverdale-on-Hudson (USA)

▶ **Heinrich Füssli**
(Zürich 1741 - Putney Hill, London 1825)
*Lady Macbeth Sleepwalking,* oil on canvas
*Die schlafwandelnde Lady Macbeth,*
Öl auf Leinwand
*Lady Macbeth slaapwandelt,* olieverf op doek
*Lady Macbeth sonámbula,* óleo sobre lienzo
1784
221 x 160 cm / 87 x 62.9 in.
Musée du Louvre, Paris

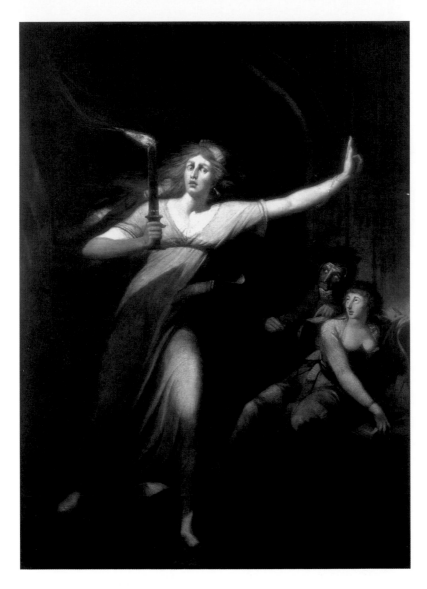

▌ *The terrified eyes of Lady Macbeth, by now lost between reality and nightmare, clutch at the viewer, almost as though trying to capture him and carry him off into her own unknown dimension.*
▌ *Die erschrockenen Augen der Lady Macbeth, die schon fast zwischen Wirklichkeit und Alptraum verloren ist, überwältigen nahezu die Aufmerksamkeit des Beobachters, um zu versuchen ihn einzufangen und ihn in die eigene unbekannte Dimension zu entführen.*
▌ *De verschrikte ogen van Lady Macbeth, verloren tussen realiteit en nachtmerrie, grijpen, vangen bijna de aandacht van de kijker om te proberen hem naar een onbekende dimensie te voeren.*
▌ *Los ojos aterrorizados de Lady Macbeth, ya perdida entre la realidad y la pesadilla, cautivan la atención del observador casi hasta el punto de querer atraparlo y llevarlo a su propia y desconocida dimensión.*

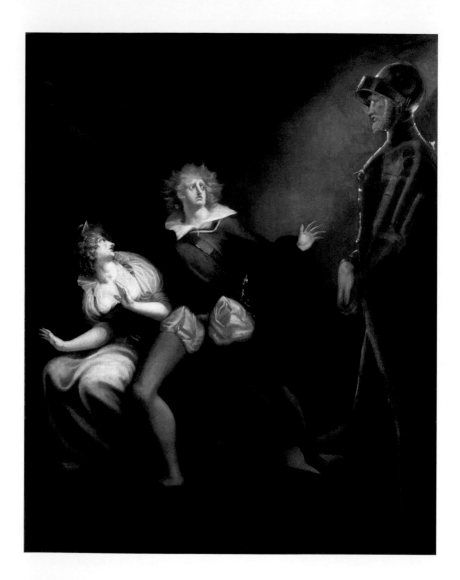

**Heinrich Füssli**
(Zürich 1741 - Putney Hill, London 1825)
*Gertrude, Hamlet and the ghost of Hamlet's father*, oil on canvas
*Gertrud, Hamlet und der Geist des Vaters*, Öl auf Leinwand
*Gertrude, Hamlet en de verschijning van de vader van Hamlet*, olieverf op doek
*Gertrudis, Hamlet y el fantasma del padre de Hamlet*, óleo sobre lienzo
c. 1785
165 x 133 cm / 65 x 52.3 in.
Fondazione Magnani Rocca, Corte di Mamiano (Parma)

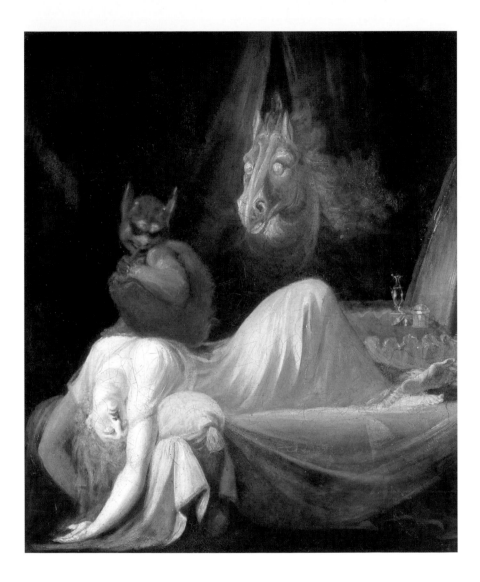

**Heinrich Füssli**
(Zürich 1741 - Putney Hill, London 1825)
*The Nightmare*, oil on canvas
*Nachtmahr*, Öl auf Leinwand
*De nachtmerrie*, olieverf op doek
*La pesadilla*, óleo sobre lienzo
1780-1781
75,5 x 64 cm / 30 x 25 in.
Goethe Museum - Freies Deutsches Hochstift, Frankfurt

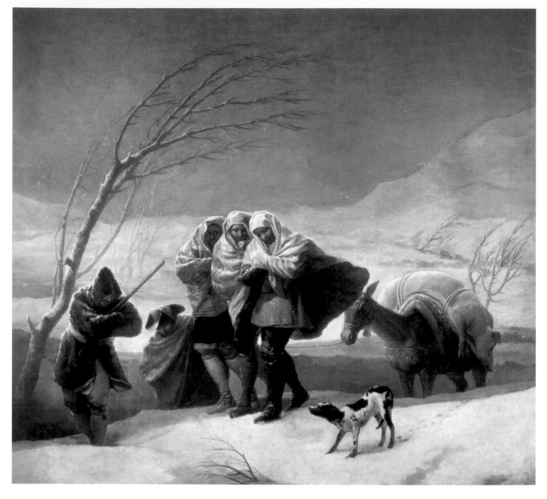

■ *Goya sees the demoniac as inherent in human nature, so in his witches' Sabbath it is the witches that are monstrous, not the goat.*
■ *Das Teuflische wohnt nach Goya in der menschlichen Natur inne. Daher ist in seinen Sabba das Scheußliche ein Merkmal der Hexen, nicht des Ziegenbocks.*
■ *Het demonische is voor Goya inherent aan de menselijke natuur, vandaar dat in zijn Sabba de wanstaltigheid kenmerkend is voor de heksen, niet voor de geit.*
■ *Lo diabólico es, para Goya, intrínseco a la naturaleza humana, por lo tanto en sus Aquelarres la monstruosidad es una característica de las brujas, no de la cabra.*

**Francisco Goya y Lucientes**
(Fuendetodos, Zaragoza 1746 - Bordeaux 1828)
*The Snowfall*, oil on canvas
*Der Schneesturm*, Öl auf Leinwand
*Sneeuwval*, olieverf op doek
*La nevada*, o *El invierno*, óleo sobre lienzo
1786
279 x 293 cm / 109.93 x 115.44 in.
Museo del Prado, Madrid

▶ **Francisco Goya y Lucientes**
(Fuendetodos, Zaragoza 1746 - Bordeaux 1828)
*Witches' Sabbath*, oil on canvas
*Hexensabbat*, Öl auf Leinwand
*Heksensabbat*, olieverf op doek
*El aquelarre*, óleo sobre lienzo
1797-1798
43 x 30 cm / 17 x 11.8 in.
Museo Lázaro Galdiano, Madrid

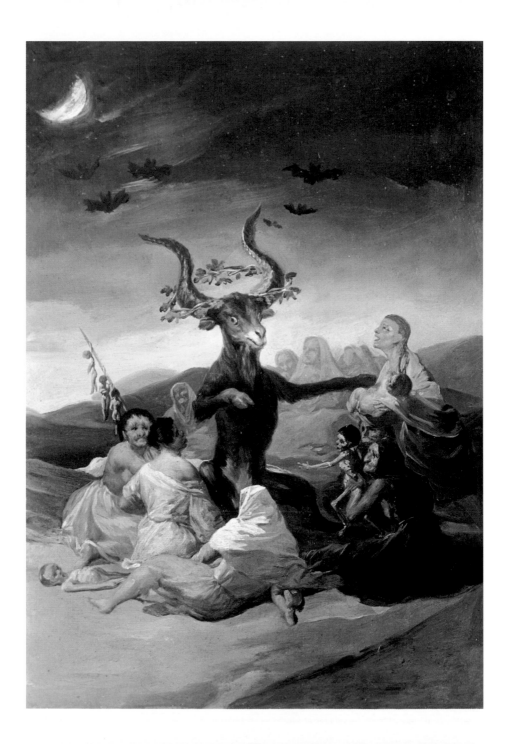

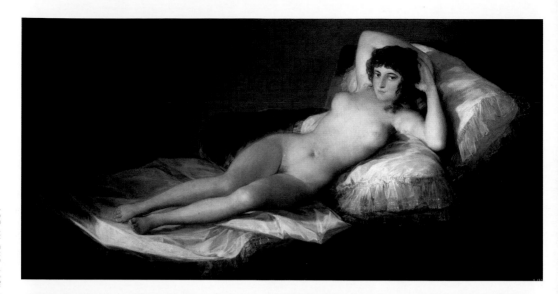

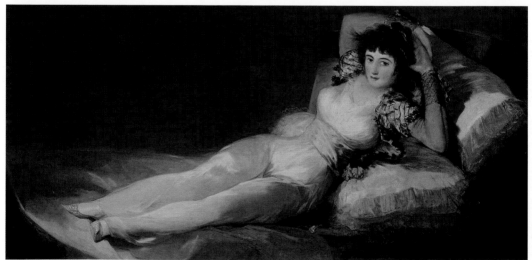

**Francisco Goya y Lucientes**
(Fuendetodos, Zaragoza 1746 - Bordeaux 1828)
*The Naked Maja* and detail, oil on canvas
*Die nackte Maja* und Detail, Öl auf Leinwand
*De naakte Maja* en detail, olieverf op doek
*La Maja desnuda* y detalle, óleo sobre lienzo
1797-1800
97 x 190 cm / 38.22 x 74.86 in.
Museo del Prado, Madrid

**Francisco Goya y Lucientes**
(Fuendetodos, Zaragoza 1746 - Bordeaux 1828)
*The Clothed Maja*, oil on canvas
*Die bekleidete Maja*, Öl auf Leinwand
*De geklede Maja*, olieverf op doek
*La Maja vestida*, óleo sobre lienzo
1800-1803
95 x 188 cm / 37.43 x 74.07 in.
Museo del Prado, Madrid

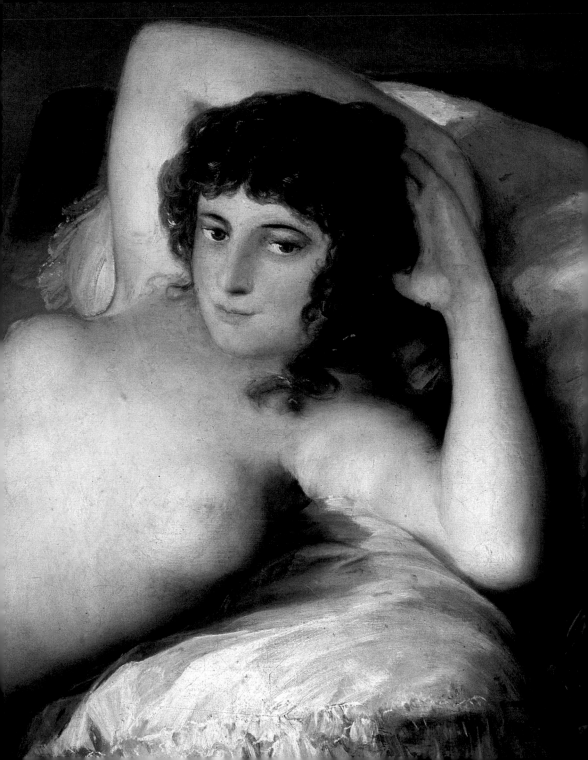

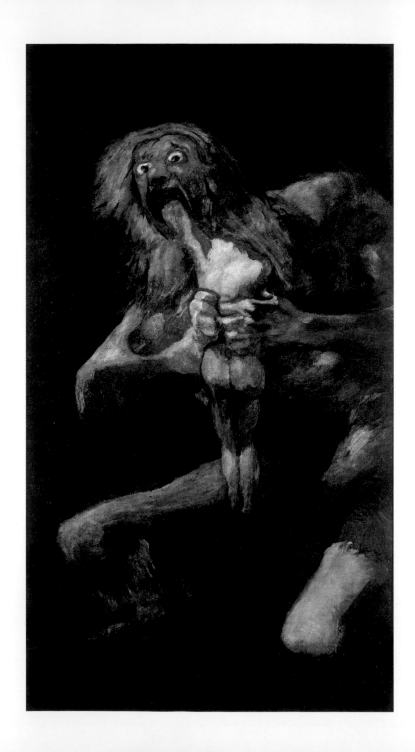

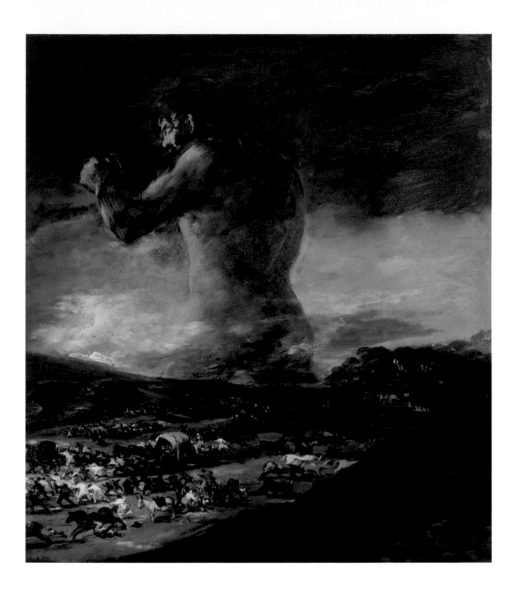

◄ **Francisco Goya y Lucientes**
(Fuendetodos, Zaragoza 1746 - Bordeaux 1828)
*Saturn Devouring One of His Children*, oil on canvas
*Saturn verschlingt einen seiner Söhne*, Öl auf Leinwand
*Saturnus verslindt een van zijn kinderen*, olieverf op doek
*Saturno devorando a un hijo*, óleo sobre lienzo
1821-1823
146 x 83 cm / 57.5 x 32.6 in.
Museo del Prado, Madrid

**Francisco Goya y Lucientes**
(Fuendetodos, Zaragoza 1746 - Bordeaux 1828)
*The Colossus*, oil on canvas
*Der Koloss*, Öl auf Leinwand
*Colossus*, olieverf op doek
*El coloso*, óleo sobre lienzo
1808-1810
116 x 105 cm / 45.6 x 41.3 in.
Museo del Prado, Madrid

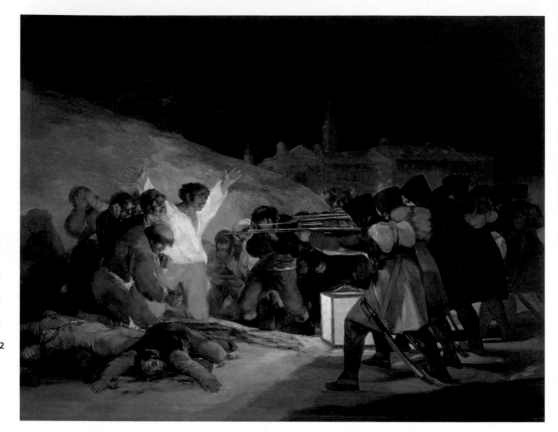

**Francisco Goya y Lucientes**
(Fuendetodos, Zaragoza 1746 - Bordeaux 1828)
*The Third of May 1808* and detail, oil on canvas
*Die Erschießung der Aufständischen 3. Mai 1808*
und Detail, Öl auf Leinwand
*3 mei 1808: executie van prins Pius op de heuvel,* olieverf op doek
*El tres de mayo de 1808, o Los fusilamientos en la montaña
del Príncipe Pío* y detalle, óleo sobre lienzo
1814
266 x 345 cm / 104.7 x 135.8 in.
Museo del Prado, Madrid

▌ *The Spanish rebellion is drowned in blood by Napoleon's
army and Goya loses all faith in human rationality.*
▌ *Die spanische Rebellion wird von der Gewalt des
napoleonischen Militärs unterdrückt: Es ist der endgültige
Vertrauensverlust Goyas vor der menschlichen Rationalität.*
▌ *De Spaanse opstand wordt gewelddadig neergeslagen door
het leger van Napoleon: dit betekent het definitieve verlies
van vertrouwen van Goya in de menselijke rationaliteit.*
▌ *La rebelión española es doblegada violentamente
por el ejército napoleónico: es la definitiva pérdida
de confianza en la racionalidad humana por parte de Goya.*

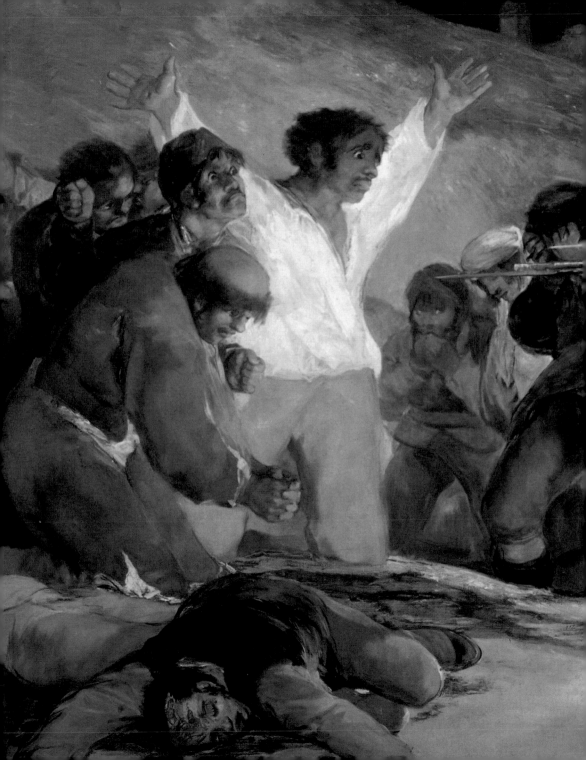

**Francisco Goya y Lucientes**
(Fuendetodos, Zaragoza 1746 - Bordeaux 1828)
*Witches' Sabbath*, oil on canvas
*Sabbat*, Öl auf Leinwand
*Sabbat*, olieverf op doek
*El aquelarre*, o *El Gran Cabrón*, óleo sobre lienzo
1819-1823
438 x 140 cm / 172.57 x 55.16 in.
Museo del Prado, Madrid

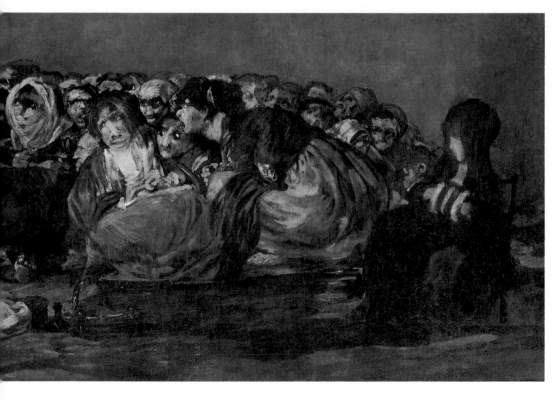

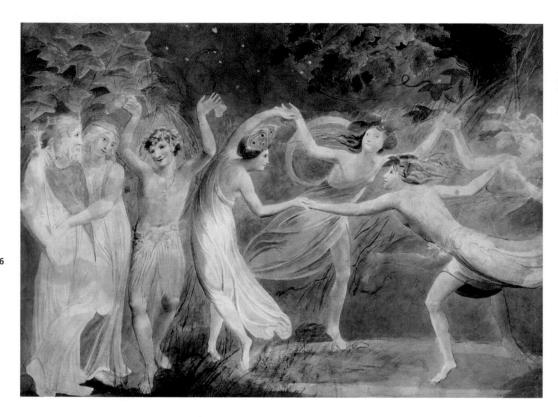

**William Blake**
(London 1757 - 1827)
*Oberon, Titania and Puck with Dancing Fairies*,
pencil and watercolour on paper
*Oberon, Titania und Puck mit tanzenden Feen*,
Bleistift und Aquarell auf Papier
*Oberon, Titania en Puck met dansende elfjes*,
potlood en acquarel op papier
*Oberon, Titania y Puck con hadas bailando*,
lápiz y acuarela sobre papel
c. 1786
47,5 x 67,5 cm / 19 x 26.5 in.
Tate Gallery, London

▶ **William Blake**
(London 1757 - 1827)
*The Ancient of Days (Urizen measuring out the material world)*,
etching, pen, ink, watercolour on paper
*The Ancient of Days (Urizen, der die Welt misst)*, Radierung,
Feder, Tinte, Aquarell auf Papier
*Het begin der tijden (Urizen meet de wereld)*, etsen, pen, inkt,
aquarel op papier
*El anciano de los días*, aguafuerte, pluma, tinta, acuarela sobre papel
1793
Stapleton Historical Collection, London

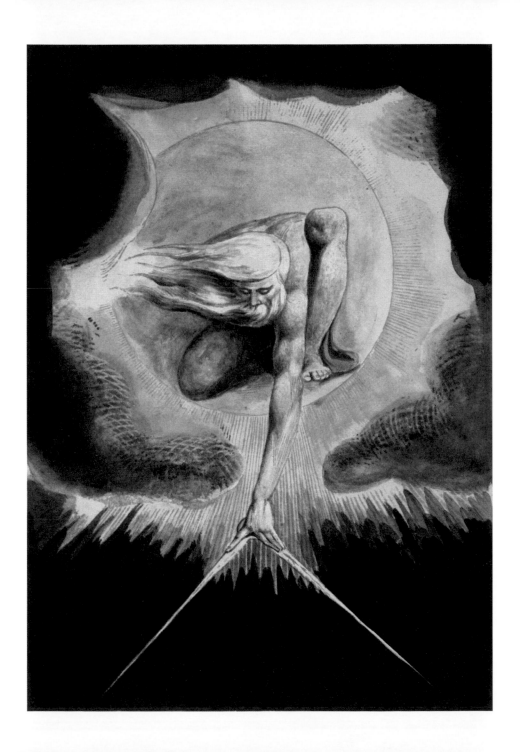

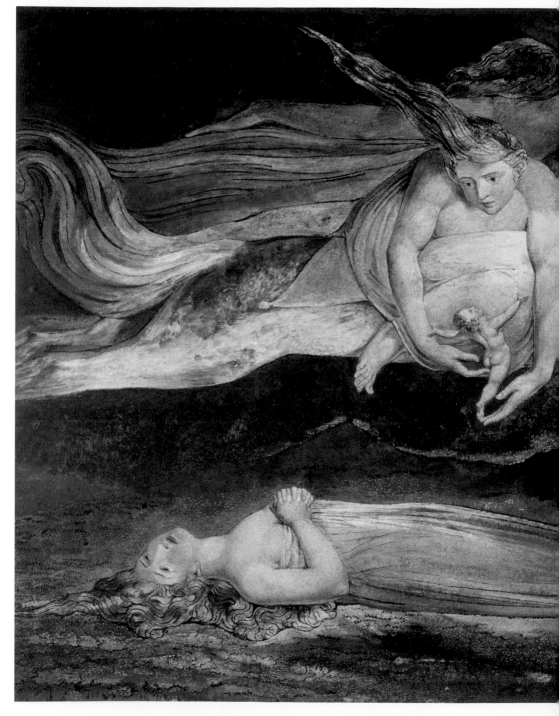

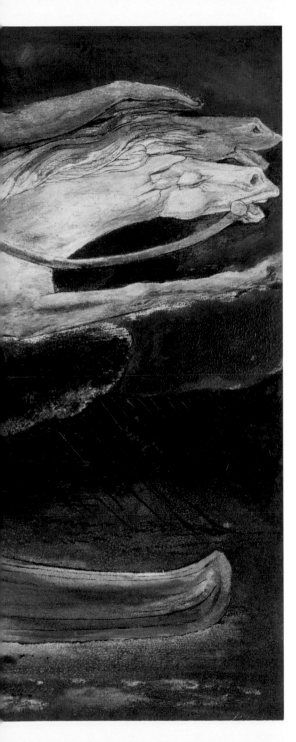

■ *Blake's work makes us instantly aware of his love*
*for the powerful forms of Michelangelo,*
*but these are expressed graphically in two dimensions.*
■ *Im Werk von Blake spüren wir sofort den Hang*
*zu den mächtigen Formen Michelangelos,*
*die aber oberflächlich in der Grafik aufgelöst sind.*
■ *IIn het werk van Blake ervaren we direct de liefde*
*voor de krachtige vormen van Michelangelo,*
*die echter oppervlakkig zijn verwerkt.*
■ *En la obra de Blake percibimos inmediatamente el amor*
*por las formas poderosas de Miguel Ángel,*
*pero resueltas gráficamente en la superficie.*

**William Blake**
(London 1757 - 1827)
*Pity*, colour print finished in ink and watercolour on paper
*Das Erbarmen*, Farbdruck mit Tinte und Aquarell auf Papier
*Piëta*, kleurenprint afgewerkt met inkt en aquarel op papier
*Piedad*, impresión a color acabada en tinta y acuarela sobre papel
1795
42,5 x 53,9 cm / 16.7 x 21.2 in.
Tate Gallery, London

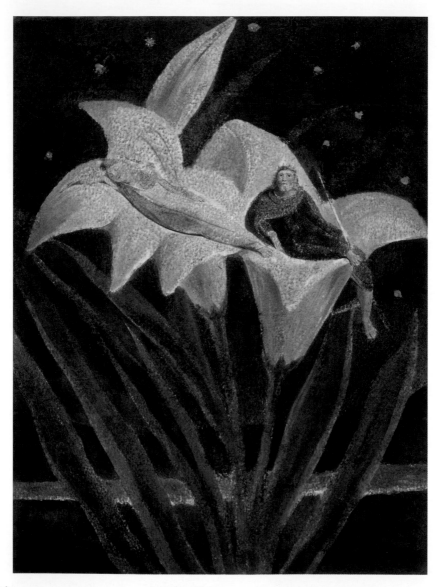

**William Blake**
(London 1757 - 1827)
*Song of Los* (Copy C, Bentley Plate 5)
*Das Lied von Los* (Kopie C, Tafel 5 von Bentley)
*Lied van Los* (Kopie C, tafel 5 van Bentley)
*La canción de Los* (Copia C, Tabla 5 de Bentley)
1795
35,9 x 24,8 cm / 14 x 9.7 in.
The Morgan Library & Museum, New York

▶ **William Blake**
(London 1757 - 1827)
*The Resurrection: Angels Rolling Away the Stone from the Sepulchre*, pen, ink, watercolors
*Die Auferstehung: Engel rollen den Stein vom Grabeingang weg*, Feder, Tinte, Aquarell
*De wederopstanding: engelen verwijderen de steen voor het graf*, pen, inkt, aquarel
*La resurrección: los ángeles moviendo la piedra del sepulcro*, pluma, tinta, acuarela
c. 1805
41,2 x 30 cm / 16.2 x 11.8 in.
Victoria & Albert Museum, London

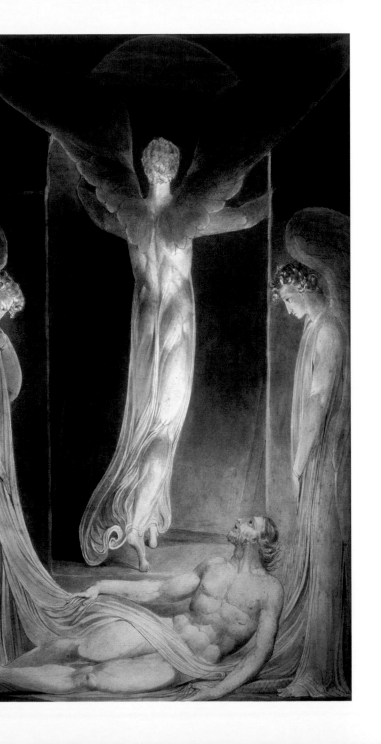

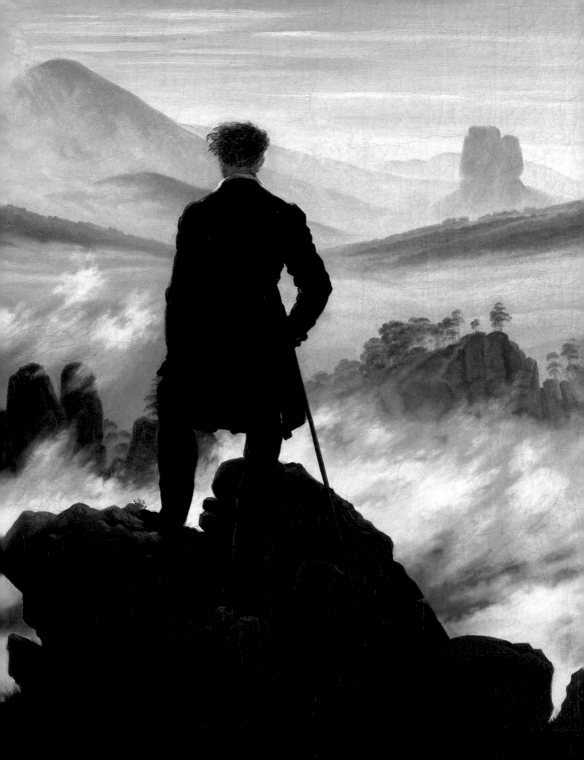

## Romanticism in England and Germany

*It's hard to date the Romantic Movement but the first perceptible development of specific artistic theories took place in Germany at the turn of the 18th and 19th centuries, the most coherent application in painting being that of Caspar David Friedrich. Romanticism took on many forms in Germany and in other lands. A common thread was the representation of nature, charged with symbolic, philosophical, and religious meaning, central to the work of Friedrich and of Turner and Constable in England. The Nazarenes, however, sought a more explicit correspondence between formal representation and religious feeling, inspired by 15th century Italian painting and Dürer.*

## Die Romantik in England und in Deutschland

*In Deutschland wurden in Bezug auf die Chronologie der romantischen Bewegung, die ersten spezifischen künstlerischen Theorien zwischen Ende des 18. und Anfang des 19. Jahrhunderts ausgearbeitet. Die schlüssigste Anwendung in der Malerei finden wir bei C. D. Friedrich. Die Abweichungen von der Romantik fanden nicht nur in Deutschland, sondern auch in den anderen Ländern statt. Ein roter Faden war die Darstellung der Natur, angereichert mit tiefen symbolischen, philosophischen und religiösen Bedeutungen und Protagonistin der Werke von Friedrich, sowie von den Engländern Turner und Constable. Andere suchten eine offensichtlichere Entsprechung zwischen formaler Darstellung und religiösem Gefühl: Die Gruppe der Nazarener, die sich im Kloster Sant'Isidoro direkt an den Werken der italienischen Maler des 15. Jahrhunderts und an Dürer inspirierten.*

# 5

## De romantiek in Engeland en Duitsland

*Hoewel het moeilijk is een precieze chronologie voor de Romantische beweging vast te stellen, zijn in Duitsland tussen het eind van de achttiende en begin van de negentiende eeuw de eerste specifieke artistieke theorieën ontwikkeld, waarvan we in de schilderkunst de meest consistente toepassing vinden bij Caspar David Friedrich. In Duitsland en andere landen kende de romantiek vele manifestaties. Een rode draad is de weergave van de natuur, boordevol diepe symbolische, filosofische en religieuze betekenissen, zoals in het werk van Friedrich en de Britten Turner en Constable. Sommigen zochten echter een duidelijker verband tussen een formele uitbeelding en religieus sentiment: de Nazareners, die elkaar in het Sant'Isodoroklooster in Rome hadden ontmoet, waren geïnspireerd door het werk van vijftiende-eeuwse Italiaanse schilders en Dürer.*

## El romanticismo en Inglaterra y en Alemania

*Si bien es difícil establecer una precisa delimitación cronológica para el movimiento romántico, podemos ubicar en la Alemania de fines del siglo XVIII y comienzos del siglo XIX la elaboración de las primeras específicas teorías artísticas, cuya aplicación más coherente en la pintura fue aportada por Friedrich. El romanticismo adquirió diferentes tonos y características dentro de la misma Alemania y en los distintos países, pero el hilo conductor constante fue la representación de la naturaleza, cargada de profundos significados simbólicos, filosóficos y religiosos, protagonista en la obra de Friedrich, como también en la de los ingleses Turner y Constable. Pero hubo también quien buscó una más evidente correspondencia entre la representación formal y el sentimiento religioso: el grupo de los Nazarenos que se inspiró directamente en la obra de los pintores italianos del siglo XV y en Dürer.*

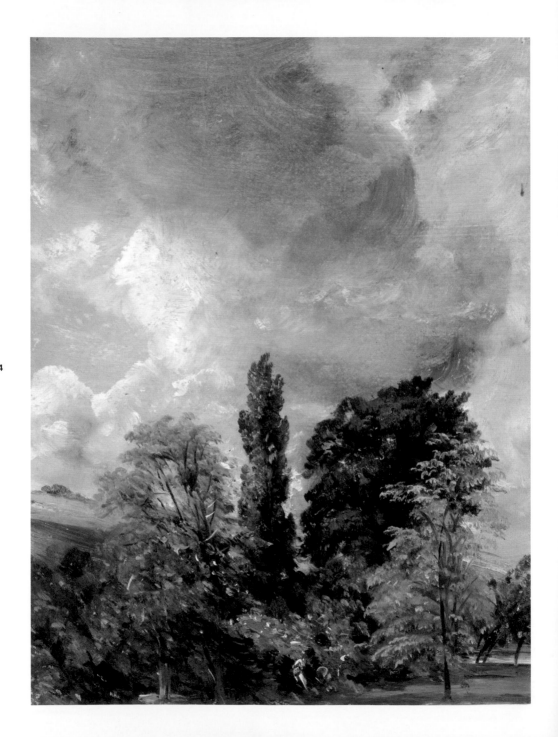

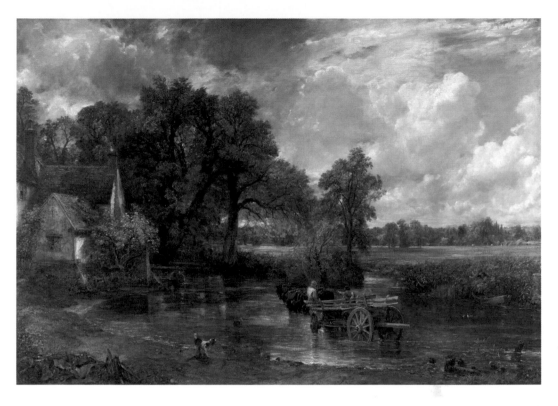

**◄ John Constable**
(East Bergholt, Suffolk 1776 - Hampstead 1837)
*The Close, Salisbury*, oil on paper
*Der Zaun, Salisbury*, Öl auf Papier
*Het hek, Salisbury*, olieverf op papier
*Salisbury, el parque de la catedral*, óleo sobre papel
26,4 x 20,3 cm / 10.4 x 8 in.
Victoria & Albert Museum, London

**John Constable**
(East Bergholt, Suffolk 1776 - Hampstead 1837)
*The Hay Wain*, oil on canvas
*Der Heuwagen*, Öl auf Leinwand
*De hooiwagen*, olieverf op doek
*El carro de heno*, óleo sobre lienzo
1821
130,2 x 185,4 cm / 51.2 x 72.9 in.
National Gallery, London

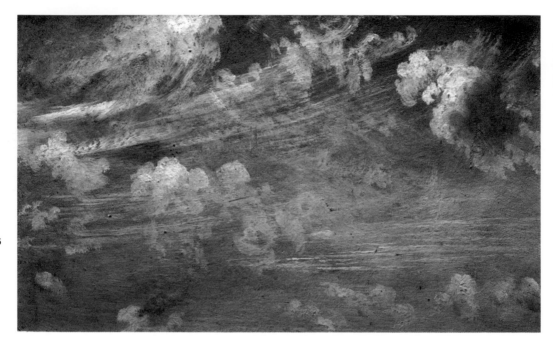

**John Constable**
(East Bergholt, Suffolk 1776 - Hampstead 1837)
*Study of Cirrus and Clouds*, oil on paper
*Federwolkenstudie*, Öl auf Papier
*Studie van cirruswolken en wolken*, olieverf op papier
*Estudio de cirros*, óleo sobre papel
*c.* 1822
11,4 x 17,8 cm / 4.5 x 7 in.
Victoria & Albert Museum, London

▌ *Constable's favourite subject – the sky and the clouds,
sketched while swiftly driven by the wind.*
▌ *Die von Constable bevorzugten Sujets sind der Himmel und die Wolken,
die er in Skizzen einfängt, während sie schnell vom Wind weiter getrieben werden.*
▌ *Favoriete onderwerpen van Constable zijn de hemel en de wolken,
vastgelegd in schetsen, als ze snel door de wind worden voortgedreven.*
▌ *Los temas preferidos de Constable son el cielo y las nubes,
capturadas en bosquejos mientras el viento las mueve rápidamente.*

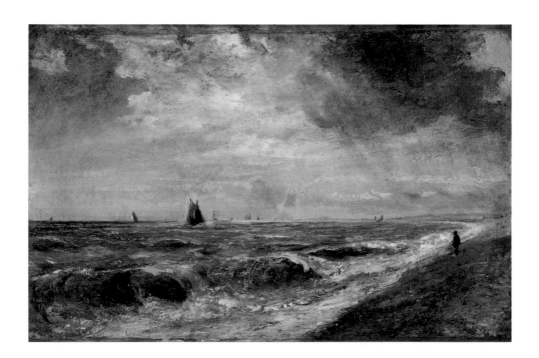

**John Constable**
(East Bergholt, Suffolk 1776 - Hampstead 1837)
*Rough Sea*, oil on paper, laid on canvas
*Bewegte See*, Öl auf geleimtem Papier
*Ruwe zee*, olieverf op papier aangebracht op doek
*La playa de Hove* (*Hove Beach*), óleo sobre papel aplicado sobre lienzo
c. 1824
31,7 x 49,5 cm / 12.5 x 19.6 in.
Victoria & Albert Museum, London

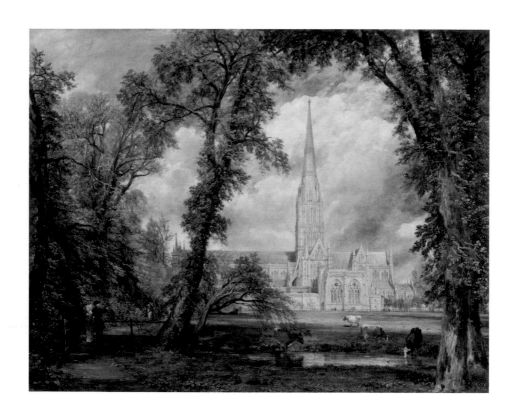

**John Constable**
(East Bergholt, Suffolk 1776 - Hampstead 1837)
*View of Salisbury Cathedral from the Bishop's Palace*, oil on canvas
*Blick auf die Kathedrale von Salisbury vom Haus des Bischofs*, Öl auf Leinwand
*Uitzicht van de kathedraal van Salisbury op het huis van de bisschop*, olieverf op doek
*La Catedral de Salisbury, vista desde el jardín del palacio arzobispal*, óleo sobre lienzo
1823
87,6 x 111,8 cm / 34.4 x 44 in.
Victoria & Albert Museum, London

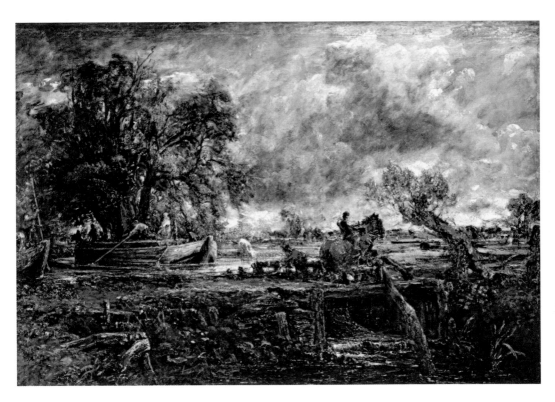

**John Constable**
(East Bergholt, Suffolk 1776 - Hampstead 1837)
*Studies for the Leaping Horse*, oil on canvas
*Studie für Das springende Pferd*, Öl auf Leinwand
*Studie van paard dat springt*, olieverf op doek
*Estudio para el salto a caballo*, óleo sobre lienzo
c. 1825
130 x 188 cm / 51 x 74 in.
Victoria & Albert Museum, London

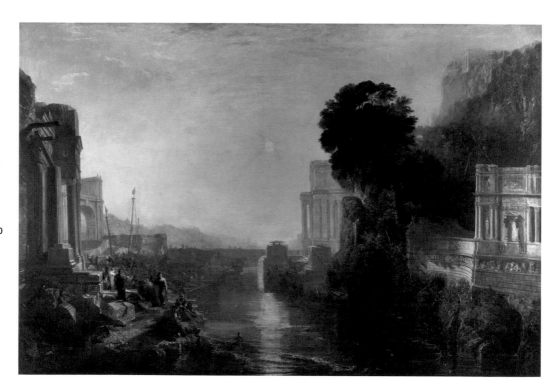

**William Turner**
(London 1775 - 1851)
*Dido building Carthage,* or *The Rise of the Carthaginian Empire,* oil on canvas
*Dido baut Karthago,* oder der *Aufstieg des karthagischen Imperiums,* Öl auf Leinwand
*Dido bouwt Carthago op of De opkomst van het Carthaagse rijk,* olieverf op doek
*Dido construyendo Cartago,* óleo sobre lienzo
1815
155,5 x 230 cm / 61.2 x 90.5 in.
National Gallery, London

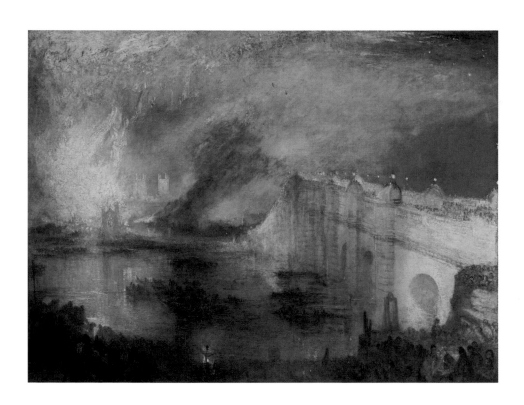

**William Turner**
(London 1775 - 1851)
*The Burning of the Houses of Lords and Commons, October 16, 1834,* oil on canvas
*Der Brand des Houses of Lords and Commons am 16. Oktober 1834,* Öl auf Leinwand
*Brand in het Houses of Lords en Commons op 16 Oktober 1834,* olieverf op doek
*El incendio de la Cámara de los Lores y de los Comunes el 16 de octubre de 1834,* óleo sobre lienzo
1834-1835
92,1 x 123,2 cm / 36.3 x 48.5 in.
Philadelphia Museum of Art, Philadelphia

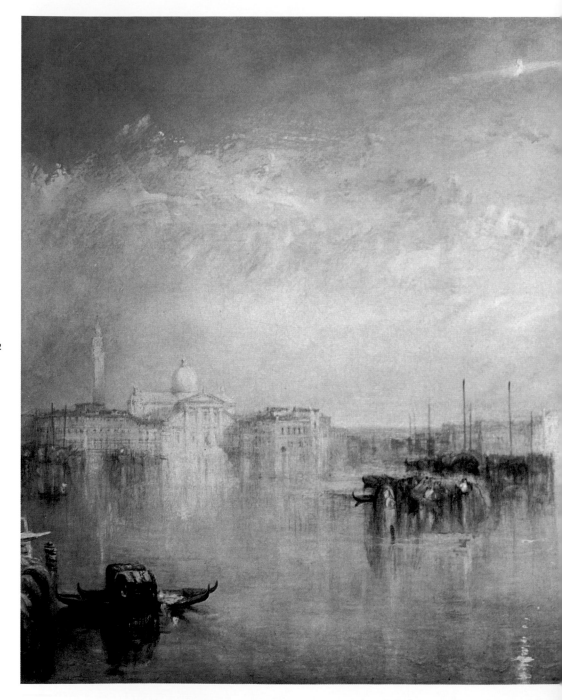

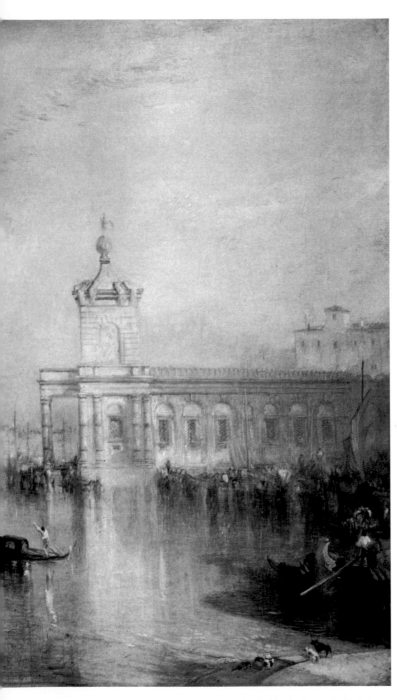

**William Turner**
(London 1775 - 1851)
*The Dogana, San Giorgio, Citella,
from the steps of the Europa, Venice,*
oil on canvas
*Die Dogana, San Giorgio und die
Citella von den Stufen des Hotels
Europa aus gesehen*, Öl auf Leinwand
*De Doge, St. George, Citadel
van de trappen van Europa, Venetië*,
olieverf op doek
*La Aduana, San Giorgio y las Zitelle
desde las escalinatas del Hotel
Europa, Venecia*, óleo sobre lienzo
1842
61,6 x 92,7 cm / 24 x 36.5 in.
Tate Gallery, London

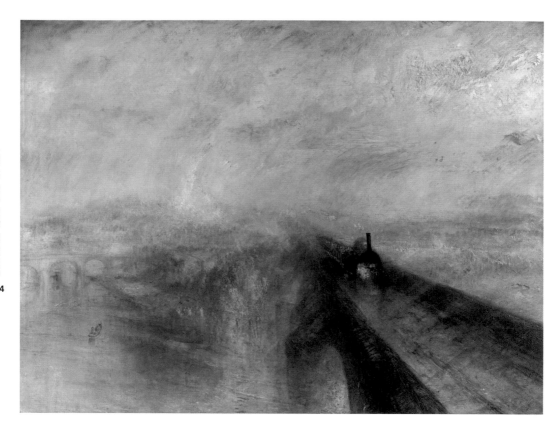

**William Turner**
(London 1775 - 1851)
*Rain, Steam, and Speed (The Great Western Railway)*, oil on canvas
*Regen, Dampf und Geschwindigkeit* (die *Great Western Railway*),
Öl auf Leinwand
*Regen, stoom en snelheid (De grote westerse spoorweg)*, olieverf op doek
*Lluvia, vapor y velocidad (El gran ferrocarril del Oeste)*, óleo sobre lienzo
1844
91 x 121,8 cm / 35.8 x 48 in.
National Gallery, London

▌ *Modernity advances impetuously in history and now also in art thanks to those like Turner who know how to capture its expressive force.*
▌ *Die Modernität schreitet stürmisch in der Geschichte voran und jetzt auch in der Kunst, dank derer, die wie Turner die Ausdruckskraft daraus gewinnen können.*
▌ *De moderniteit loopt voortdurend voor op de geschiedenis en nu ook in de kunst, dankzij degenen die, zoals Turner, greep hebben op haar expressieve kracht.*
▌ *La modernidad avanza impetuosamente en la historia, y ahora también en el arte, gracias a quienes, como Turner, saben plasmar su fuerza expresiva.*

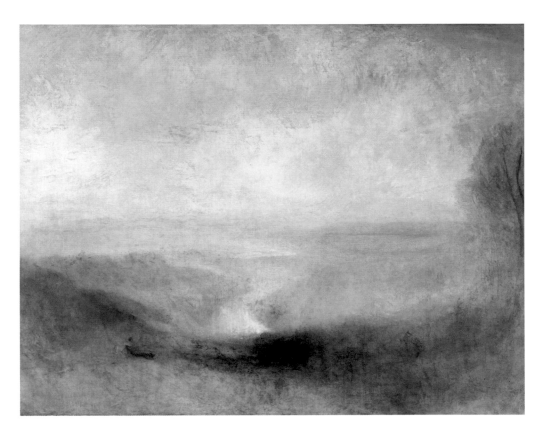

**William Turner**
(London 1775 - 1851)
*Landscape with River and Bay in the Background*, oil on canvas
*Landschaft mit Fluss und Bucht in der Ferne*, Öl auf Leinwand
*Landschap met rivier en baai op de achtergrond*, olieverf op doek
*Paisaje con un río y una bahía en la lejanía*, óleo sobre lienzo
1845
94 x 124 cm / 37 x 49 in.
Musée du Louvre, Paris

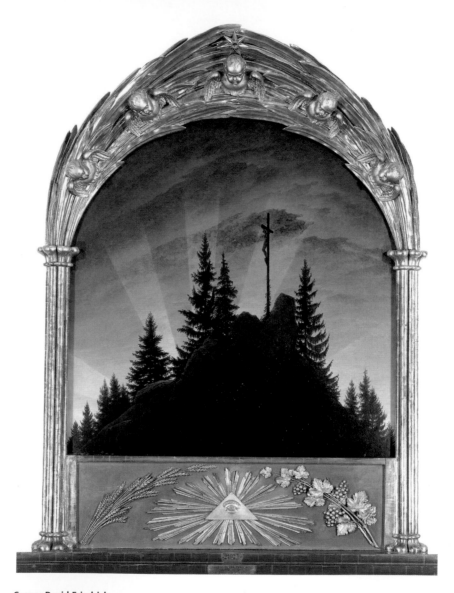

**Caspar David Friedrich**
(Greifswald 1774 - Dresden 1840)
*The Cross on the Mountain*, oil on canvas
*Das Kreuz im Gebirge*, Öl auf Leinwand
*Het kruis op de berg*, olieverf op doek
*La cruz en la montaña*, óleo sobre lienzo
1808
115 x 110 cm / 45.2 x 43.3 in.
Galerie Neue Meister, Staatliche Kunstsammlungen, Dresden

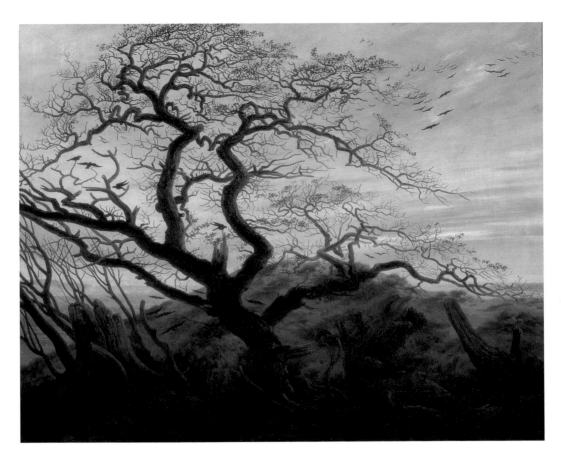

▋ *In the work of Friedrich, traditional landscape painting is subverted, against all probability, and the elements are charged with a profound symbolic significance.*
▋ *In den Werken von Friedrich ist die traditionelle Landschaftsmalerei entgegen jeder Wahrscheinlichkeit umgestürzt und die Elemente sind mit einer tiefen symbolischen Bedeutung angefüllt.*
▋ *In het werk van Friedrich wordt het traditionele landschapschilderij op zijn kop gezet, tegen alle waarschijnlijkheid in, en bevatten de elementen een diepgaande symbolische betekenis.*
▋ *En las obras de Friedrich la pintura tradicional de paisajes está trastocada, contra toda verosimilitud y con elementos cargados de un profundo significado simbólico.*

**Caspar David Friedrich**
(Greifswald 1774 - Dresden 1840)
*The Tree of Crows*, oil on canvas
*Krähen auf einem Baum*, Öl auf Leinwand
*De boom met de kraaien*, olieverf op doek
*El árbol de los cuervos*, óleo sobre lienzo
c. 1822
54 x 71 cm / 21.2 x 27.9 in.
Musée du Louvre, Paris

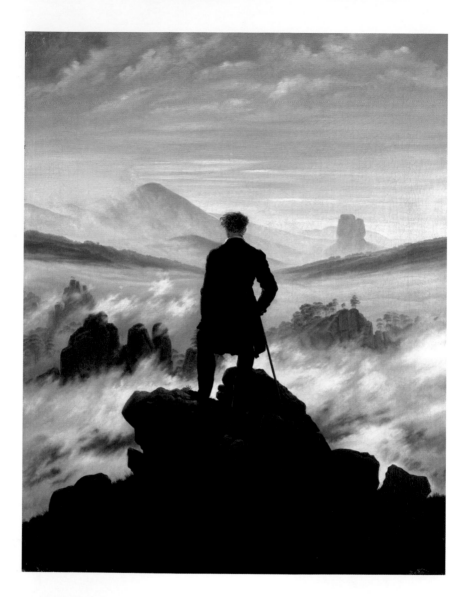

**Caspar David Friedrich**
(Greifswald 1774 - Dresden 1840)
*Wanderer Above a Sea of Fog*, oil on canvas
*Der Wanderer über dem Nebelmeer*, Öl auf Leinwand
*Reiziger op een zee van mist*, olieverf op doek
*El viajero contemplando un mar de nubes*, óleo sobre lienzo
1818
94,8 x 74,8 cm / 37.4 x 29.5 in.
Hamburger Kunsthalle, Hamburg

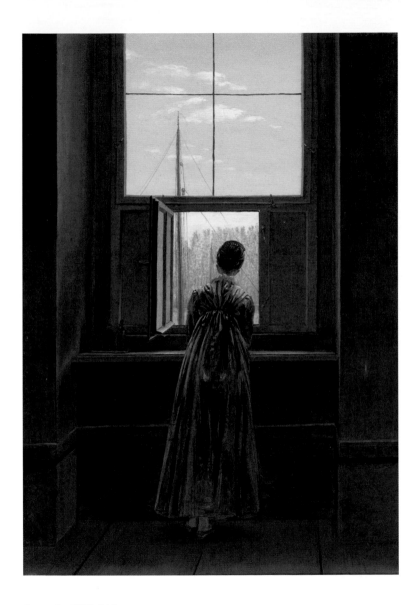

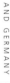

**Caspar David Friedrich**
(Greifswald 1774 - Dresden 1840)
*Woman at the window*, oil on canvas
*Frau am Fenster*, Öl auf Leinwand
*Vrouw aan venster*, olieverf op doek
*Mujer asomada a la ventana*, óleo sobre lienzo
1822
44 x 37 cm / 17.3 x 37 in.
Nationalgalerie, Staatliche Museen, Berlin

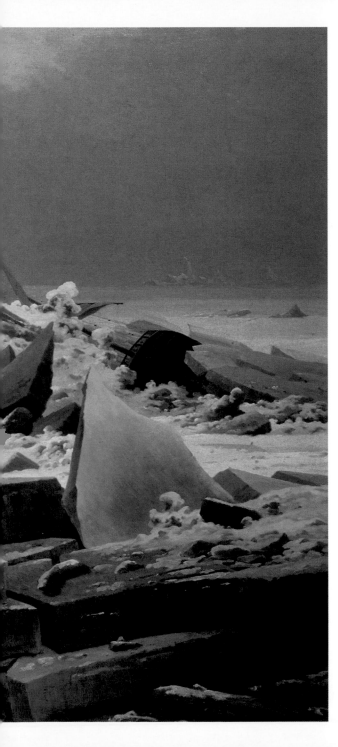

**Caspar David Friedrich**
(Greifswald 1774 - Dresden 1840)
*The Polar Sea*, or *The Wreck of Hope*, oil on canvas
*Das Eismeer* oder *Die gescheiterte Hoffnung*,
Öl auf Leinwand
*De poolzee of Het wrak van de hoop*, olieverf op doek
*El Océano Glacial*, o *El naufragio de la Esperanza*, óleo
sobre lienzo
1823-1824
96,7 x 126,9 cm / 38.1 x 50 in.
Hamburger Kunsthalle, Hamburg

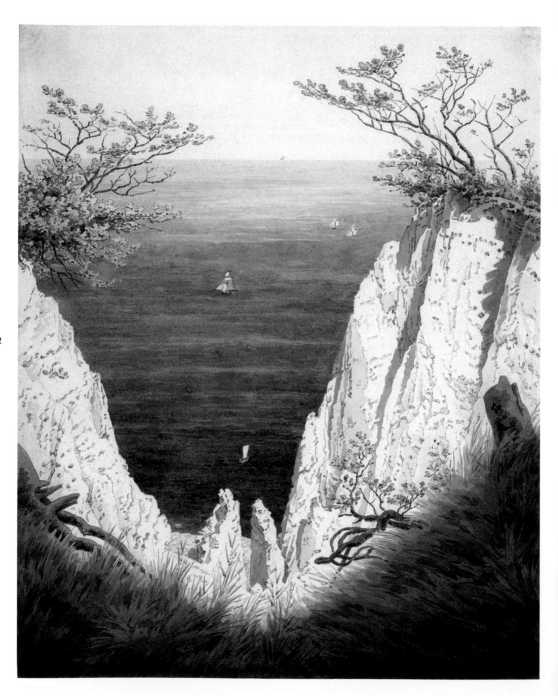

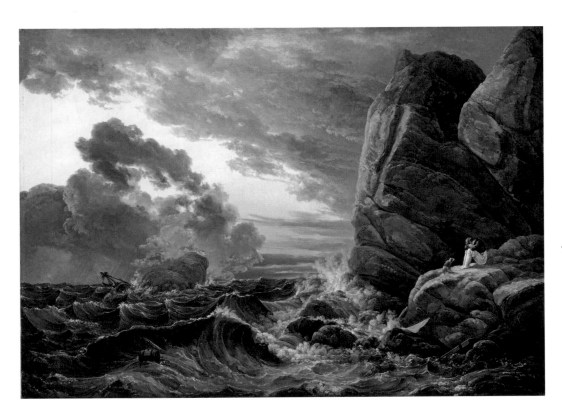

◀ **Caspar David Friedrich**
(Greifswald 1774 - Dresden 1840)
*Chalk Cliffs at Ruegen*, watercolour over pencil
*Die Kreidefelsen auf Rügen*, Aquarell auf Bleistift
*De witte rotsen van Ruegen*, aquarel op potlood
*Acantilados blancos en Rügen*, acuarela sobre lápiz
1825-1826
31,7 x 25,2 cm / 12.5 x 9.8 in.
Museum der bildenden Künste, Leipzig

**Johan Christian Dahl**
(Bergen 1788 - Dresden 1857)
*Morning After a Stormy Night*, oil on canvas
*Morgen nach einer Sturmnacht*, Öl auf Leinwand
*Ochtend na een stormnacht*, olieverf op doek
*Mañana después de una noche de tormenta*, óleo sobre lienzo
1819
74,5 x 105,3 cm / 29.3 x 41.3 in.
Neue Pinakothek, München

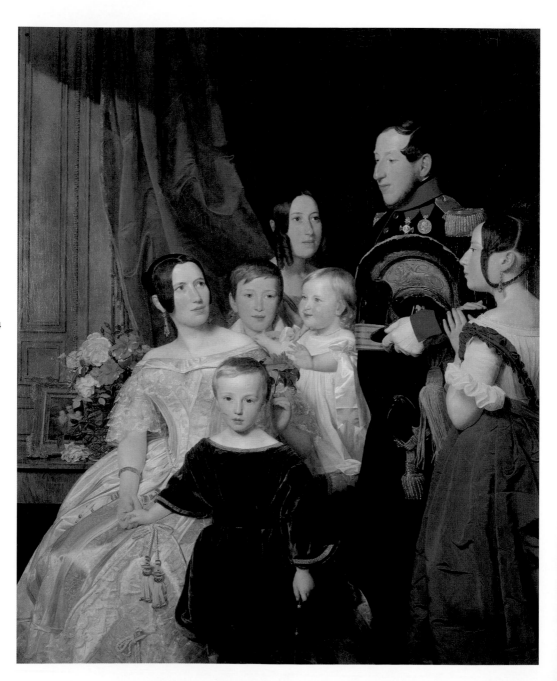

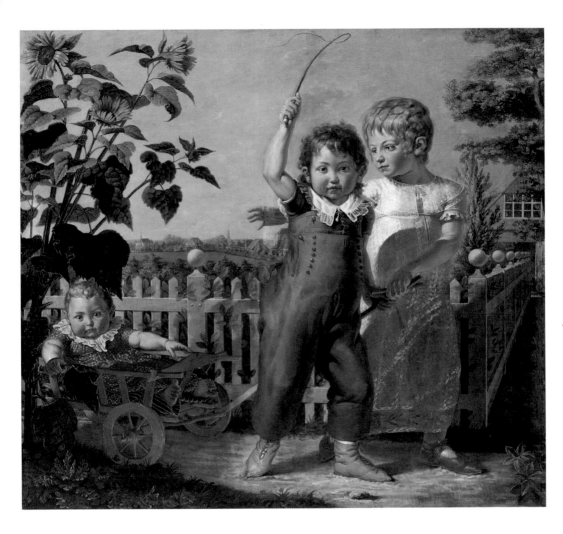

◀ **Ferdinand Georg Waldmüller**
(Wien 1793 - Baden 1865)
*The Gierster Family*, oil on canvas
*Die Familie Gierster*, Öl auf Leinwand
*De familie Gierster*, olieverf op doek
*La familia Gierster*, óleo sobre lienzo
1838
174 x 143 cm / 68.5 x 56.3 in.
Historisches Museum, Wien

**Otto Philipp Runge**
(Wolgast 1777 - Hamburg 1810)
*The Huelsenbeck Children*, oil on canvas
*Die Hülsenbeck'schen Kinder*, Öl auf Leinwand
*De kinderen Huelsenbeck*, olieverf op doek
*Los niños Huelsenbeck*, óleo sobre lienzo
1805-1806
131,5 x 143,5 cm / 51.7 x 56.5 in.
Hamburger Kunsthalle, Hamburg

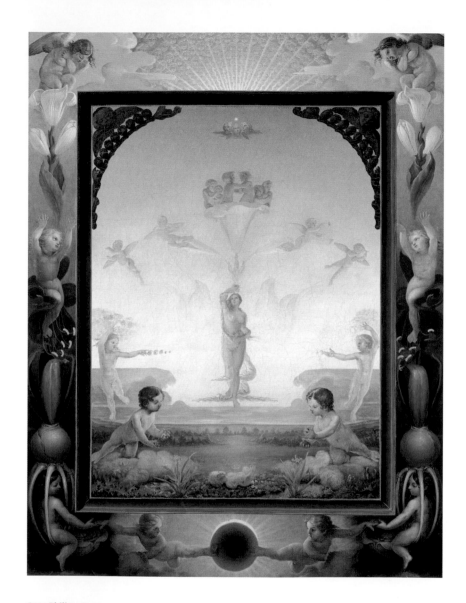

**Otto Philipp Runge**
(Wolgast 1777 - Hamburg 1810)
*The "Small" Morning*, oil on canvas
*Der kleine Morgen*, Öl auf Leinwand
*De "kleine" ochtend*, olieverf op doek
*La "pequeña" mañana*, óleo sobre lienzo
1808
109 x 85,5 cm / 42.9 x 33.6 in.
Hamburger Kunsthalle, Hamburg

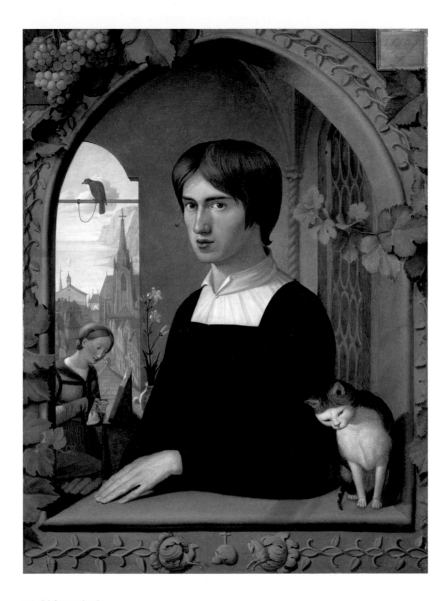

**Friedrich Overbeck**
(Lübeck 1789 - Roma 1869)
*Portrait of the Painter Franz Pforr*, oil on canvas
*Bildnis des Malers Franz Pforr*, Öl auf Leinwand
*Portret van schilder Franz Pforr*, olieverf op doek
*Retrato del pintor Franz Pforr*, óleo sobre lienzo
1810
62 x 47 cm / 24.4 x 18.5 in.
Nationalgalerie, Staatliche Museen, Berlin

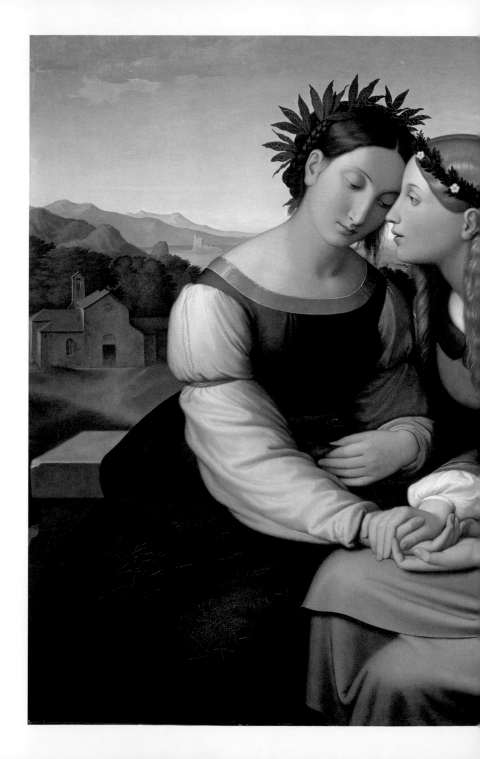

▊ *The two girls and the landscapes behind them,*
*Italy and Germany: the two halves that make up the "creation"*
*and the inspiration of Overbeck and the Nazarenes.*
▊ *Die zwei Mädchen und die Landschaft hinter ihrem Rücken,*
*Italia und Germania: Die zwei Hälften, die die "Schaffung"*
*und Inspiration von Overbeck und der Nazarener darstellen.*
▊ *De twee meisjes en het landschap achter hen,*
*Italië en Duitsland: de twee helften, die samen de 'schepping'*
*en de inspiratie van Overbeck en de Nazareners vormen.*
▊ *Las dos muchachas y los paisajes a sus espaldas,*
*Italia y Germania: las dos mitades que constituyen la*
*"creación" y la inspiración de Overbeck y de los Nazarenos.*

**Friedrich Overbeck**
(Lübeck 1789 - Roma 1869)
*Italy and Germany*, oil on canvas
*Italia und Germania*, Öl auf Leinwand
*Italië en Duitsland*, olieverf op doek
*Italia y Germania (Sulamith y María)*, óleo sobre lienzo
1828
94 x 104 cm / 37 x 40.9 in.
Neue Pinakothek, München

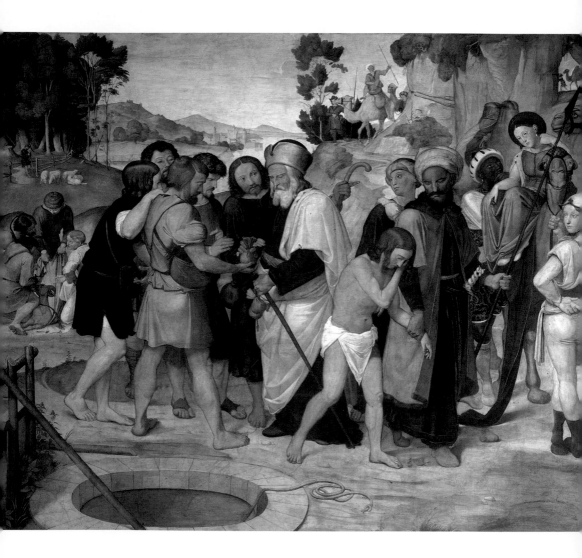

**Friedrich Overbeck**
(Lübeck 1789 - Roma 1869)
*Joseph Sold by His Brothers*, fresco and tempera
*Der Verkauf Josephs*, Fresko, mit Tempera nachbearbeitet
*Jozef verkocht door zijn broers*, fresco bijgewerkt op eiwit
*José vendido por sus hermanos*, fresco retocado en temple
1817
243 x 304 cm / 95.6 x 119.6 in.
Nationalgalerie, Staatliche Museen, Berlin

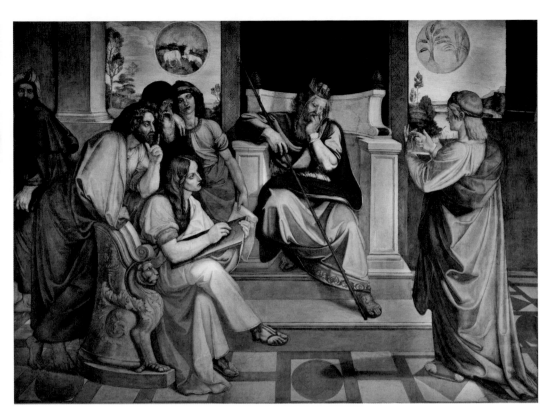

**Peter von Cornelius**
(Düsseldorf 1783 - Berlin 1867)
*Joseph the Patriarch explaining the Pharaoh's dreams*, fresco and tempera
*Joseph deutet die Träume des Pharaos*, Fresko, mit Tempera nachbearbeitet
*Jozef verklaart de farao diens dromen,* fresco bijgewerkt op eiwit
*José interpreta el sueño del faraón*, fresco retocado en temple
1816-1817
246 x 331 cm / 96.8 x 130.3 in.
Nationalgalerie, Staatliche Museen, Berlin

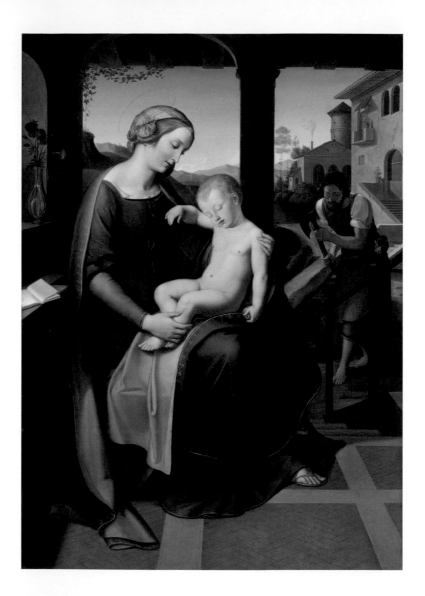

**Wilhelm von Schadow**
(Berlin 1788 - Düsseldorf 1862)
*The Holy Family Beneath the Portico*, oil on canvas
*Die Heilige Familie unter dem Portikus*, Öl auf Leinwand
*De heilige familie onder een portiek*, olieverf op doek
*La sagrada familia en el pórtico*, óleo sobre lienzo
1818
142,5 x 102,4 cm / 56 x 102.4 in.
Neue Pinakothek, München

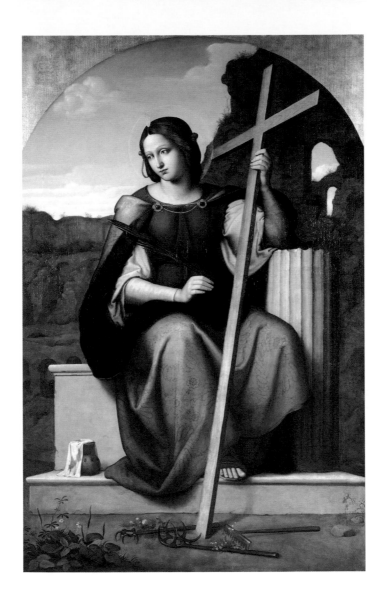

**Philipp Veit**
(Berlin 1793 - 1877)
*Religion*, oil on canvas
*Die Religion*, Öl auf Leinwand
*Religie*, olieverf op doek
*La Religión*, óleo sobre lienzo
1819
194,5 x 127 cm / 76.5 x 50 in.
Nationalgalerie, Staatliche Museen, Berlin

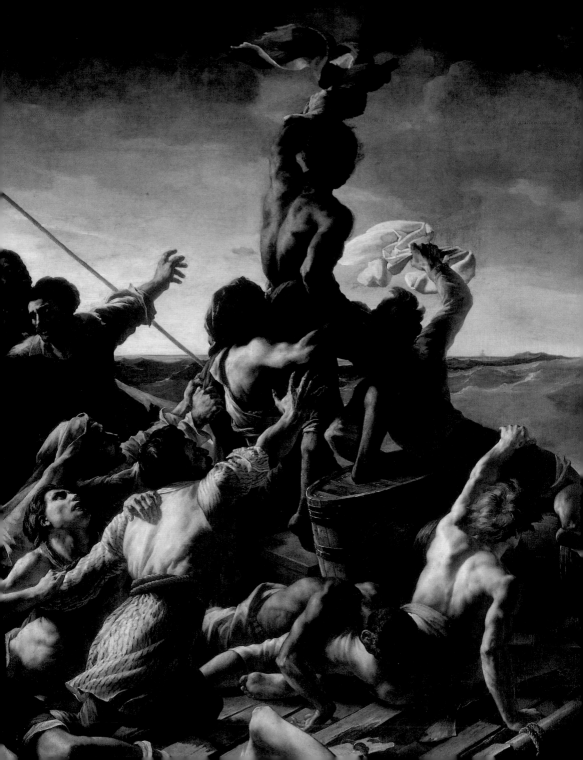

# Romanticism
# in France and Italy

*Shaken by the collapse of the Napoleonic dream, in the first quarter of the 19th century, France found an ideal form for the expression of its moral and civic aspirations in historical paintings, rich in patriotic meaning. Historical subjects were often transposed into the modern era in the work of the major French romantic painters, Delacroix and Géricault, driven by an ever more pressing urge to sharpen public awareness of politically contentious topics. Historical genre painting, marked by a strong ideological commitment, was also widespread in Italy, while work more representative of romantic sensibility spread only midway through the 19th century.*

# Die Romantik
# in Frankreich und in Italien

*Aus dem napoleonischen Traum aufgewacht, fand Frankreich ab dem ersten Quartal des 19. Jahrhunderts in der historischen Malerei, die mit patriotischen Symbolen durchwoben war, die ideale Ausdrucksform für die eigenen moralischen und gesellschaftlichen Bestrebungen. Das historische Sujet wird oft auf moderne Art und Weise in den Werken der meisten Maler der französischen Romantik, Delacroix und Géricault transportiert, die immer mehr darauf bestehen, das Publikum auf Themen des politischen Protests und Kampfes zu sensibilisieren. Die historische Malerei, die von einem starken ideologischen Eifer gekennzeichnet ist, war auch in Italien dominant, während Phänomene, die eher die romantische Sensibilität darstellten, sich erst Mitte des 19. Jahrhunderts durchsetzten.*

**6**

# De romantiek
# in Frankrijk en Italië

*Na het uiteenspatten van de napoleontische droom, vond Frankrijk sinds het eerste kwart van de negentiende eeuw de ideale expressievorm van zijn morele en maatschappelijke ambities in de historieschilderkunst, die rijk was aan patriottische betekenissen. De grootste schilders van de Franse romantiek, Delacroix en Géricault, gaven het historische onderwerp vaak een moderne vorm om het publiek bewust te maken van de politieke strijd en protesten. Ook in Italië was de door een sterke ideologische betrokkenheid gekenmerkte historieschilderkunst dominant, terwijl werken met meer romantische aspecten pas vanaf het midden van de negentiende eeuwn opkwamen.*

# El romanticismo
# en Francia y en Italia

*Abatida por la caída del sueño napoleónico, desde el primer cuarto del siglo XIX Francia encontró en la pintura histórica, cargada de significados patrióticos, la forma ideal para la expresión de sus propias aspiraciones morales y civiles. El sujeto histórico a menudo es plasmado en clave moderna en la obra de los más grandes pintores del romanticismo francés, Delacroix y Géricault, impulsados por una exigencia cada vez mayor de sensibilización del público hacia los temas de la protesta y de la lucha política. La pintura histórica, marcada por un fuerte compromiso ideológico, prevaleció también en Italia, mientras que los fenómenos más representativos de la sensibilidad romántica se afirmaron recién a mediados del siglo XIX.*

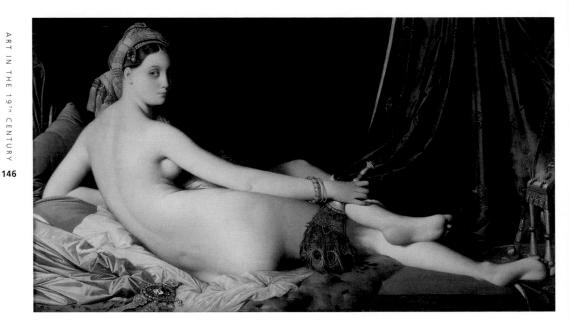

**Jean-Auguste-Dominique Ingres**
(Montauban 1780 - Paris 1867)
*Great Odalisque*, oil on canvas
*Die große Odaliske*, Öl auf Leinwand
*De grote odalisk*, olieverf op doek
*La gran odalisca*, óleo sobre lienzo
1814
91 x 162 cm / 35.8 x 63.7 in.
Musée du Louvre, Paris

▌ *The sinuous line that outlines the body of La Grande Odalisque defines its soft shapes on the surface, while the spaces are barely hinted at by the delicate chiaroscuro.*
▌ *Die gewundene Linie, die den Körper der Großen Odaliske umreißt, definiert die weichen Formen an der Oberfläche, während die Volumen kaum vom zarten Chiaroscuro angedeutet werden.*
▌ *De golvende omtrek van het lichaam van de Grote odalisk, definieert de zachte vormen aan het oppervlak, terwijl de ruimte nauwelijks wordt geaccentueerd door het delicate clair-obscur.*
▌ *La línea sinuosa que delinea el cuerpo de la Gran odalisca define sus formas suaves en la superficie, mientras los volúmenes son apenas insinuados por el delicado claroscuro.*

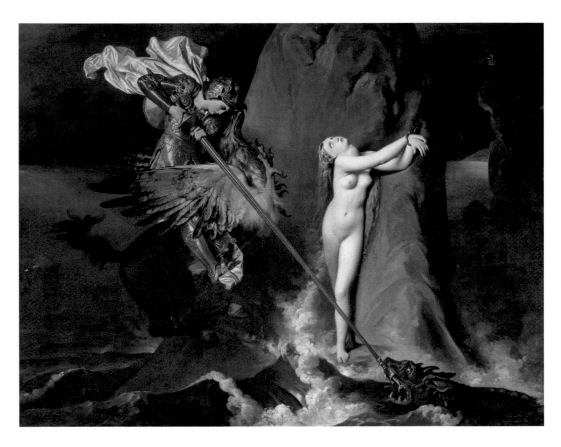

**Jean-Auguste-Dominique Ingres**
(Montauban 1780 - Paris 1867)
*Roger Freeing Angelica*, oil on canvas
*Rüdiger befreit Angelika*, Öl auf Leinwand
*Roger bevrijdt Angelica*, olieverf op doek
*Roger liberando a Angélica*, óleo sobre lienzo
1819
147 x 190 cm / 57.8 x 74.8 in.
Musée du Louvre, Paris

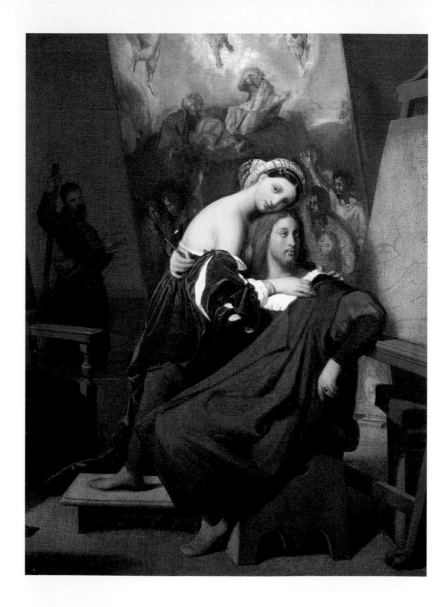

**Jean-Auguste-Dominique Ingres**
(Montauban 1780 - Paris 1867)
*Raphael and La Fornarina*, oil on canvas
*Raffael und die Fornarina*, Öl auf Leinwand
*Raphael en de Fornarina*, olieverf op doek
*Rafael y La Fornarina*, óleo sobre lienzo
1813-1840
Gallery of Fine Arts, Columbus

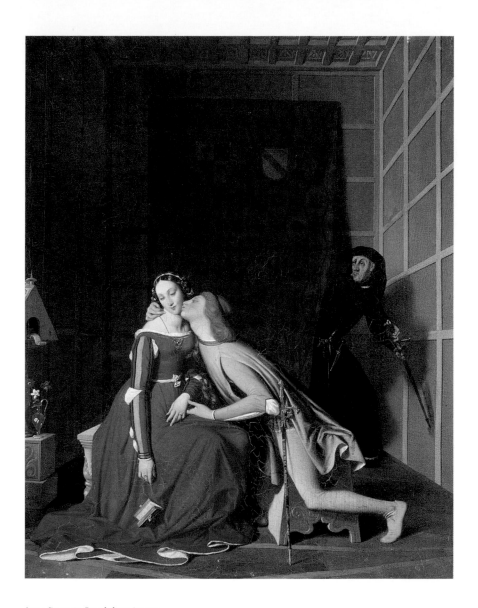

**Jean-Auguste-Dominique Ingres**
(Montauban 1780 - Paris 1867)
*Paolo and Francesca*, oil on canvas
*Paolo und Francesca*, Öl auf Leinwand
*Paolo en Francesca*, olieverf op doek
*Paolo y Francesca*, óleo sobre lienzo
1819
50 x 41 cm / 19.6 x 16.1 in.
Musée des Beaux-Arts, Angers

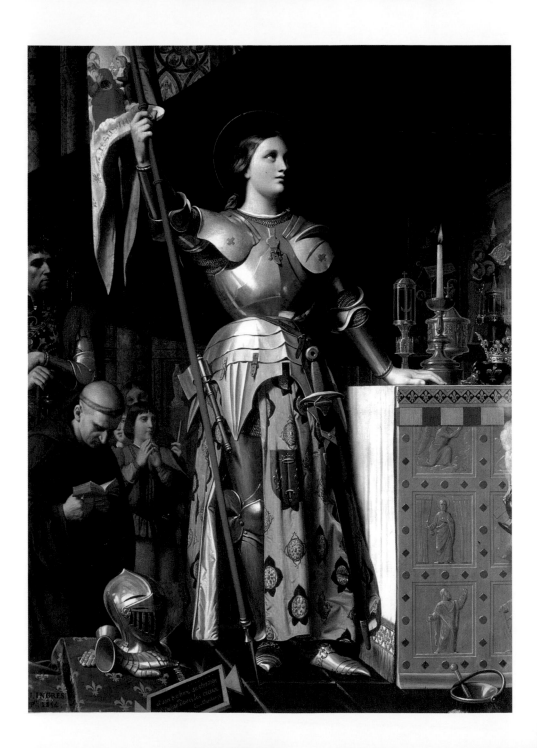

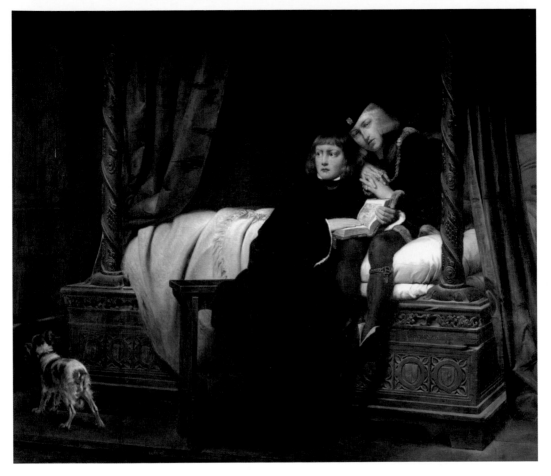

▌ *Delaroche involves the viewer emotionally, depicting The Princes in the Tower in all the verisimilitude and humanity of their plight.*
▌ *Delaroche möchte den Betrachter emotional miteinbeziehen, indem er die Kinder von Edward in i hrer ganzen Wahrscheinlichkeit und Menschlichkeit ihrer Situation darstellt.*
▌ *Delaroche richt zich op de emoties van de toeschouwer en toont Edwards kinderen in de echtheid en menselijkheid van hun situatie.*
▌ *Delaroche aspira a la implicación emotiva del observador representando a los hijos de Eduardo en toda la verosimilitud y humanidad de su situación.*

◀ **Jean-Auguste-Dominique Ingres**
(Montauban 1780 - Paris 1867)
*Joan of Arc at the Coronation of Charles VII in Reims Cathedral,* oil on canvas
*Jeanne d'Arc bei der Krönung Karls VII.,* Öl auf Leinwand
*Jeanne d'Arc bij de kroning van Karel VII,* olieverf op doek
*Juana de Arco en la coronación de Carlos VII,* óleo sobre lienzo
1854
240 x 178 cm / 94.4 x 70 in.
Musée du Louvre, Paris

**Paul Delaroche**
(Paris 1797 - 1856)
*The Children of Edward (1483),* oil on canvas
*Die Kinder von König Edward (1483),* Öl auf Leinwand
*De zonen van Eduard (1483),* olieverf op doek
*Los hijos de Eduardo (1483),* óleo sobre lienzo
1831
181 x 215 cm / 71.2 x 84.6 in.
Musée du Louvre, Paris

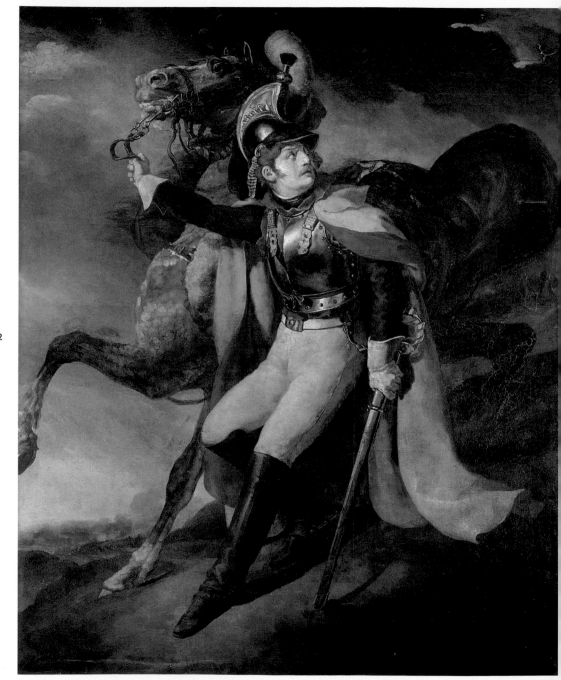

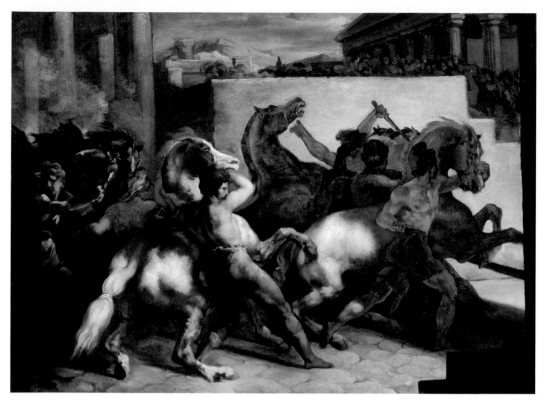

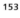

▎ Géricault in Rome: the power of man struggling against beast expressed through the study of antiquity and the forms of Michelangelo.
▎ Géricault in Rom: die Kraft des Nahkampfes zwischen Mensch und Tier äußert sich über das Studium der Antike und der Formen bei Michelangelo.
▎ Géricault in Rome: de macht van het gevecht tussen mens en dier, uitgebeeld volgens studies van de Oudheid en de vormen van Michelangelo.
▎ Géricault en Roma: la potencia del cuerpo a cuerpo entre hombre y animal, expresada a través del estudio de lo antiguo y de las formas inspiradas en Miguel Ángel.

◄ **Théodore Géricault**
(Rouen 1791 - Paris 1824)
*Officer Leaving the Battlefield*, oil on canvas
*Verwundeter Kürassier verlässt das Schlachtfeld*, Öl auf Leinwand
*Gewonde kurassier verlaat het strijdveld*, olieverf op doek
*Coracero herido*, óleo sobre lienzo
1814
358 x 294 cm / 140 x 115.7 in.
Musée du Louvre, Paris

**Théodore Géricault**
(Rouen 1791 - Paris 1824)
*Race of Wild Horses in Rome*, oil on canvas
*Rennen der Wildpferde in Rom*, Öl auf Leinwand
*Berber paardenrace in Rome*, olieverf op doek
*La carrera de los caballos Barberi*, óleo sobre lienzo
1817
45 x 60 cm / 17.7 x 23.6 in.
Musée du Louvre, Paris

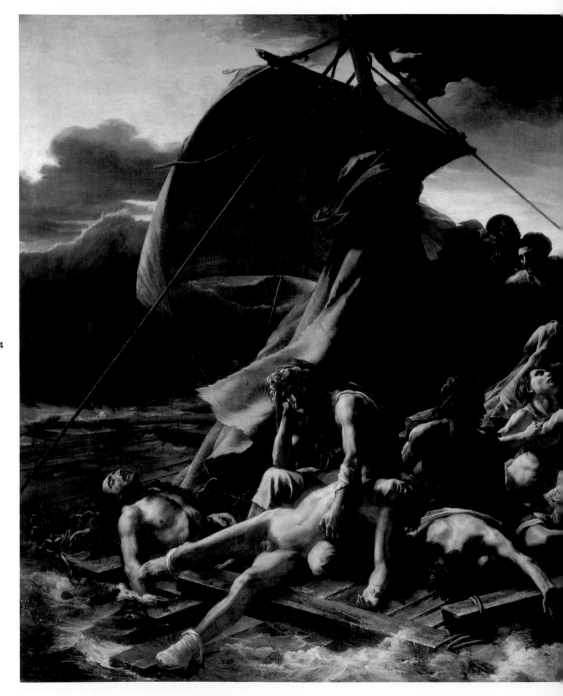

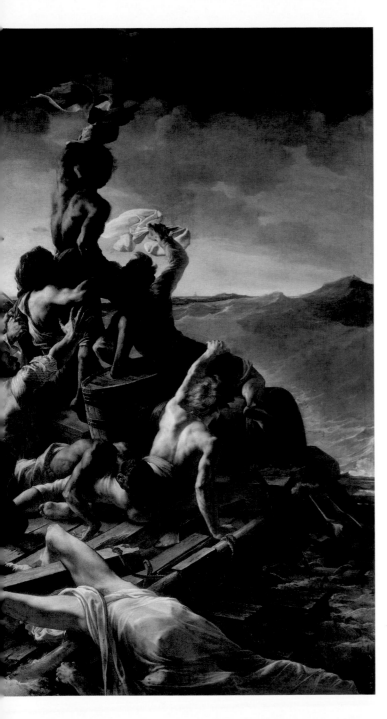

**Théodore Géricault**
(Rouen 1791 - Paris 1824)
*The Raft of the Medusa*, oil on canvas
*Das Floß der Medusa*, Öl auf Leinwand
*Het vlot van Medusa*, olieverf op doek
*La balsa de la Medusa*, óleo sobre lienzo
1818-1819
491 x 716 cm / 193.3 x 281.9 in.
Musée du Louvre, Paris

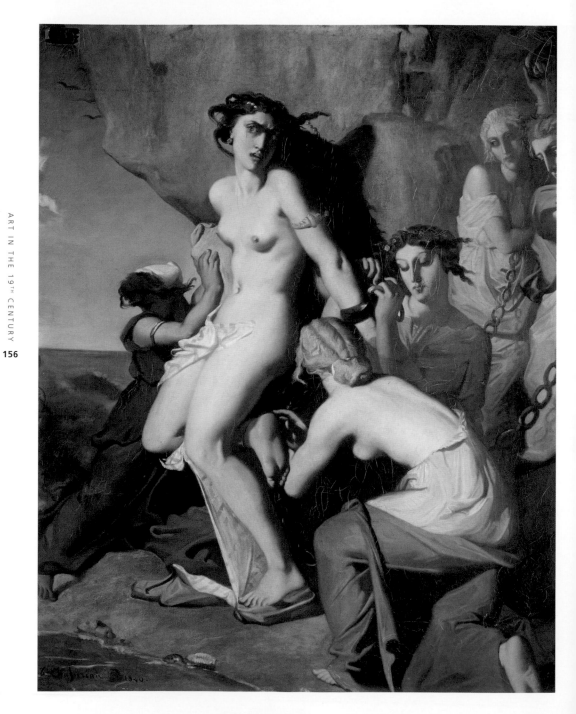

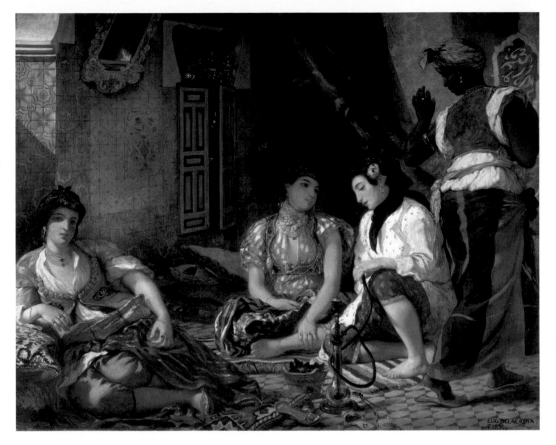

▌ *Delacroix brought back from his trip to Morocco an atmosphere of magic and sensual escape that captured the imagination of the romantics in the "civilised" West.*

▌ *Delacroix bringt von seiner Reise nach Marokko eine magische Atmosphäre und sinnliche Flucht mit, die die Vorstellungswelt der Romantiken im "zivilisierten" Westen bereichern.*

▌ *Delacroix brengt van zijn reis naar Marokko een magische en sensuele sfeer mee, en vervult de verbeelding van de romantici van het "beschaafde" Westen.*

▌ *De su viaje a Marruecos, Delacroix se lleva consigo las atmósferas de evasión mágica y sensual que pueblan el imaginario de los románticos del "civilizado" Occidente.*

◀ **Théodore Chasseriau**
(Santa Bárbara de Samaná, Santo Domingo 1819 - Paris 1856)
*Andromeda and the Nereids*, oil on canvas
*Andromeda wird von den Nereiden an den Felsen gebunden*, Öl auf Leinwand
*Andromeda geketend aan de rots van de Nereïden*, olieverf op doek
*Andrómeda encadenada a la roca por las nereidas*, óleo sobre lienzo
1840
92 x 74 cm / 36.2 x 29.1 in.
Musée du Louvre, Paris

**Eugène Delacroix**
(Charenton-Saint-Maurice, Paris 1798 - Paris 1863)
*Women of Algiers in their Rooms*, oil on canvas
*Die Frauen von Algier in ihrem Gemach*, Öl auf Leinwand
*Vrouwen van Algiers in hun harem*, olieverf op doek
*Mujeres de Argel (en su apartamento)*, óleo sobre lienzo
1834
180 x 229 cm / 70.8 x 90.1 in.
Musée du Louvre, Paris

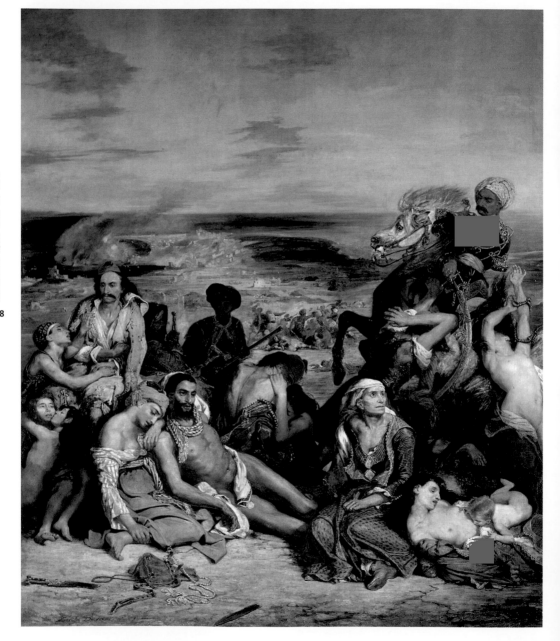

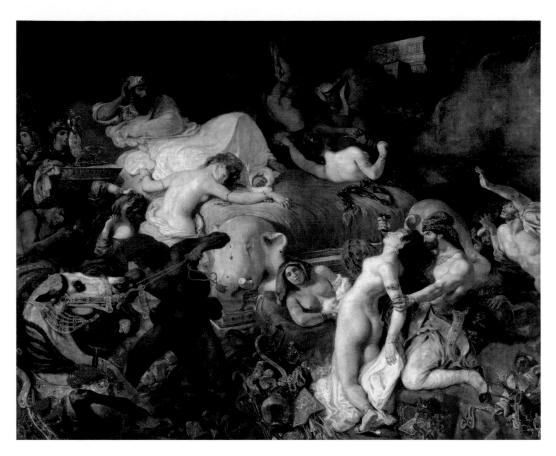

◀ **Eugène Delacroix**
(Charenton-Saint-Maurice, Paris 1798 - Paris 1863)
*The Massacre on Chios*, oil on canvas
*Das Massaker von Chios*, Öl auf Leinwand
*Het bloedbad van Chios*, olieverf op doek
*La matanza de Quíos*, óleo sobre lienzo
1823-1824
417 x 354 cm / 164.1 x 139.3 in.
Musée du Louvre, Paris

**Eugène Delacroix**
(Charenton-Saint-Maurice, Paris 1798 - Paris 1863)
*The Death of Sardanapalus*, oil on canvas
*Der Tod des Sardanapal*, Öl auf Leinwand
*De dood van Sardanapalus*, olieverf op doek
*La muerte de Sardanápalo*, óleo sobre lienzo
1827-1828
395 x 495 cm / 155.5 x 194.8 in.
Musée du Louvre, Paris

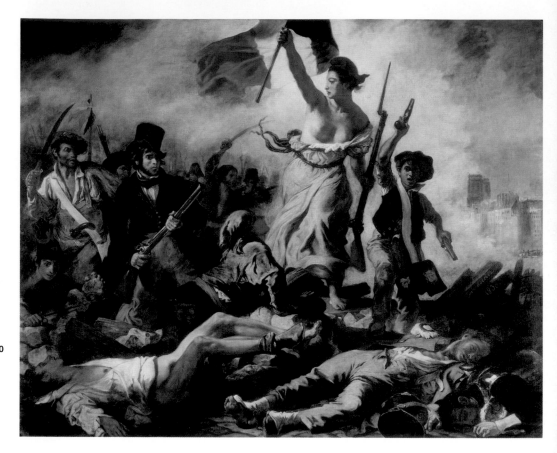

**Eugène Delacroix**
(Charenton-Saint-Maurice, Paris 1798 - Paris 1863)
*Liberty Leading the People* and detail, oil on canvas
*Die Freiheit führt das Volk* und Detail, Öl auf Leinwand
*Vrijheid leidt het volk* en detail, olieverf op doek
*La libertad guiando al pueblo* y detalle, óleo sobre lienzo
1830
260 x 325 cm / 102.3 x 127.9 in.
Musée du Louvre, Paris

▊ *The armed people led by Freedom advances on the barricades:
a contemporary subject in which realistic elements enrich a composition
still based on academic models.*
▊ *Das bewaffnete und von der Freiheit angeführte Volk geht auf die
Barrikaden: Ein aktuelles Sujet, in dem realistische Elemente eine noch
nach den akademischen Vorbildern entworfene Komposition aufwerten.*
▊ *De gewapende en door Vrijheid geleide mensen op de barricaden:
een hedendaags onderwerp waarin realistische elementen een naar
academisch voorbeeld opgezette compositie verrijken.*
▊ *La libertad guiando al pueblo: un tema contemporáneo en el cual
los elementos realistas enriquecen una composición estudiada
todavía según modelos académicos.*

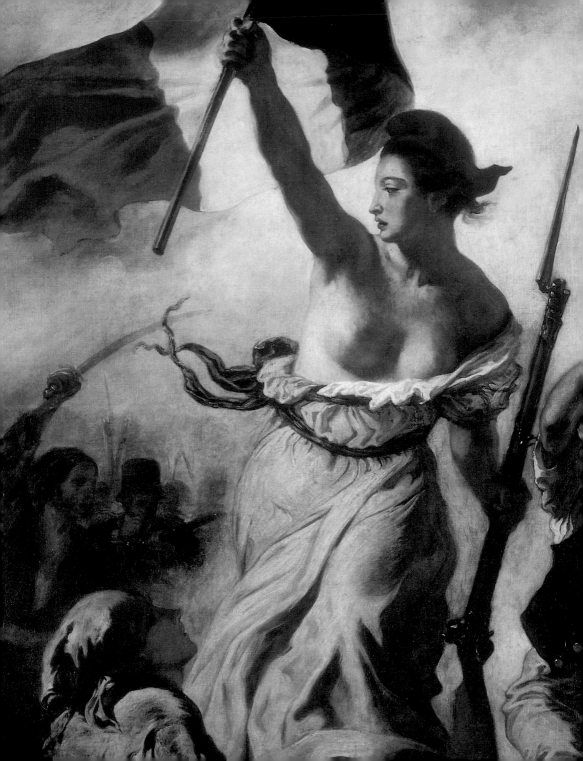

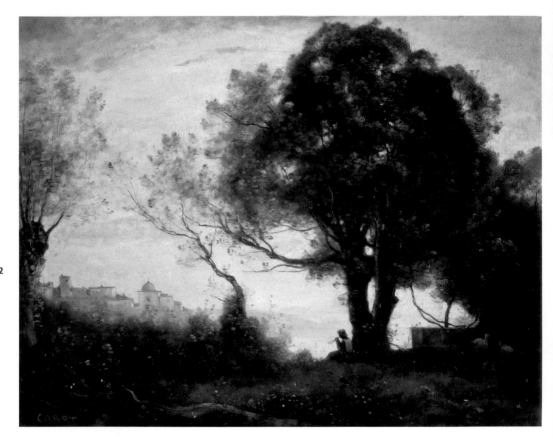

**Jean-Baptiste Camille Corot**
*Memories of Italy: Castelgandolfo*, oil on canvas
*Erinnerungen an Italien: Castelgandolfo*, Öl auf Leinwand
*Herinneringen aan Italië: Castelgandolfo*, olieverf op doek
*Recuerdo de Italia: Castelgandolfo*, óleo sobre lienzo
c. 1865
65 x 81 cm / 25.5 x 31.8 in.
Musée du Louvre, Paris

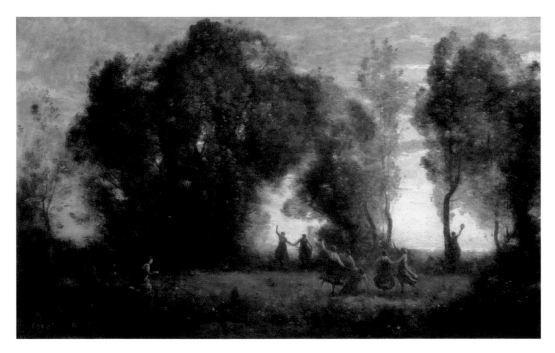

**Jean-Baptiste Camille Corot**
(Paris 1796 - 1875)
*Dance of Nymphs*, oil on canvas
*Tanz der Nymphen*, Öl auf Leinwand
*Dans van nimfen*, olieverf op doek
*La danza de las ninfas*, óleo sobre lienzo
c. 1860
47 x 77 cm / 18.5 x 30.3 in.
Musée d'Orsay, Paris

▌ *Corot's landscapes are brightened by a calm, diffuse Mediterranean light that imbues them with contemplative serenity and a feeling of timelessness.*
▌ *Die Landschaften von Corot sind von einem mediterranen, ruhigen und weiten Licht aufgehellt, das ihnen eine beschauliche Heiterkeit verleiht, die sie von der Zeit entrückt.*
▌ *Corots landschappen worden beschenen door een rustig en diffuus mediterraan licht, waardoor ze een contemplatieve sereniteit krijgen die ze tijdloos maakt.*
▌ *Los paisajes de Corot están iluminados por una luz mediterránea, calma y difusa, que les otorga una serenidad contemplativa, como suspendiéndolos en un sitio sin tiempo.*

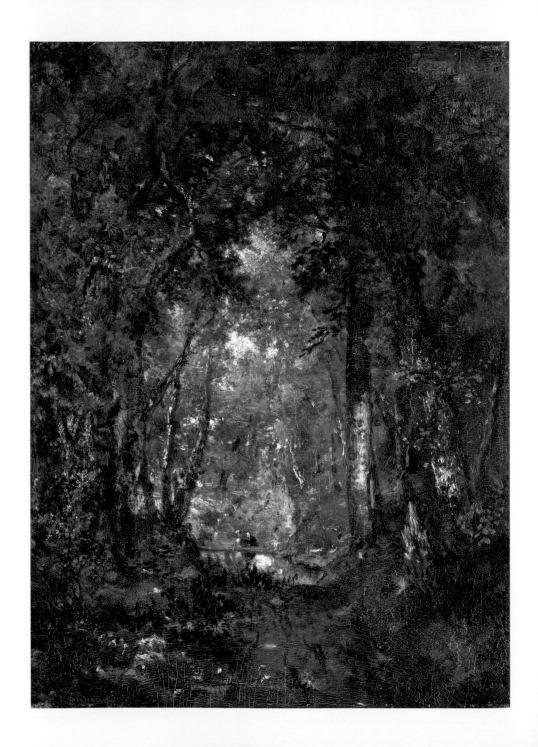

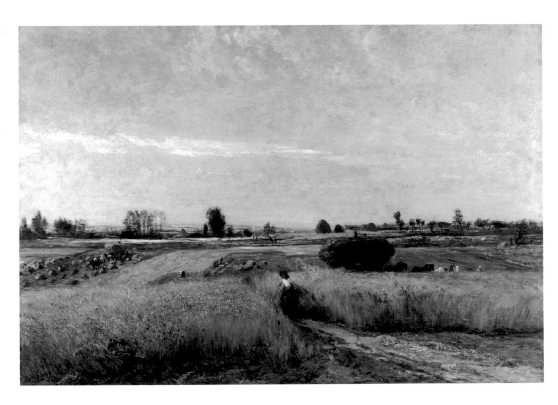

◀ **Théodore Rousseau**
(Paris 1812 - Barbizon 1867)
*In the Forest of Fontainebleau*, oil on wood
*Der Wald von Fontainebleau*, Öl auf Tafel
*In het bos van Fontainebleau*, olieverf op tablet
*En el bosque de Fontainebleau*, óleo sobre tabla
40,5 x 30 cm / 15.9 x 11.8 in.
Hamburger Kunsthalle, Hamburg

**Charles-François Daubigny**
(Paris 1817 - 1878)
*Harvest Time*, oil on canvas
*Die Ernte*, Öl auf Leinwand
*De oogst*, olieverf op doek
*Cosecha*, óleo sobre tabla
1851
135 x 196 cm / 53.1 x 77.1 in.
Musée d'Orsay, Paris

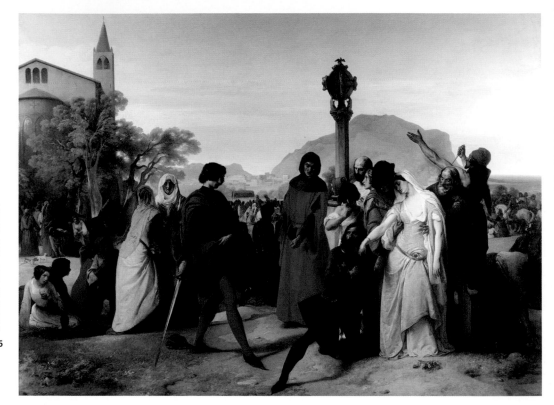

▌ Individual and ideal Risorgimento sentiments of love of country provide Hayez, the principal champion of Italian historical romanticism, with his favourite themes.
▌ Das individuelle Gefühl und das für das Risorgimento typische Ideal von Amor Patrio stellen die Lieblingsthemen der Arbeiten von Hayek dar, dem Hauptvertreter der historischen italienischen Romantik.
▌ Individuele gevoelens en het voor de risorgimento typische ideaal van patriottisme zijn de favoriete thema's van Hayez, de voornaamste exponent van de Italiaanse historische romantiek.
▌ El sentimiento individual y el ideal de amor patriótico inspirado por el Resurgimiento constituyen los temas preferidos de la obra de Hayez, exponente principal del romanticismo histórico italiano.

**Francesco Hayez**
(Venezia 1791 - Milano 1882)
The Sicilian Vespers, oil on canvas
Sizilianische Abende, Öl auf Leinwand
Siciliaanse Vespers, olieverf op doek
Las vísperas sicilianas, óleo sobre lienzo
1845-1846
255 x 300 cm / 100.3 x 118.1 in.
Galleria Nazionale di Arte Moderna, Roma

▶ **Francesco Hayez**
(Venezia 1791 - Milano 1882)
The Kiss, oil on canvas
Der Kuss, Öl auf Leinwand
De kus, olieverf op doek
El beso, óleo sobre lienzo
1859
112 x 88 cm / 44 x 34.6 in.
Pinacoteca di Brera, Milano

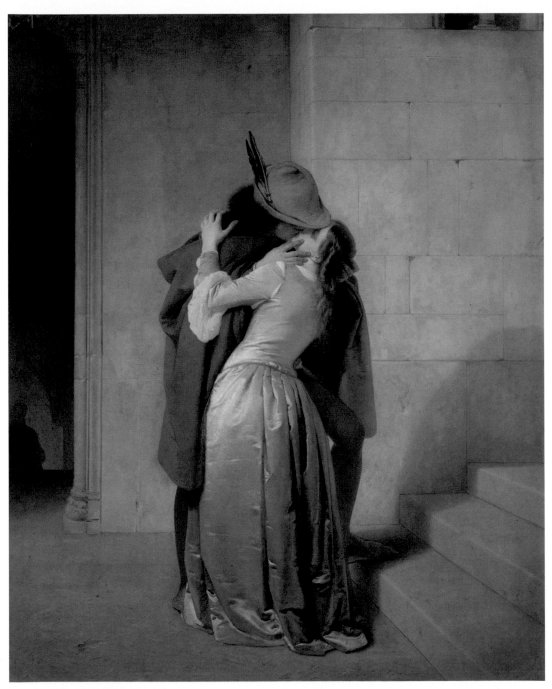

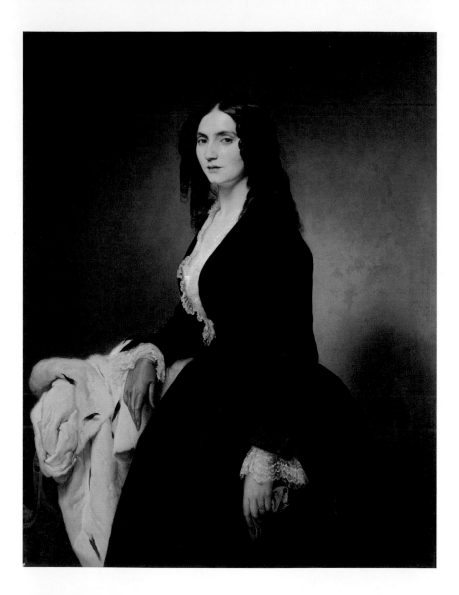

**Francesco Hayez**
(Venezia 1791 - Milano 1882)
*Portrait of Signora Matilde Branca*, oil on canvas
*Porträt der Matilde Juva-Branca*, Öl auf Leinwand
*Portret van dame Matilde Juva-Branca*, olieverf op doek
*Matilde Juva-Branca*, óleo sobre lienzo
1851
120 x 94 cm / 47.2 x 37 in.
Galleria d'Arte Moderna, Milano

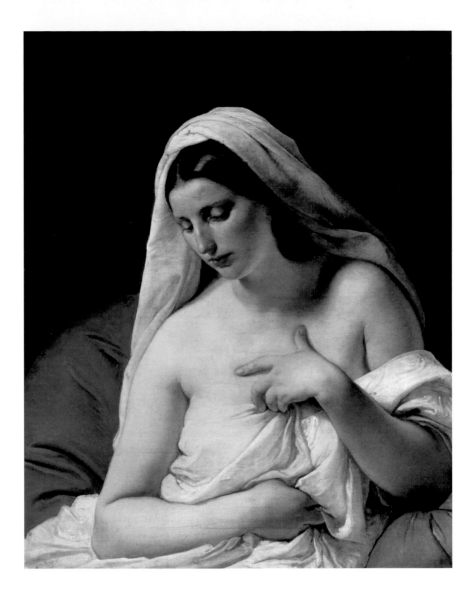

**Francesco Hayez**
(Venezia 1791 - Milano 1882)
*Odalisque*, oil on canvas
*Odaliske*, Öl auf Leinwand
*Odalisk*, olieverf op doek
*Odalisca*, óleo sobre lienzo
1867
82 x 68 cm / 32.2 x 26.7 in.
Pinacoteca di Brera, Milano

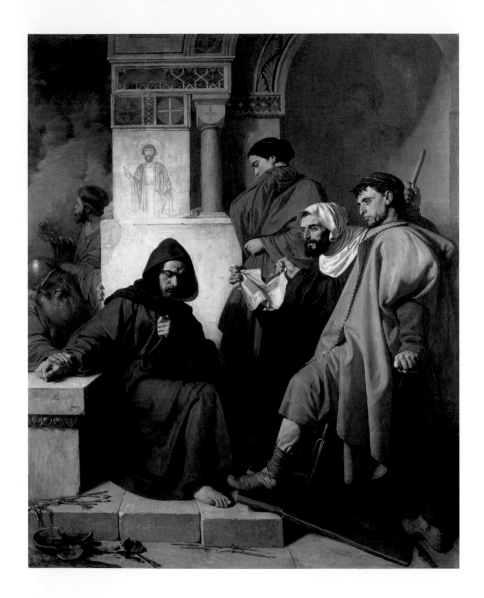

**Domenico Morelli**
(Napoli 1826 - 1901)
*The Iconoclasts*, oil on canvas
*Die Bilderstürmer*, Öl auf Leinwand
*Beeldenstormers*, olieverf op doek
*Los iconoclastas*, óleo sobre lienzo
1855
257 x 212 cm / 101.1 x 83.4 in.
Museo Nazionale di Capodimonte, Napoli

▶ **Domenico Morelli**
(Napoli 1826 - 1901)
*The Sicilian Vespers*, oil on canvas
*Sizilianische Abende*, Öl auf Leinwand
*Siciliaanse Vespers*, olieverf op doek
*Las vísperas sicilianas*, óleo sobre lienzo
1859-1860
264 x 185 cm / 103.9 x 72.8 in.
Museo Nazionale di Capodimonte, Napoli

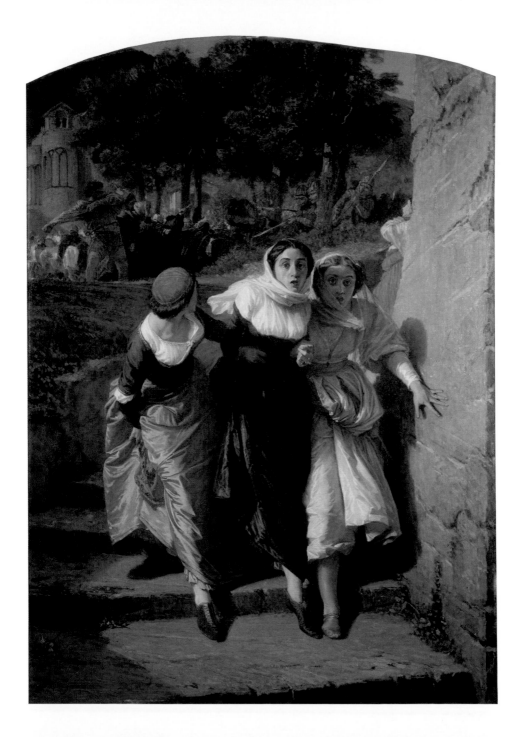

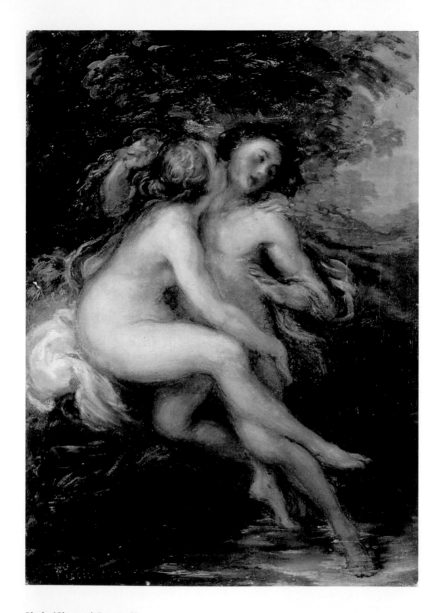

**Piccio (Giovanni Carnovali)**
(Montegrino, Varese 1804 - Cremona 1873)
*Salmacis and Hermaphroditus*, oil on canvas
*Salmacis und Hermaphrodit*, Öl auf Leinwand
*Salmace en Hermafrodiet*, olieverf op doek
*Salmacis y Hermafrodito*, óleo sobre lienzo
1856
Collezione privata, Crema

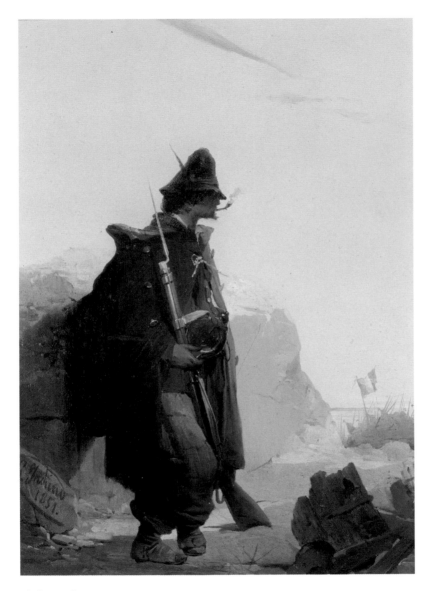

**Girolamo Induno**
(Milano 1825 - 1890)
*Volunteer Defending Rome*, oil on cardboard
*Freiwilliger für die Verteidigung Roms*, Öl auf Karton
*Een vrijwilliger bij de verdediging van Rome*, olieverf op karton
*Un voluntario defendiendo Roma*, óleo sobre cartón
1851
34,5 x 26,5 cm / 13.5 x 10.6 in.
Museo del Risorgimento, Milano

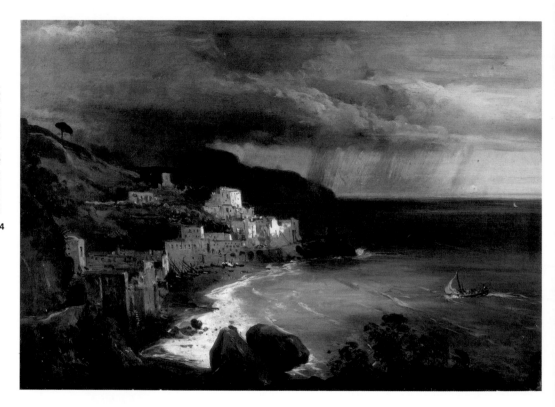

**Giacinto Gigante**
(Napoli 1806 - 1876)
*Storm over the Bay of Amalfi,* oil on canvas
*Die Küste von Amalfi bei Sturm,* Öl auf Leinwand
*Storm op de golf van Amalfi,* olieverf op doek
*Tormenta en el golfo de Amalfi,* óleo sobre lienzo
*c.* 1837
29 x 41 cm / 11.4 x 16.1 in.
Museo Nazionale di Capodimonte, Napoli

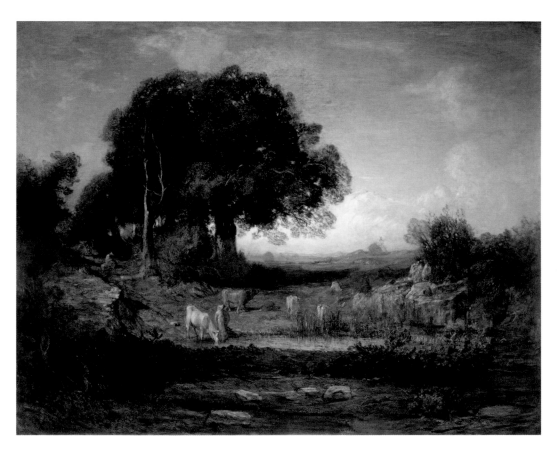

**Antonio Fontanesi**
(Reggio Emilia 1818 - Torino 1882)
*Countryside*, oil on canvas
*Auf dem Land*, Öl auf Leinwand
*Platteland*, olieverf op doek
*Campiña*, óleo sobre lienzo
1867-1868
150 x 190 cm / 59 x 74.8 in.
Galleria d'Arte Moderna, Firenze

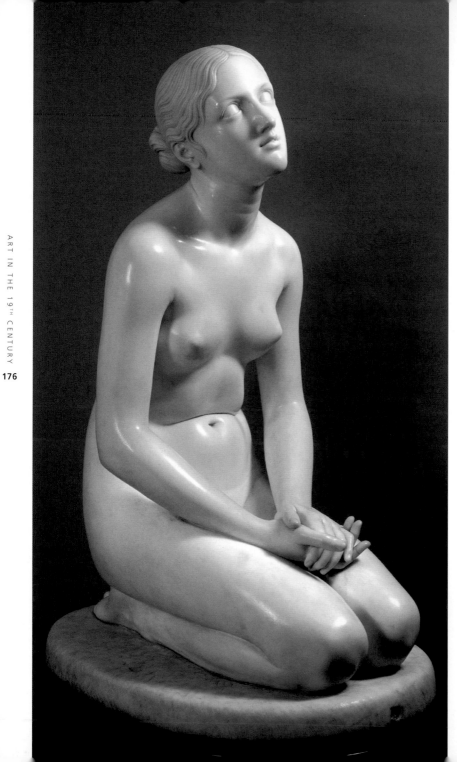

◀ **Lorenzo Bartolini**
(Savignano di Prato 1777
- Firenze 1850)
*Trust in God*, marble
*Der Glaube an Gott*,
Marmor
*Geloof in God*, marmer
*La Fe en Dios*, mármol
1835
93 x 43 x 61 cm
36.6 x 16.9 x 24 in.
Museo Poldi Pezzoli, Milano

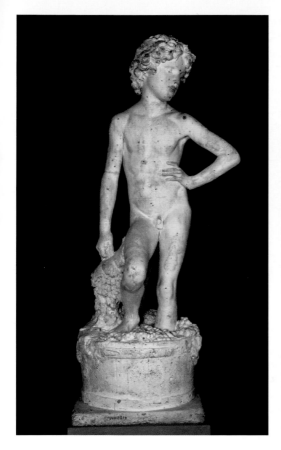

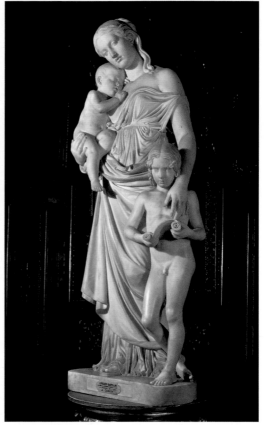

▌ *Purist sculpture: a clean neoclassical line defines figures animated from within by a naturalistic vitality derived from the models of the Quattrocento.*

▌ *Die puristische Skulptur: eine saubere neoklassizistische Linie definiert die Figuren, die in ihrem Innern von einer naturalistischen Lebendigkeit beseelt sind, die von den Vorbildern des italienischen Quattrocento stammen.*

▌ *De puristische beeldhouwkunst: een zuivere, neoklassieke lijn definieert de figuren die zijn bezield met een natuurlijke vitaliteit die is afgeleid van Italiaanse voorbeelden uit de vijftiende eeuw.*

▌ *La escultura purista: una limpia línea neoclásica dota a las figuras animadas en su interior de una vitalidad naturalista que tiene origen en los modelos del Quattrocento italiano.*

**Lorenzo Bartolini**
(Savignano di Prato 1777 - Firenze 1850)
*The Grape masher,* plaster cast
*Der Weinleser,* Gips
*De druivenstamper,* gips
*Niño pisando la uva,* yeso
1818
h. 133 cm / 52.3 in.
Galleria dell'Accademia, Firenze

**Lorenzo Bartolini**
(Savignano di Prato 1777 - Firenze 1850)
*Charity,* marble
*Die erziehende Liebe,* Marmor
*Caritas educatrice,* marmer
*La Caridad educadora,* mármol
1817-1824
h. 181 cm / 71.2 in.
Galleria Palatina, Firenze

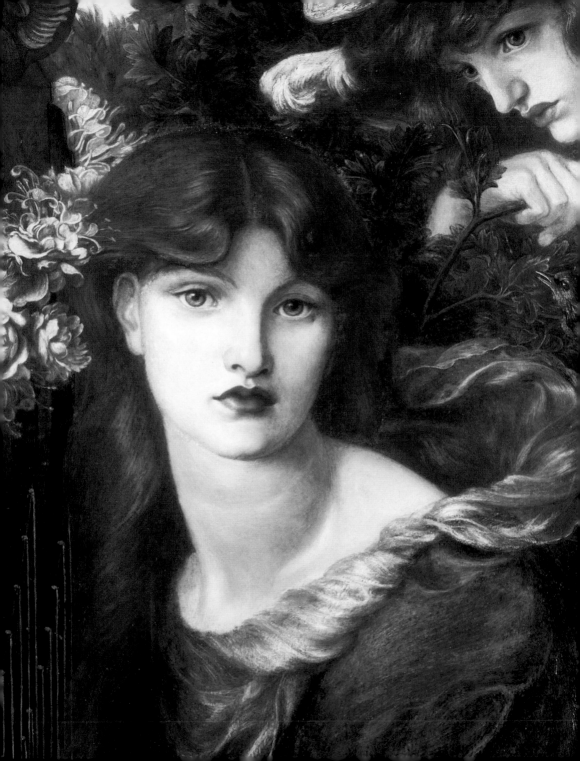

## The Pre-Raphaelites

The Pre-Raphaelite Brotherhood was founded in London in 1848. Inspired by a rejection of academic art, the hidebound conventions of Victorian society and modern industrial development, they consciously modeled their work on art before Raphael. Only thus, they believed, could they recover ethical values, spontaneity and the faithfulness to Nature and "truth" which, in their view, Raphael had betrayed in order to achieve ideal beauty.

## Die Präraffaeliten

1848 entstand in London die Bruderschaft der Präraffaeliten. Inspiriert von dem Wunsch, sich der akademischen Kunst, der Konventionalität der viktorianischen Gesellschaft und der modernen Industrialisierung entgegenzustellen, wurde ihr Vorbild von der Kunst vor der Zeit von Raffael verkörpert: Sie glaubten nur darin die ethischen Werte, Spontaneität und die Beziehung zur Ursprünglichkeit, sowie die "Wahrheit" wiederfinden zu können, die von Raffael durch das Erreichen der ideellen Schönheit verraten wurde.

7

## De Prerafaëlieten

In 1848 werden in Londen de prerafaëlieten opgericht. Gemotiveerd door een sterk gevoel van verzet tegen de academische kunst, de conventionaliteit van de victoriaanse samenleving en de moderne industrialisering, was hun voorbeeld de kunst van voor Raphaël; alleen in die periode dachten ze ethische waarden, spontaniteit en de relatie tot de oorspronkelijkheid zowel als de "waarheid" te kunnen terugvinden, die door Raphaël was verraden door het bereiken van het schoonheidsideaal.

## Los Prerrafaelitas

En 1848 surgió en Londres la Confraternidad de los Prerrafaelitas. Inspirados por un sentimiento de fuerte oposición al arte de las academias, al convencionalismo de la sociedad victoriana y al moderno desarrollo industrial, su modelo estaba representado por el arte que antecedió a Rafael: sólo en este arte creían poder encontrar valores éticos, espontaneidad y una fidelidad a la naturaleza, como así también la "verdad" que a partir de Rafael había sido traicionada para alcanzar la belleza ideal.

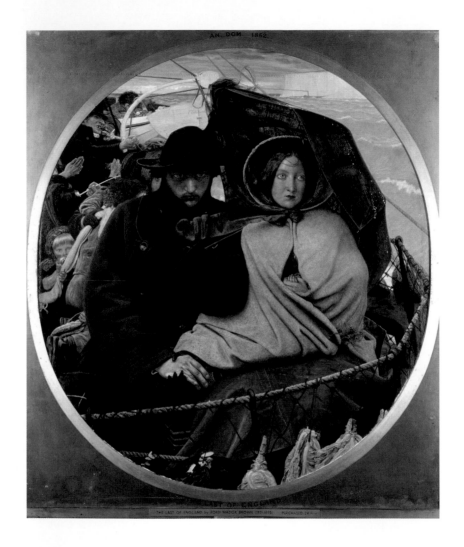

**Ford Madox Brown**
(Calais 1821 - London 1893)
*The Last of England*, oil on panel
*Abschied von Engeland*, Öl auf Tafel
*Afscheid van Engeland*, olie op paneel
*Adiós a Inglaterra*, óleo sobre panel
1852-1855
82,5 x 75 cm / 32.3 x 29.5 in.
City Museum and Art Gallery, Birmingham

▶ **William Holman Hunt**
*The Awakening Conscience*, oil on canvas
*Erwachendes Gewissen*, Öl auf Leinwand
*Het ontwaken van het bewustzijn*, olieverf op doek
*El despertar de la conciencia*, óleo sobre lienzo
1853
76 x 55 cm / 29.9 x 21.6 in.
Tate Gallery, London

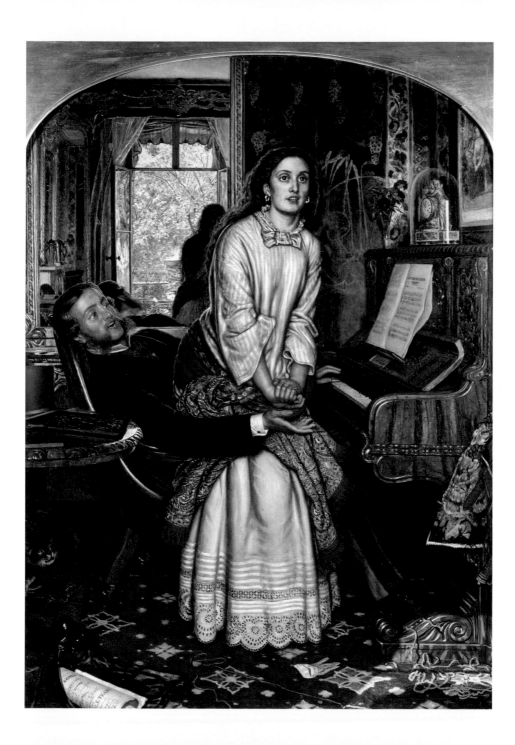

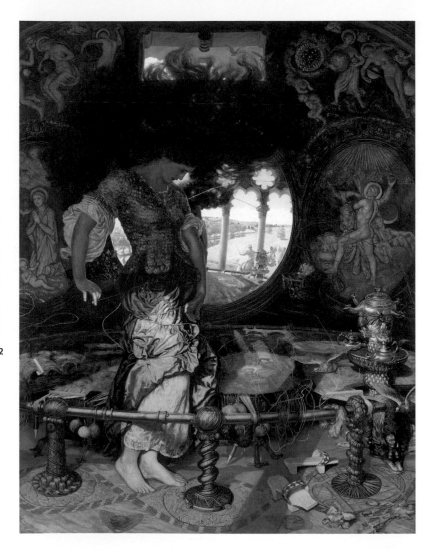

**William Holman Hunt**
(London 1827 - 1910)
*The Lady of Shalott* and detail, oil on canvas
*Lady of Shalott* und Detail, Öl auf Leinwand
*Lady of Shalott* en detail, olieverf op doek
*Lady of Shalott* y detalle, óleo sobre lienzo
1886-1905
188,5 x 146,2 cm / 74.2 x 57.6 in.
Wadsworth Atheneum Museum of Art, Hartford (CT)

▐ *At the cusp of the Nineteenth and Twentieth centuries,*
*Hunt was alone in keeping faith with the principles of the Brotherhood*
*as the pre-Raphaelite lexicon veered towards Art Nouveau.*
▐ *Nur um den Prinzipien der Bruderschaft Treue zu halten wendet sich*
*zwischen dem 19. und 20. Jahrhundert die Lexik der Präraffaeliten in*
*den Bildern von Hunt, dem Stil der Art Nouveau zu.*
▐ *Tussen de negentiende en twintigste eeuw richt de lexicon van de*
*prerafaëlieten in de schilderijen van Hunt zich op de art nouveaustijl,*
*alleen om trouw te blijven aan de beginselen van de broederschap.*
▐ *Entre los siglos XIX y XX, en las pinturas de Hunt,*
*el único que permanece fiel a los principios de la Confraternidad,*
*el léxico prerrafaelita gira hacia el estilo art nouveau.*

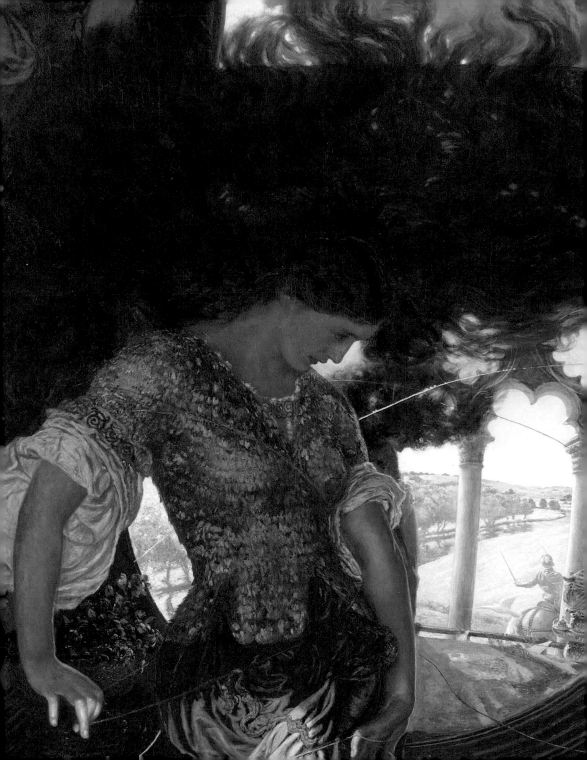

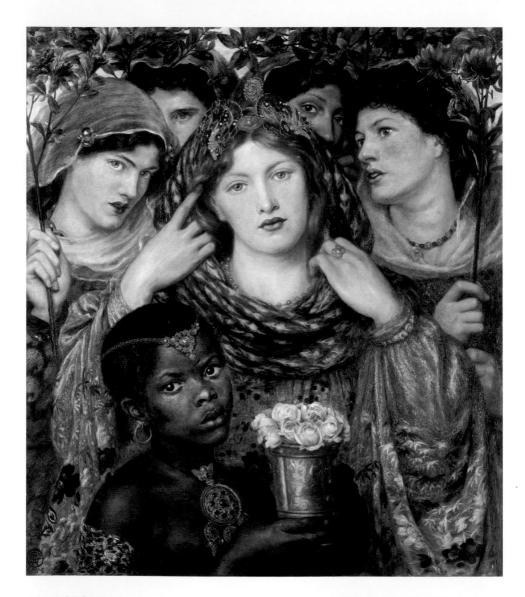

**Dante Gabriel Rossetti**
(London 1828 - Birchington 1882)
*The beloved*, oil on canvas
*Die Braut*, Öl auf Leinwand
*De geliefde*, olieverf op doek
*La novia*, óleo sobre lienzo
c. 1865
82 x 76 cm / 32.2 x 29.9 in.
Tate Gallery, London

▶ **Dante Gabriel Rossetti**
(London 1828 - Birchington 1882)
*La Ghirlandata*
Oil on canvas
Öl auf Leinwand
Olieverf op doek
Óleo sobre lienzo
1873
Guildhall Library and Art Gallery, London

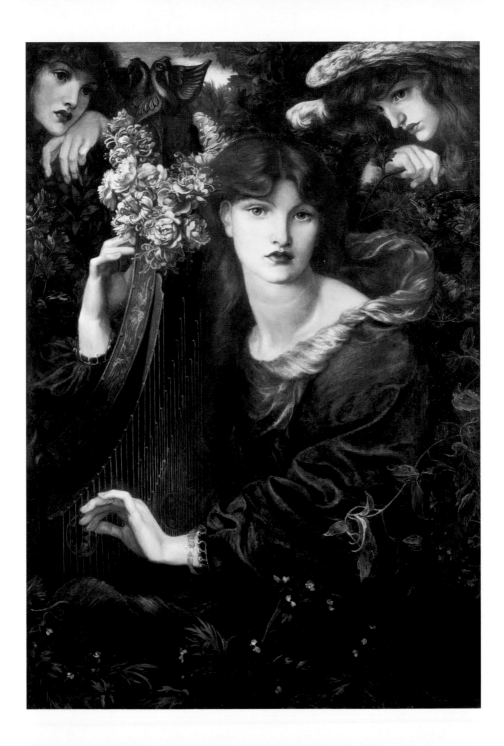

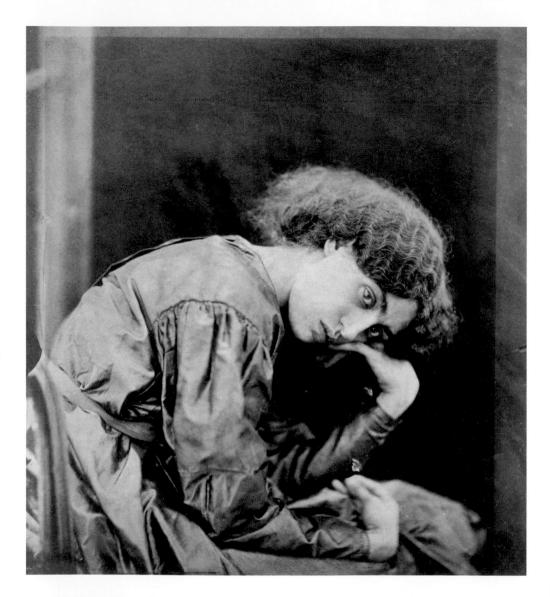

**Dante Gabriel Rossetti**
(London 1828 - Birchington 1882)
*Jane Morris*
Photograph
Fotografie
Foto
Fotografía
1865
Victoria & Albert Museum, London

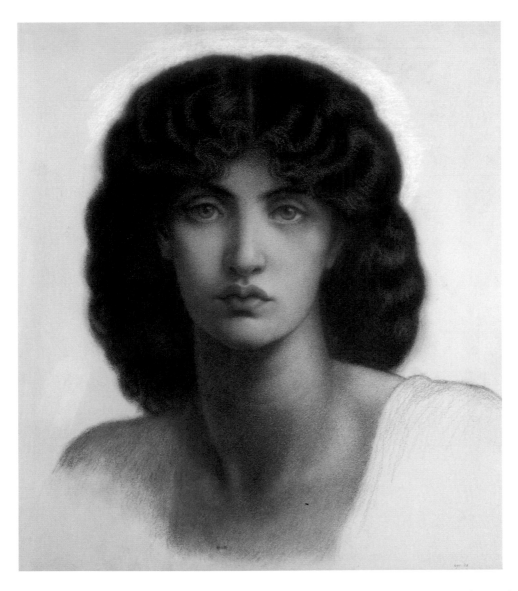

**Dante Gabriel Rossetti**
(London 1828 - Birchington 1882)
*Study for the head for Astarte Syriaca*, pastel
*Studie für den Kopf von Astarte Syriaca*, Pastell
*Studie voor het hoofd van Astarte Syriaca*, pastel
*Estudio para la cabeza de Astarte Syriaca*, pintura al pastel
1875
55 x 45 cm / 21.6 x 17.7 in.
Victoria & Albert Museum, London

▌ *Astarte, Syrian goddess of Love, represents only one of Rossetti's many sublimations of the features of Jane Morris.*
▌ *Astarte, syrische Liebesgöttin, stellt eine der vielen Veredelungen von Rossetti der Charakteristika von Jane Morris dar.*
▌ *Astarte, de Syrische godin van de liefde, vertegenwoordigt slechts een van de vele fraaie portretten van Rossetti met Jane Morris' als model.*
▌ *Astarté, divinidad siríaca del Amor, representa sólo una de las tantas sublimaciones de Rossetti de los rasgos de Jane Morris.*

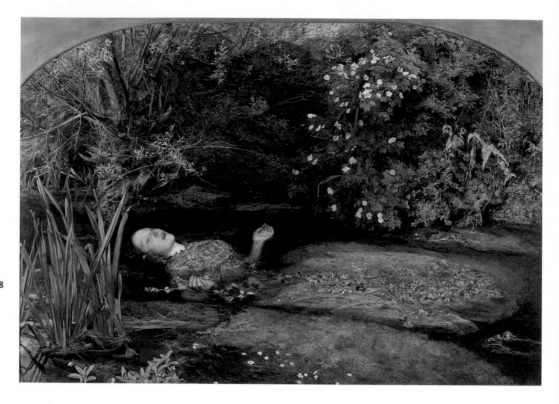

■ *Elizabeth Siddal, the ideal model for the entire Pre-Raphaelite group, floats ghost-like as Ophelia, surrounded by plants and flowers rich in symbolism.*
■ *Elizabeth Siddal, das ideale Beispiel für alle Präraffeliten, schwimmt gespenstisch in der Rolle der Ophelia, die von Pflanzen und Blumen voller symbolischer Andeutungen umgeben ist.*
■ *Elizabeth Siddal, het ideale model voor de prerafaëlieten, drijft spookachtig als Ophelia tussen bloemen en planten die rijk zijn aan symbolische betekenissen.*
■ *Elizabeth Siddal, modelo ideal para todo el grupo de los prerrafaelitas, flota como un espectro en las vestes de Ofelia, rodeada de plantas y flores ricas de alusiones simbólicas.*

**John Everett Millais**
(Southampton 1829 - London 1896)
*Ophelia*, oil on canvas
*Ophelia*, Öl auf Leinwand
*Ophelia*, olieverf op doek
*Ofelia*, óleo sobre lienzo
1852
70 x 110 cm / 27.5 x 43.3 in.
Tate Gallery, London

▶ **John Everett Millais**
(Southampton 1829 - London 1896)
*The Blind Girl*, oil on canvas
*Das blinde Mädchen*, Öl auf Leinwand
*De jonge blinde*, olieverf op doek
*La muchacha ciega*, óleo sobre lienzo
1856
32,5 x 24,5 cm / 12.7 x 9.6 in.
City Museum and Art Gallery, Birmingham

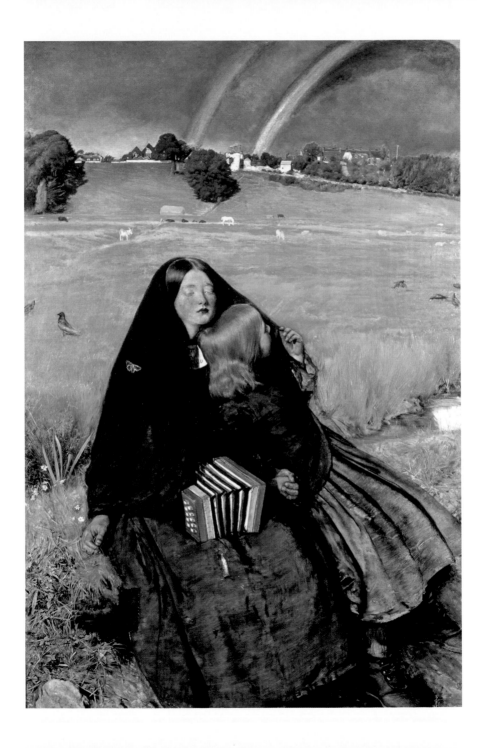

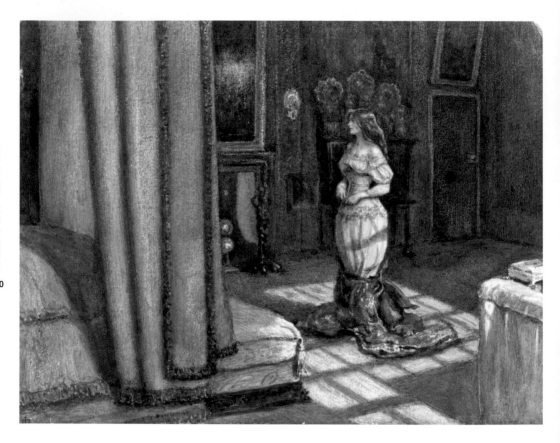

**John Everett Millais**
(Southampton 1829 - London 1896)
*The Eve of St. Agnes*, watercolour
*Der Vorabend von St. Agnes*, Aquarell
*De vooravond van St. Agnes*, aquarel
*La víspera de Santa Inés*, acuarela
1863
20,8 x 27,5 cm / 8.2 x 10.8 in.
Victoria & Albert Museum, London

▶ **John Everett Millais**
(Southampton 1829 - London 1896)
*Portia (Kate Dolan)*
Oil on canvas
Öl auf Leinwand
Olieverf op doek
Óleo sobre lienzo
1886
125,1 x 83,8 cm / 49.2 x 33 in.
The Metropolitan Museum of Art, New York

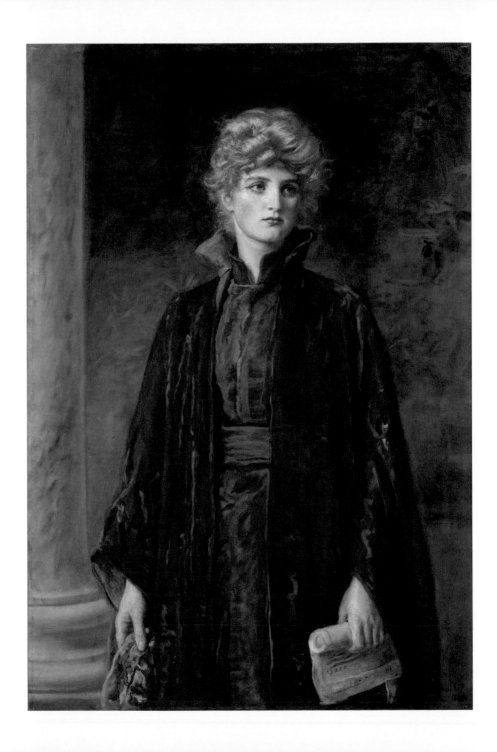

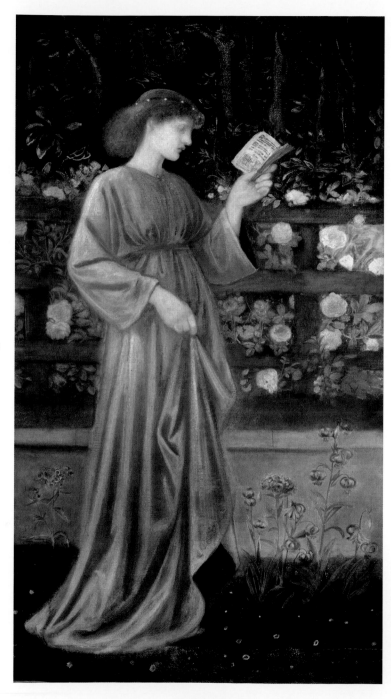

**Edward Coley
Burne-Jones**
(Birmingham 1833 - Fulham 1898)
*Princess Sabra (The King's Daughter)*,
oil on canvas
*Prinzessin Sabra (Die Tochter
des Königs)*, Öl auf Leinwand
*Prinses Sabra (De dochter
van de koning)*, olieverf op doek
*La princesa Sabra (La hija del rey)*,
óleo sobre lienzo
1865-1866
100 x 60 cm / 39.3 x 23.6 in.
Musée d'Orsay, Paris

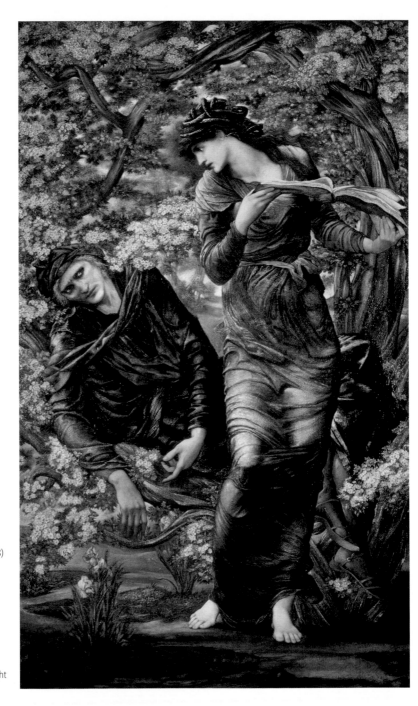

**Edward Coley**
**Burne-Jones**
(Birmingham 1833 - Fulham 1898)
*The Beguiling of Merlin*,
oil on canvas
*The Beguiling of Merlin*,
Öl auf Leinwand
*De magie van Merlijn*,
olieverf op doek
*La seducción de Merlín*,
óleo sobre lienzo
1874
186 x 111 cm / 73.2 x 43.7 in.
Lady Lever Art Gallery, Port Sunlight
(Liverpool)

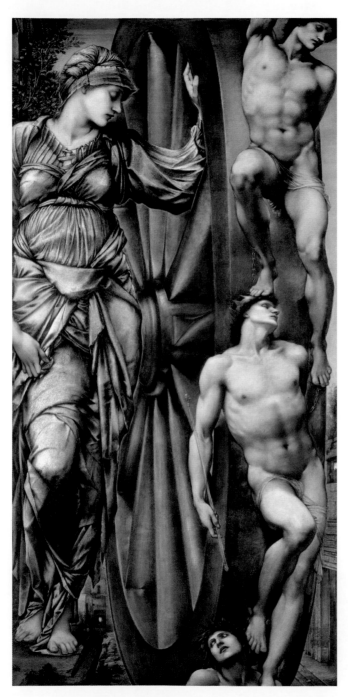

**Edward Coley
Burne-Jones**
(Birmingham 1833 - Fulham 1898)
*The Wheel of Fortune*, oil on canvas
*Das Glücksrad*, Öl auf Leinwand
*Het rad van fortuin*, olieverf op doek
*La rueda de la fortuna*, óleo sobre lienzo
1875
200 x 100 cm / 78.7 x 39.3 in.
Musée d'Orsay, Paris

▶ **Edward Coley
Burne-Jones**
(Birmingham 1833 - Fulham 1898)
*The Golden Stairs*, oil on canvas
*Die goldene Treppe*, Öl auf Leinwand
*De schaal van goud*, olieverf op doek
*La escalera de oro*, óleo sobre lienzo
1876-1880
277 x 117 cm / 109 x 46 in.
Tate Gallery, London

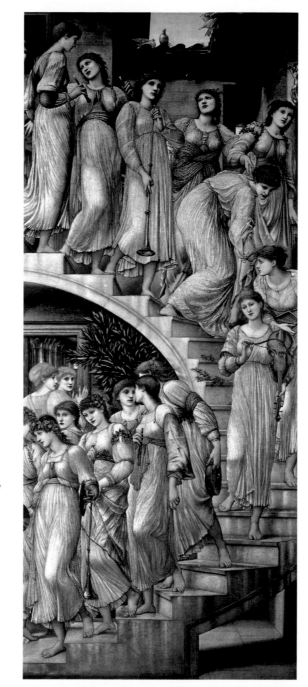

■ *Burne-Jones creates here a painting with a deliberately ambiguous theme, an enigmatic dream in which figures overtly inspired by the Renaissance are perfectly transposed into a symbolist context.*

■ *Burne-Jones verwirklicht ein bewusst zweideutiges Gemälde, ein rätselhafter Traum, in dem sich die Figuren von klarer Rennaissance-Inspiration in einen nahezu symbolistischen Kontext einordnen.*

■ *Een opzettelijk dubbelzinnig schilderij van Burne-Jones, met als thema een raadselachtige droom, waarin de door de renaissance geïnspireerde figuren in een perfecte symbolische context zijn geplaatst.*

■ *Burne-Jones realiza una pintura sobre un tema voluntariamente ambiguo, un enigmático sueño, en el cual las figuras de clara inspiración renacentista se colocan perfectamente en un contexto simbolista.*

**◄ William Morris**
(Walthamstow 1834 - Hammersmith 1896)
*Artichoke*, three-ply machine woven carpeting
*Teppichmuster mit Artischockendekoration*, dreifach gezwirntes Wollgarn
*Voorbeeld van tapijt versierd met artisjokken*, wolgaren met drie koppen
*Muestra de alfombra con diseños de alcachofas*, hilado de lana de tres cabos
c. 1878
113 x 89,5 cm / 44.5 x 35 in.
Victoria & Albert Museum, London

**William Morris**
(Walthamstow 1834 - Hammersmith 1896)
*The Strawberry Thief*, printed cotton
*Der Erdbeerdieb*, Handdruck auf Baumwolle
*De aardbeiendief*
*El ladrón de fresas*, impresión a mano
sobre tapiz de algodón
1883
Stapleton Historical Collection, London

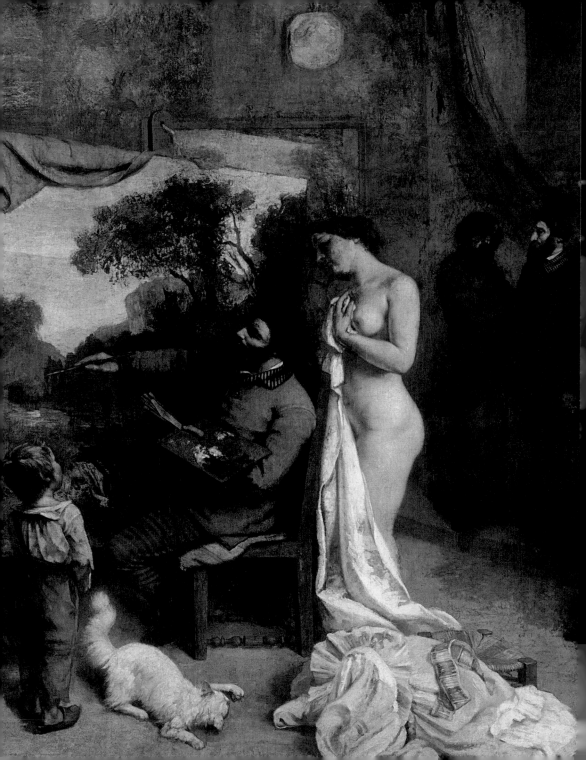

## The birth
## of Realism in France

*While there are already in the
works of Géricault, Daumier, and
Delacroix instances of political
and social commitment and the
faithful observation of daily and
contemporary realities, a more
coherent formulation of realism arose,
again in France, above all from 1848
onwards. It was Courbet who in 1855
defined the new artistic poetics in the
Pavillon du Réalisme. Far from mere
imitation, the artist's aspiration was
to provide a faithful, objective, and
impartial representation of the real
world, grounded in the meticulous
observation of contemporary life.*

## Die Entstehung
## des Realismus in Frankreich

*Auch wenn bereits in den Werken
von Géricault, Daumier und Delacroix
Vorgänger des politischen und sozialen
Engagements und der Nähe zur alltäglichen
und vorherrschenden Realität zu finden
waren, kam es gerade in Frankreich nach
1848 zu einer noch konsequenteren
Formulierung des Realismus. Es war
Courbet, der die neue künstlerische Poesie
innerhalb des Pavillon du Réalisme im Jahr
1855 definierte. Das Bestreben des Künstlers
war nun nicht mehr die schlichte Imitation,
sondern vielmehr die treue, objektive und
unparteiische Wiedergabe der realen Welt,
die auf der sorgfältigen Beobachtung des
zeitgenössischen Lebens beruhte.*

# 8

## De geboorte
## van het realisme in Frankrijk

*Hoewel in de werken van Gericault,
Daumier, Delacroix al voorbeelden
waren te vinden van politiek en sociaal
engagement en een getrouwe weergave
van de dagelijkse, toenmalige realiteit,
ontwikkelde zich na 1848 juist in
Frankrijk een consequenter formulering
van het realisme. Courbet was degene
die wel de nieuwe poëtische kunst in
het Pavillon du Réalisme definieerde in
1855. Een verre van eenvoudige imitatie,
de wens van de kunstenaar is het geven
van een nauwkeurige, objectieve en
onpartijdige weergave in de echte
wereld, gebaseerd op nauwkeurige
observatie van het hedendaagse leven.*

## El nacimiento
## del realismo en Francia

*Aunque ya en las obras de Géricault,
Daumier y Delacroix se pueden encontrar
antecedentes del compromiso político
y social, y de la adhesión a la realidad
cotidiana y contemporánea, una
formulación más coherente del realismo
tuvo lugar, precisamente en Francia,
sobre todo a partir de 1848.
Fue Courbet quien definió la nueva
poética artística dentro del Pabellón del
Realismo de 1855. Hahiéndose alejado
de la simple imitación, la aspiración del
artista es dar una representación fiel,
objetiva e imparcial del mundo real,
fundada en la meticulosa observación
de la vida contemporánea.*

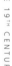

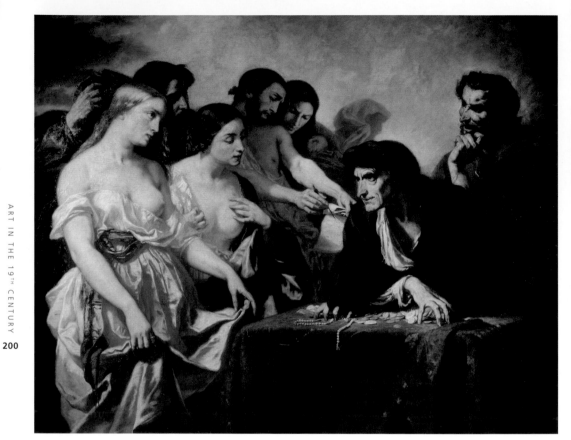

**Thomas Couture**
(Senlis, Oise 1815 - Villiers-le-Bel, Paris 1879)
*The Love of Gold*, oil on canvas
*Die Liebe zum Gold*, Öl auf Leinwand
*De liefde voor goud*, olieverf op doek
*El amor al oro*, óleo sobre lienzo
1844
154 x 188 cm / 60.6 x 74 in.
Musée des Augustins, Toulouse

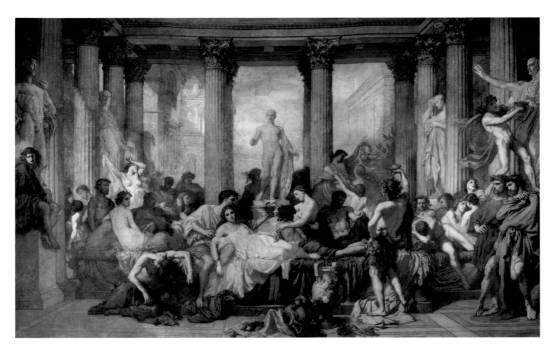

**Thomas Couture**
(Senlis, Oise 1815 - Villiers-le-Bel, Paris 1879)
*The Romans of the Decadence*, oil on canvas
*Die Römer der Verfallszeit*, Öl auf Leinwand
*De Romeinen van het decadentisme*, olieverf op doek
*Los Romanos de la decadencia*, óleo sobre lienzo
1847
466 x 775 cm / 183.4 x 305.1 in.
Musée d'Orsay, Paris

▌ *Couture presents a historical subject, an allegory of contemporary France, employing a realistic aesthetic, while making references to the classics from Veronese and Tiepolo to Poussin.*
▌ *Couture stellt gemäß einer realistischen Ästhetik, die gleichzeitig reich an klassischen Verweisen auf Veronese, Tiepolo und Poussin ist, ein geschichtliches Sujet dar, Allegorie des zeitgenössischen Frankreichs.*
▌ *Couture beeldt overeenkomstig een realistische esthetiek, die rijk is aan klassieke verwijzingen naar Verona, Tiepolo en Poussin, een historisch onderwerp uit, een allegorie van het toenmalige Frankrijk.*
▌ *Couture representa un tema histórico, alegoría de la Francia contemporánea, según una estética realista, rica al mismo tiempo de referencias clásicas: de Veronese y Tiepolo a Poussin.*

**Horace Vernet**
(Paris 1789 - 1863)
*Taking of the Smalah of Abd el-Kader,* oil on canvas
*Die Einnahme der Smalah des Abd-el-Kader,* Öl auf Leinwand
*Bestorming van Smalah van Abd el Kader,* olieverf op doek
*La toma de Smalah de Abd-el-Kader,* óleo sobre lienzo
Musée du Chateau, Versailles

► **Jean-Louis-Ernest Meissonier**
(Lyon 1815 - Paris 1891)
*Barricades in June 1848,* oil on canvas
*Die Barrikade, Rue de la Mortellerie, Juni 1848,* Öl auf Leinwand
*Barricade van juni 1848,* olieverf op doek
*La barricada, rue de la Mortellerie, junio de 1848,* óleo sobre lienzo
1849
29,2 x 22,2 cm / 11.4 x 8.6 in.
Musée du Louvre, Paris

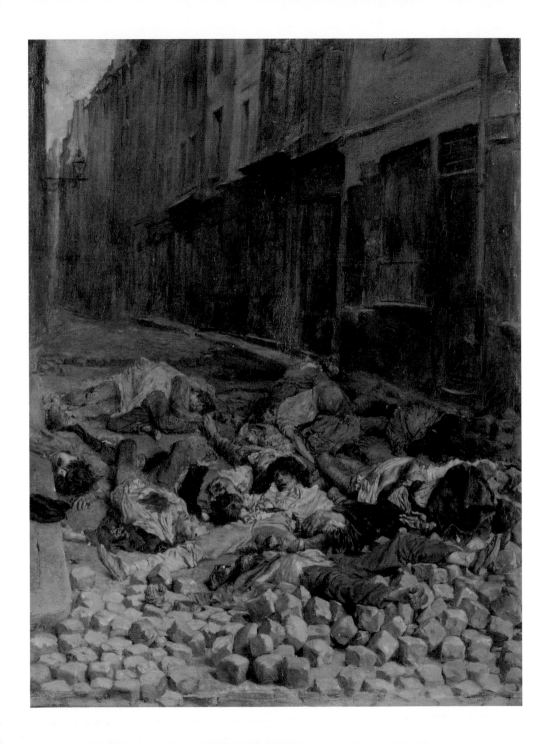

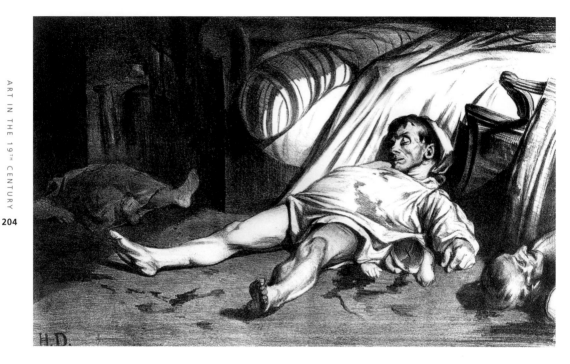

**Honoré Daumier**
(Marseille 1808 - Valmondois 1879)
*The Massacre at Rue Transnonain, 15 April 1834*, lithograph
*Massaker in der Rue Transnonain am 15. April 1834*, Lithografie
*Het bloedbad van Rue Transnonain op 15 april 1834*, lithografie
*La masacre de Rue Transnonain, 15 April 1834*, litografía
1837
36,5 x 55 cm / 14.3 x 21.6 in.
Private collection / Privatsammlung / Privécollectie / Colección privada

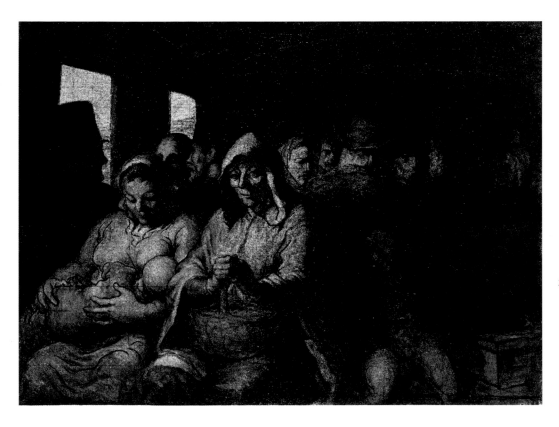

**Honoré Daumier**
(Marseille 1808 - Valmondols 1879)
*The Third-Class Carriage*, oil on canvas
*Wagen dritter Klasse*, Öl auf Leinwand
*Het derdeklasrijtuig klas rijtuig*, olieverf op doek
*El vagón de tercera clase*, óleo sobre lienzo
c. 1862-1864
65,5 x 90 cm / 25.6 x 35.4 in.
The Metropolitan Museum of Art, New York

▮ *The shapeless and almost colourless "mass" of the third class, their gaze lost in space and their features grotesquely outlined, in Daumier's implacably accusing scrutiny of social conditions.*
▮ *Die gestaltlose und nahezu farblose "Masse" der dritten Klasse, mit einem in der Leere verlorenen Blick und mit auf grotteske Weise durchgeführten Linien, wird von Daumier mit unnachsichtig und mit gesellschaftlich anklagend beobachtet.*
▮ *De vormeloze en bijna kleurloze derde klasse, met een lege blik en groteske trekken, zoals waargenomen door Daumier als in een meedogenloze sociale aanklacht.*
▮ *La "masa" informe y casi incolora de la tercera clase, con la mirada perdida en el vacío y los rasgos delineados de manera grotesca, es observada por Daumier con una implacable mirada de denuncia social.*

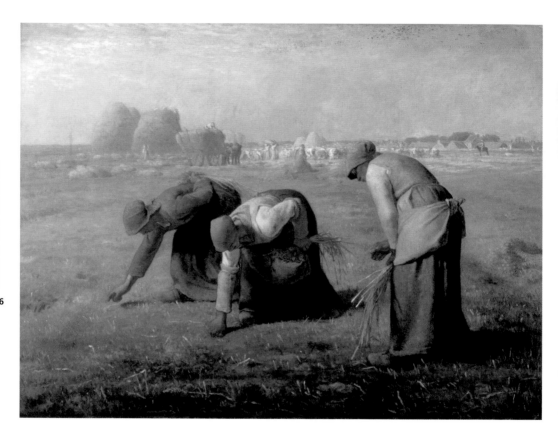

**Jean-François Millet**
(Gruchy 1814 - Barbizon 1875)
*The Gleaners*, oil on canvas
*Die Ährenleserinnen*, Öl auf Leinwand
*De arenleester*, olieverf op doek
*Las espigadoras*, óleo sobre lienzo
1857
83,5 x 111 cm / 33 x 43.7 in.
Musée d'Orsay, Paris

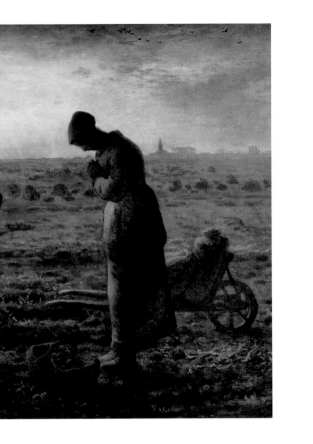

**Jean-François Millet**
(Gruchy 1814 - Barbizon 1875)
*The Angelus*, oil on canvas
*Angelus*, Öl auf Leinwand
*Angelus*, olieverf op doek
*El Angelus*, óleo sobre lienzo
1857-1859
55 x 66 cm / 21.6 x 25.9 in.
Musée d'Orsay, Paris

▌ *Two farmers are shown at the moment work is interrupted
by the ringing of the bells announcing the Angelus.
Millet presents the rural world in an ennobling and heroic light.*
▌ *Zwei Bauern werden in dem Moment gezeigt, in dem sie die Arbeit beim Klang
der Glocken zum Angelus unterbrechen: die Welt auf dem Land ist der edle
und heldenhafte Protagonist der Werke von Millet.*
▌ *Twee boeren op het moment dat hun werk wordt onderbroken door
het klokgelui voor het angelus. Het platteland is het edele en heroïsche
leidmotief in het werk van Millet.*
▌ *Dos campesinos son representados en el momento de la interrupción
del trabajo al tocar las campanas que anuncian el Ángelus: el mundo rural
es protagonista en la obra de Millet, con una visión ennoblecedora y heroica.*

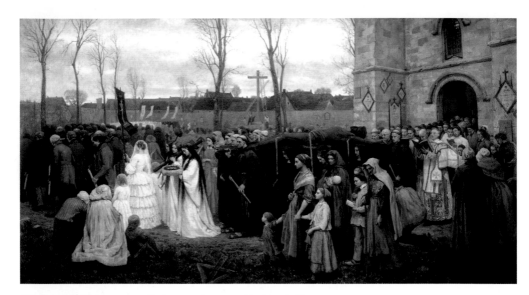

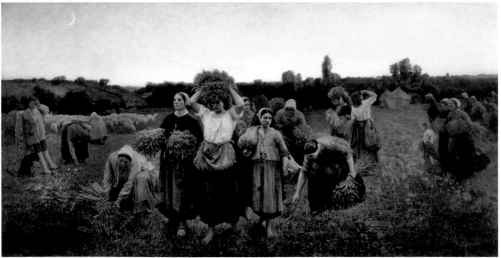

**Jules Breton**
(Courrières 1827 - Paris 1906)
*Erecting a Calvary*, oil on canvas
*Die Inszenierung eines Leidenswegs, Prozession*
*vor einer bretonischen Kirche*, Öl auf Leinwand
*De enscenering van een lijdensweg, processie voor*
*een Bretonse kerk*, olieverf op doek
*El montaje de una procesión* (boceto), óleo sobre lienzo
1858
135 x 250 cm / 53.1 x 98.4 in.
Musée des Beaux-Arts, Lille

**Jules Breton**
(Courrières 1827 - Paris 1906)
*Calling in the Gleaners* and detail, oil on canvas
*Rückkehr der Ährenleserinnen* und Detail, Öl auf Leinwand
*Het terugroepen van de arenleesters* en detail, olieverf op doek
*El llamamiento de las espigadoras* y detalle, óleo sobre lienzo
1859
90 x 176 cm / 35.4 x 69.2 in.
Musée d'Orsay, Paris

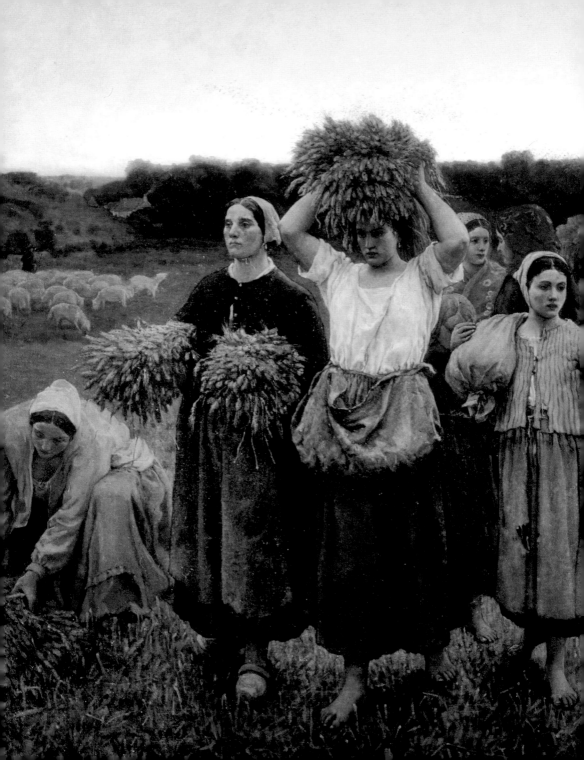

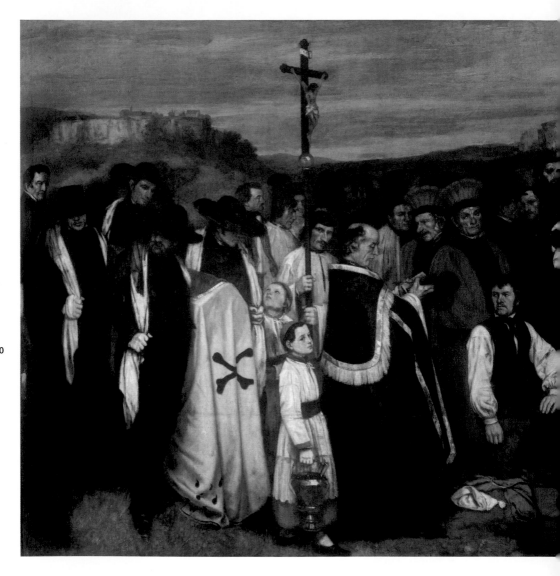

**Gustave Courbet**
(Ornans 1819 - La Tour-de-Peilz, Vevey 1877)
*The Burial at Ornans*, oil on canvas
*Ein Begräbnis in Ornans*, Öl auf Leinwand
*Begrafenis in Ornans*, olieverf op doek
*Un entierro en Ornans*, óleo sobre lienzo
1849
315 x 668 cm / 124 x 263 in.
Musée d'Orsay, Paris

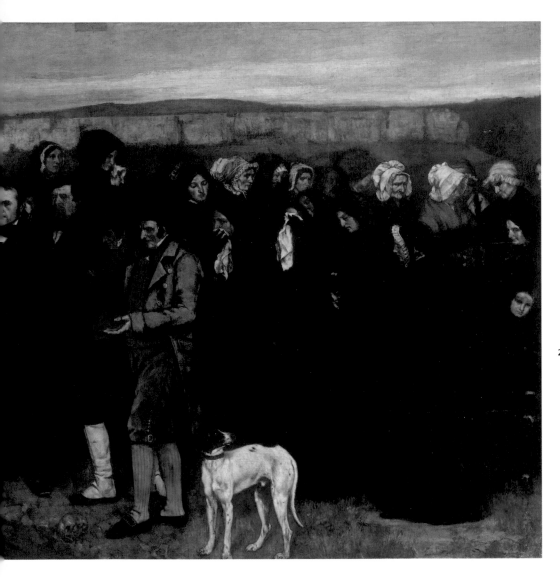

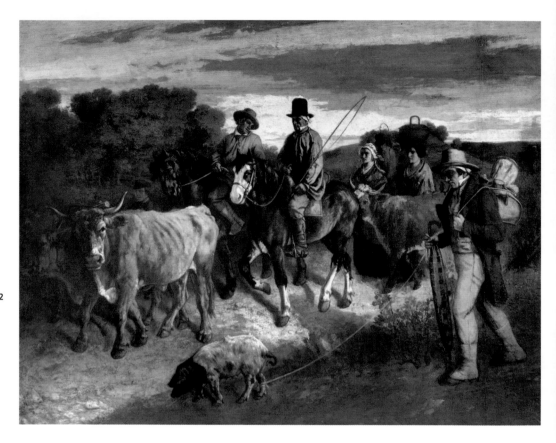

## Gustave Courbet

(Ornans 1819 - La Tour-de-Peilz, Vevey 1877)
*Farmers of Flagey on the Return
from the Market*, oil on canvas
*Bauern von Flagey bei der Rückkehr
vom Markt*, Öl auf Leinwand
*Boeren van Flagey komen terug
van een beurs*, olieverf op doek
*Los campesinos de Flagey
volviendo de una feria*, óleo sobre lienzo
1850-1855
205 x 275 cm / 80.7 x 108.2 in.
Musée des Beaux-Arts, Besançon

▌ *Courbet represents a daily and banal reality without embellishing it:
his father and some fellow citizens dressed as farmers return from a fair as
though they were in a slow procession.*
▌ *Ohne die tägliche und banale Realität zu bekämpfen, zeigt Courbet sie:
Sein Vater und einige Mitbürger in der Bauernkleidung kehren
wie in einer langsamen Prozession vom Markt zurück.*
▌ *Courbet toont een dagelijkse, banale realiteit, zonder verfraaiingen:
zijn vader en enkele burgers in boerenkleding, keren in een langzame stoet
terug van de markt.*
▌ *Courbet representa una realidad cotidiana y simple sin embellecerla:
su padre y algunos conciudadanos con trajes de campesinos
vuelven de una feria como en una lenta procesión.*

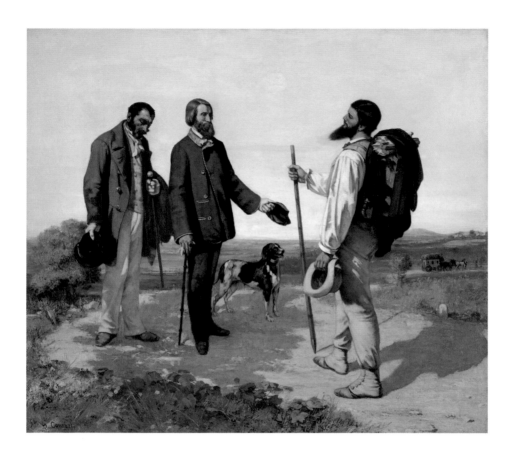

**Gustave Courbet**
(Ornans 1819 - La Tour-de-Peilz, Vevey 1877)
*The Meeting* or *Bonjour, Monsieur Courbet*, oil on canvas
*Das Treffen* oder *Guten Tag, Monsieur Courbet*, Öl auf Leinwand
*De ontmoeting* of *Goedendag Monsieur Courbet*, olieverf op doek
*El encuentro* o *Buenos días señor Courbet*, óleo sobre lienzo
1854
129 x 149 cm / 50.7 x 58.6 in.
Musée Fabre, Montpellier

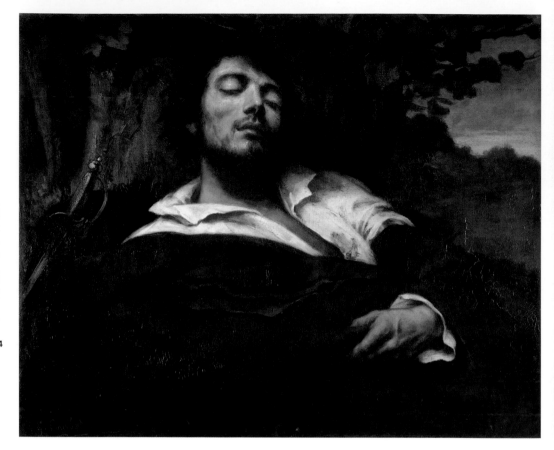

**Gustave Courbet**
(Ornans 1819 - La Tour-de-Peilz, Vevey 1877)
*Wounded Man*, oil on canvas
*Der Verletzte*, Öl auf Leinwand
*Gewonde man*, olieverf op doek
*El hombre herido*, óleo sobre lienzo
1844-1854
81 x 97 cm / 31.8 x 38.1 in.
Musée d'Orsay, Paris

▶ **Gustave Courbet**
(Ornans 1819 - La Tour-de-Peilz, Vevey 1877)
*Man with a Pipe*, oil on canvas
*Mann mit Pfeife*, Öl auf Leinwand
*Man met de pijp*, olieverf op doek
*El hombre de la pipa*, óleo sobre lienzo
1849
45 x 37 cm / 17.7 x 14.5 in.
Musée Fabre, Montpellier

▶ **Gustave Courbet**
(Ornans 1819 - La Tour-de-Peilz, Vevey 1877)
*The Artist's Studio*, oil on canvas
*Das Atelier des Malers*, Öl auf Leinwand
*Atelier van de schilder*, olieverf op doek
*El taller del pintor*, óleo sobre lienzo
1855
361 x 598 cm / 142.1 x 235.4 in.
Musée d'Orsay, Paris

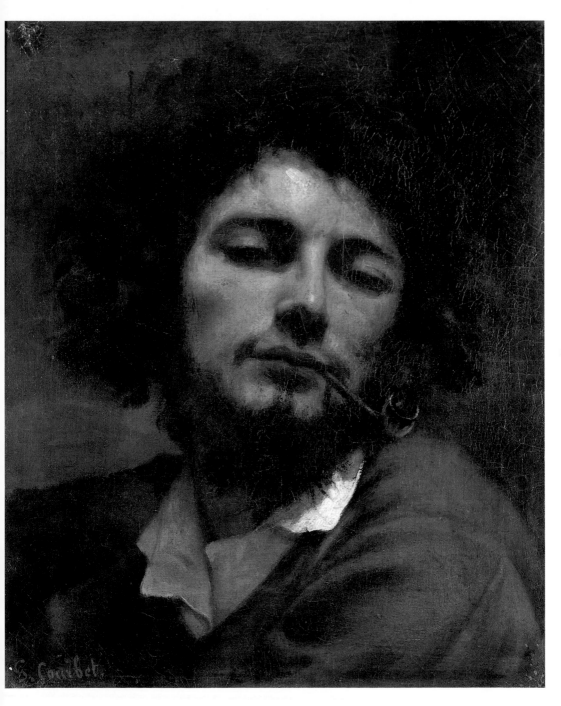

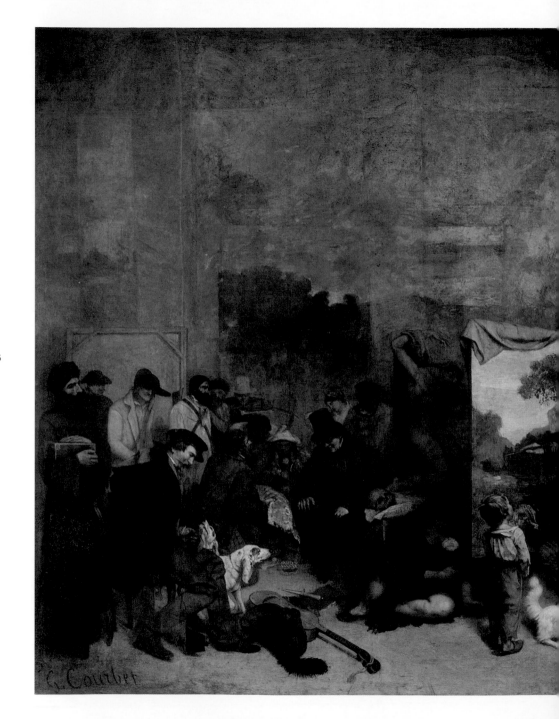

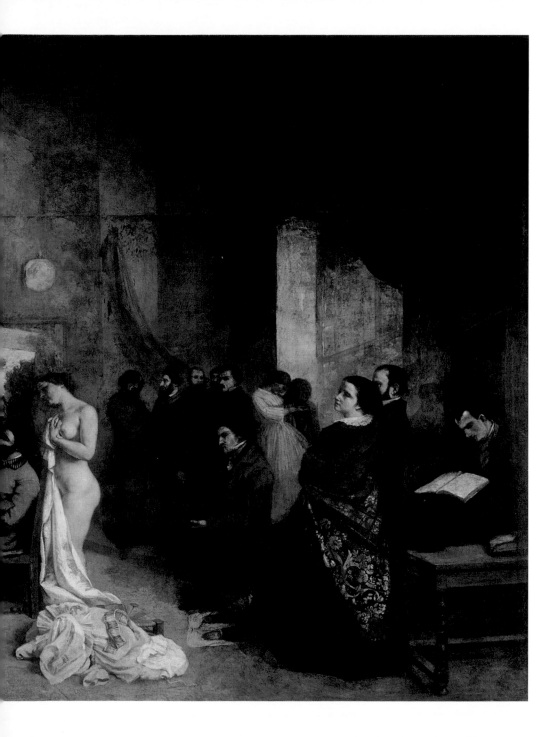

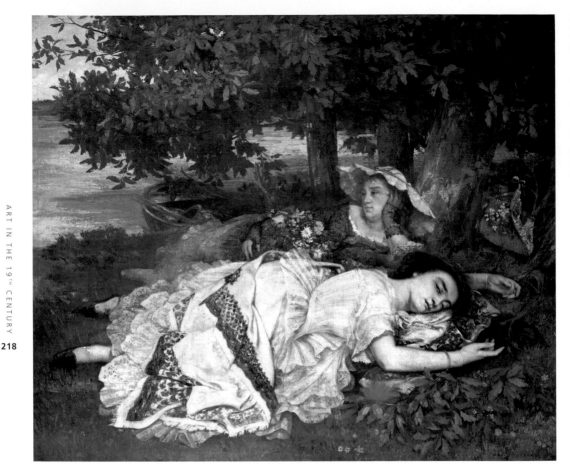

**Gustave Courbet**
(Ornans 1819 - La Tour-de-Peilz, Vevey 1877)
*Young Ladies on the Banks of the Seine*, oil on canvas
*Mädchen am Seineufer*, Öl auf Leinwand
*Meisjes aan de oevers van de Seine*, olieverf op doek
*Cortesanas al borde del Sena*, óleo sobre lienzo
1856
174 x 206 cm / 68.5 x 81.1 in.
Musée du Petit Palais, Paris

▌ *Two ladies of easy virtue lie on the banks of the Seine: a subject hitherto confined to cheap prints is elevated to large format painting and enriched with innumerable suggestive references.*
▌ *Zwei Mädchen in "skandalösen" Kleidern ruhen am Seineufer: Ein bisher auf den Druck für das Volk begrenztes Sujet wird zu einem Gemälde in großem Format aufgewertet und mit zahlreichen anzüglichen Hinweisen bereichert.*
▌ *Twee meisjes in "schandaleuze" kostuums op de oever van de Seine: een tot dan toe tot volksprenten beperkt gebleven onderwerp, wordt in grote schilderijen verwerkt, verrijkt met talloze suggestieve verwijzingen.*
▌ *Dos muchachas con escandalosos "costumbres" recostadas a orillas del Sena: un tema hasta entonces confinado a las estampas populares se eleva así al nivel de la pintura de gran formato y se enriquece con numerosas referencias alusivas.*

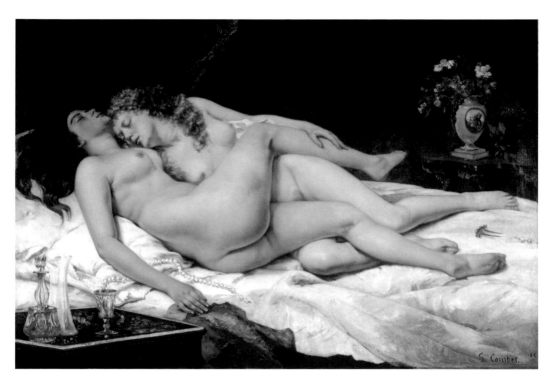

**Gustave Courbet**
(Ornans 1819 - La Tour-de-Peilz, Vevey 1877)
*The Sleepers*, oil on canvas
*Der Schlaf*, Öl auf Leinwand
*De slaap*, olieverf op doek
*El sueño* o *Las amigas* o *Pereza y lujuria*, óleo sobre lienzo
1866
135 x 200 cm / 53.1 x 78.7 in.
Musée du Petit Palais, Paris

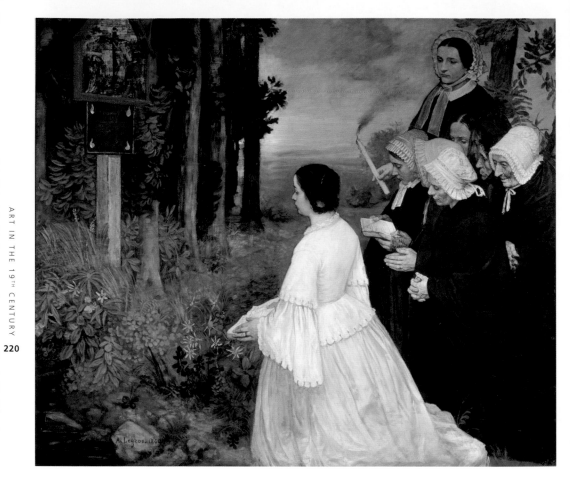

**Alphonse Legros**
(Dijon 1837 - Watford 1911)
*Ex Voto*, oil on canvas
*Ex-voto*, Öl auf Leinwand
*Ex-voto*, olieverf op doek
*Ex-voto*, óleo sobre lienzo
1861
174 x 197 cm / 68.5 x 77.5 in.
Musée des Beaux-Arts, Dijon

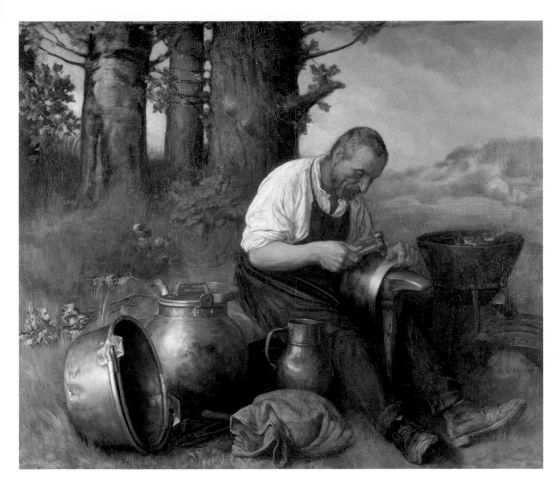

**Alphonse Legros**
(Dijon 1837 - Watford 1911)
*The Tinker,* oil on canvas
*Der Kesselflicker,* Öl auf Leinwand
*De ketellapper,* olieverf op doek
*El reparador de ollas,* óleo sobre lienzo
1874
115 x 132,5 cm / 45.2 x 52.1 in.
Victoria & Albert Museum, London

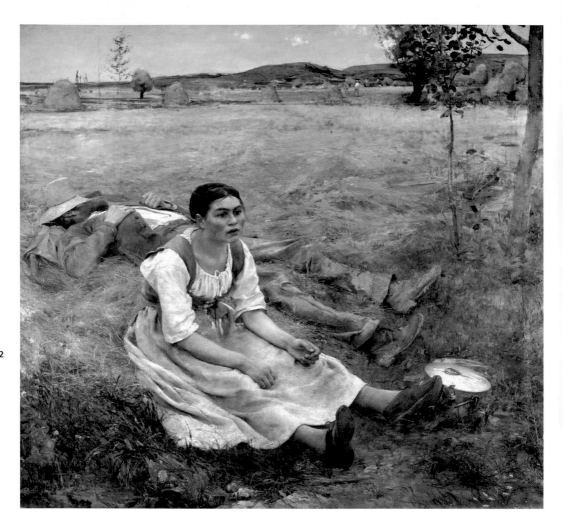

**Jules Bastien-Lepage**
(Damvillers, Meuse 1848 - Paris 1884)
*Hay Making*, oil on canvas
*Heuernte*, Öl auf Leinwand
*Hooi*, olieverf op doek
*La cosecha*, óleo sobre lienzo
1877
180 x 195 cm / 70.8 x 76.7 in.
Musée d'Orsay, Paris

▌ *A masterpiece of naturalism transposed to a pictorial setting:*
*that is how Zola spoke of the repose of Bastien-Lepage's worn out and prostrate farmers.*
▌ *Das Meisterwerk des Naturalismus auf die Malerei übertragen:*
*So zeigte Zola die Erholung der zerschlagenen und erschöpften Bauern in Bastien-Lepage.*
▌ *Een in de schilderkunst geïntroduceerd meesterwerk van naturalisme:*
*zo toont Zola de uitrustende en uitgeputte boeren bij Bastien-Lepage.*
▌ *La obra maestra del naturalismo llevada al ámbito pictórico:*
*así Zola definió el reposo de los campesinos agotados y consumidos de Bastien-Lepage.*

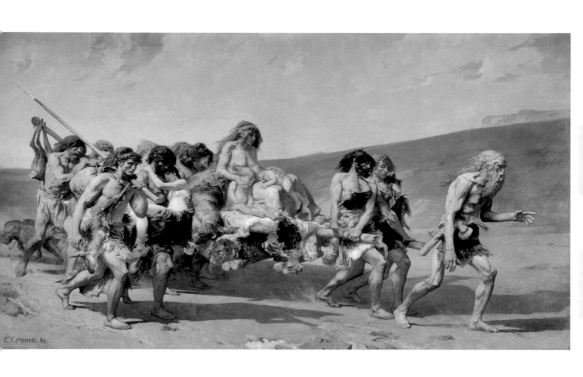

**Fernand Cormon**
(Paris 1845 - 1924)
*Cain*, oil on canvas
*Kain*, Öl auf Leinwand
*Kaïn*, olieverf op doek
*Caín*, óleo sobre lienzo
1880
400 x 700 cm / 157.4 x 275.6 in.
Musée d'Orsay, Paris

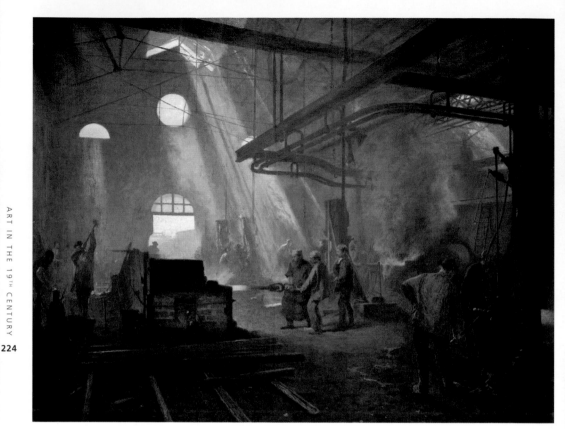

**Fernand Cormon**
(Paris 1845 - 1924)
*An Iron Foundry* and detail, oil on canvas
*Die Gießerei* und Detail, Öl auf Leinwand
*De gieterij* en detail, olieverf op doek
*La fragua* y detalle, óleo sobre lienzo
1893
72 x 90 cm / 28.3 x 35.43 in.
Musée d'Orsay, Paris

▌ *Specialising in prehistoric scenes and religious subjects,*
*Cormon deals in this painting with an aspect of modern life,*
*in which natural light and fire play a fundamental role.*
▌ *Auf prähistorische Szenen und religöse Sujets spezialisiert behandelt*
*Cormon in diesem Gemälde einen Aspekt des modernen Lebens,*
*in dem das natürliche Licht und das Feuer eine grundlegende Rolle spielen.*
▌ *Cormon, gespecialiseerd in prehistorische taferelen en religieuze onderwerpen,*
*Cormon behandelt in dit schilderij is een aspect van het moderne leven,*
*waarin het natuurlijke licht en vuur een belangrijke rol spelen.*
▌ *Especializado en escenas prehistóricas y temas religiosos,*
*Cormon trata en esta pintura un aspecto de la vida moderna,*
*en el cual la luz natural y la del fuego juegan un rol fundamental.*

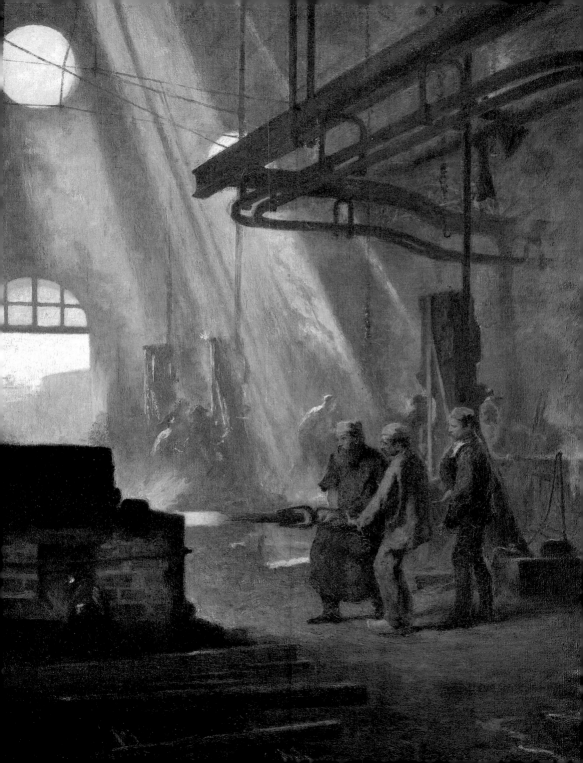

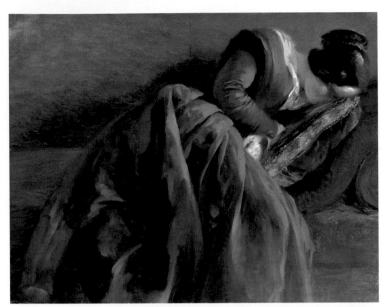

**Adolf von Menzel**
(Breslau 1815 - Berlin 1905)
*The Artist's Sister Emilie Sleeping*, oil
on paper laid down
on canvas
*Die schlafende Schwester
des Künstlers*, Öl auf Papier,
auf Leinwand angebracht
*Zus van de artiest die slaapt*,
olieverf op papier op doek geplakt
*Emilie Menzel dormida*, óleo sobre
papel pegado sobre tela
c. 1848
46,8 x 60 cm / 18.5 x 23.6 in.
Hamburger Kunsthalle, Hamburg

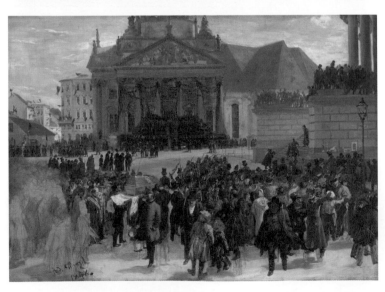

**Adolf von Menzel**
(Breslau 1815 - Berlin 1905)
*Victims of the March Revolution in
Berlin Lying in State* and detail, oil on
canvas
*Aufbahrung der Märzgefallenen
und Detail*, Öl auf Leinwand
*Staatsbegrafenis voor de slachtoffers
van de Maartrevolutie in Berlijn
en detail*, olieverf op doek
*Los funerales públicos por las victimas
de la Revolución de Marzo en Berlín
y detalle*, óleo sobre lienzo
1848
45 x 63 cm / 17.7 x 24.8 in.
Hamburger Kunsthalle, Hamburg

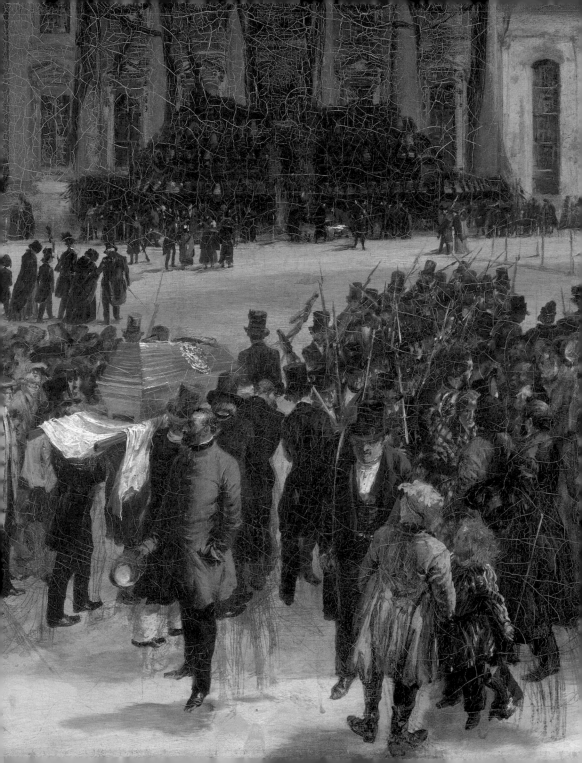

▌ The busts, anatomical parts and masks on the wall of von Menzel's studio, are dramatically lit in a contrast of light and shade typical of his work.
▌ Büsten, anatomische Teile und Masken an den Wänden des Ateliers von Menzel werden dramatisch in einem für seine Malerei typischen Kontrast von Licht und Schatten beleuchtet.
▌ Bustes, lichaamsdelen en maskers aan de muur van de studio van Von Menzel, worden dramatisch, in een voor zijn schilderkunst typerend contrast van licht en schaduw, verlicht.
▌ Bustos, partes del cuerpo y máscaras sobre la pared del estudio de von Menzel, son iluminados dramáticamente en un contraste de luces y sombras típico de su pintura.

**Adolf von Menzel**
(Breslau 1815 - Berlin 1905)
*The Iron-rolling Mill* (*Modern Cyclops*), oil on canvas
*Das Eisenwalzwerk* (*Moderne Zyklopen*), Öl auf Leinwand
*IJzerwalserij* (*Moderne Cycloop*), olieverf op doek
*El horno de fundición y el laminador* (*Cíclopes modernos*), óleo sobre lienzo
1872-1875
158 x 254 cm / 62.2 x 100 in.
Nationalgalerie, Staatliche Museen, Berlin

▶ **Adolf von Menzel**
(Breslau 1815 - Berlin 1905)
*Wall in the Artist's Studio*, oil on canvas
*Atelierwand*, Öl auf Leinwand
*Muur in de studio van de artiest*, olieverf op doek
*Pared del taller del artista*, óleo sobre lienzo
1872
111 x 79,3 cm / 43.7 x 31.2 in.
Hamburger Kunsthalle, Hamburg

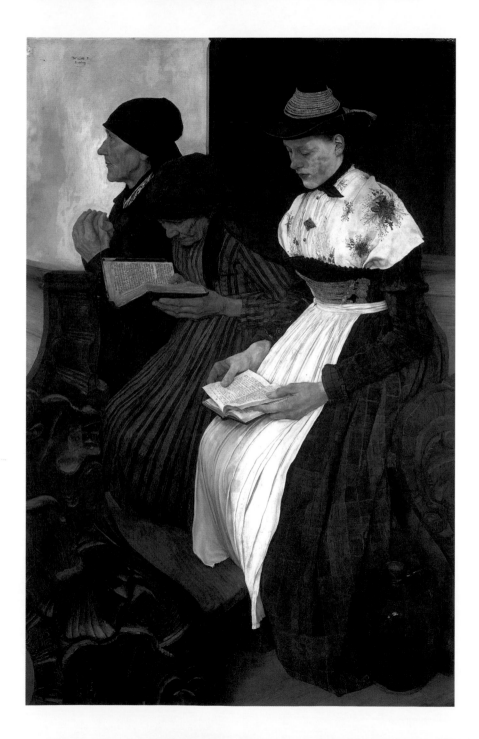

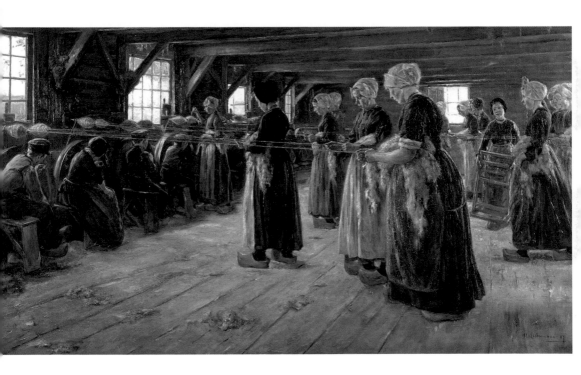

**◄ Wilhelm Leibl**
(Köln 1844 - Würzburg 1900)
*Three Women in a Church*, oil on wood
*Die drei Frauen in der Kirche*, Öl auf Tafel
*Drie vrouwen in de kerk*, olieverf op tablet
*Tres mujeres en la iglesia*, óleo sobre tabla
1882
113 x 77 cm / 44.4 x 30.3 in.
Hamburger Kunsthalle, Hamburg

**Max Liebermann**
(Berlin 1847 - 1935)
*The Flax Barn at Laren*, oil on canvas
*Flachsscheuer in Laren*, Öl auf Leinwand
*Het spinnen van vlas in Laren*, olieverf op doek
*Depósito de lino en Laren*, óleo sobre lienzo
1887
135 x 232 cm / 53.1 x 91.3 in.
Nationalgalerie, Staatliche Museen, Berlin

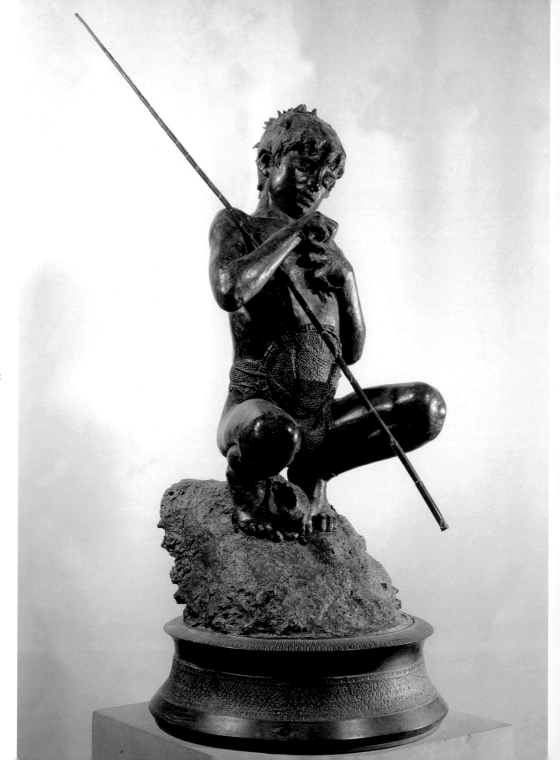

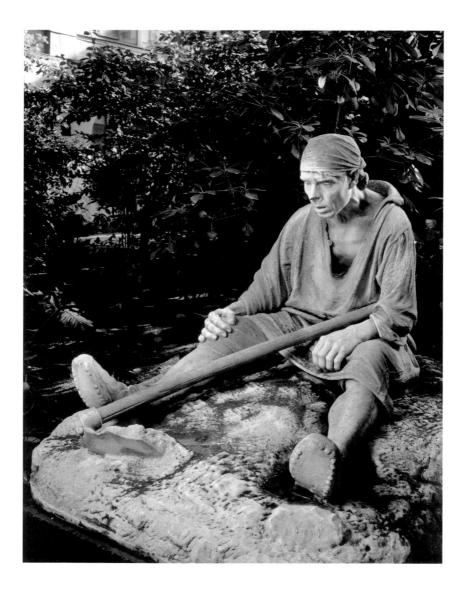

◀ **Vincenzo Gemito**
(Napoli 1852 - 1929)
*The Fisherboy*, bronze
*Pescatorello*, Bronze
*De visser*, brons
*El pescador*, bronce
1877
h. 132 cm / 51.9 in.
Museo del Bargello, Firenze

**Achille D'Orsi**
(Napoli 1845 - 1922)
*Proximus tuus*
Marble
Marmor
Marmer
Mármol
1880
Accademia di Belle Arti, Napoli

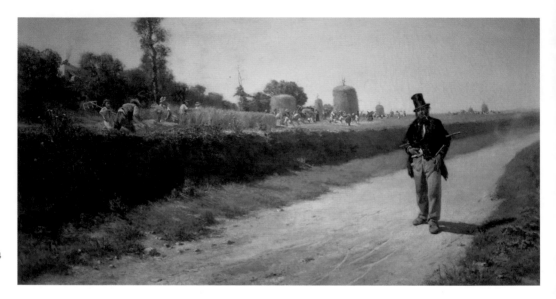

**Michele Cammarano**
(Napoli 1835 - 1920)
*Sloth and work*, oil on canvas
*Muße und Arbeit*, Öl auf Leinwand
*Vrije tijd en werk*, olieverf op doek
*Trabajo y ocio*, óleo sobre lienzo
1863
60 x 120 cm / 23.6 x 47.2 in.
Museo Nazionale di Capodimonte, Napoli

▌ *Clear is the visual contrast sought by Cammarano in placing*
*in the foreground an idle layabout sharply lit so that his every detail can be seen,*
*while in the background the farmers work side by side*
*almost blending together with each other and the landscape.*
▌ *Eindeutig ist der sichtbare Kontrast, den Cammarano ausgearbeitet hat,*
*Der müßige Tagträumer, wird vom Licht getroffen, das ihn in seinen Einzelheiten*
*in den Vordergrund gestellt während im Hintergrund hingegen die Bauern*
*Seite an Seite arbeiten und beinahe miteinander und mit der Landschaft verschmelzen.*
▌ *Duidelijk zichtbaar is het door Cammarano nagestreefde contrast,*
*met op de voorgrond een niksende dagdromer in het licht dat hem*
*in al zijn details toont en op de achtergrond de boeren die zij aan zij werken*
*en bijna in elkaar en in het landschap opgaan.*
▌ *Es claro el contraste visual buscado por Cammarano al colocar*
*en primer plano al ocioso vagabundo iluminado por una luz*
*que lo define en cada uno de sus detalles, mientras en el fondo los campesinos*
*trabajan codo a codo, casi fundiéndose entre ellos y con el paisaje.*

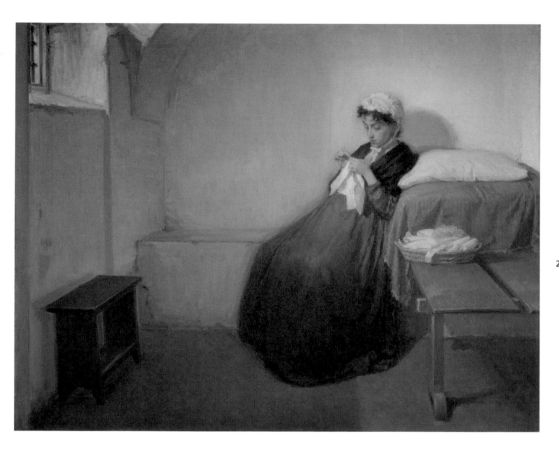

**Gioacchino Toma**
(Galatina 1836 - Napoli 1891)
*Luisa Sanfelice in prison*, oil on canvas
*Luisa Sanfelice im Gefängnis*, Öl auf Leinwand
*Luisa Sanfelice in de gevangenis*, olieverf op doek
*Luisa Sanfelice en prisión*, óleo sobre lienzo
1877
61 x 78 cm / 24 x 30.7 in.
Galleria Nazionale di Arte Moderna, Roma

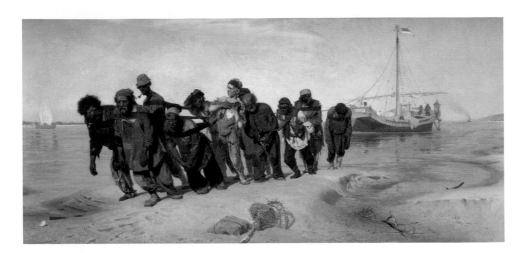

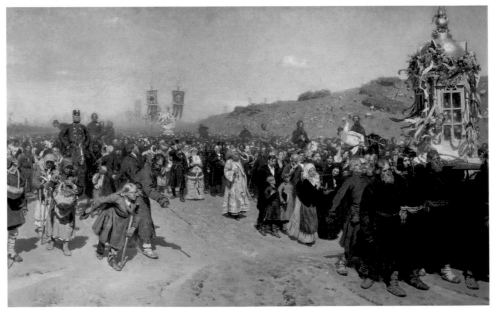

**Ilja Repin**
(Chuhuiv 1844 - Repino 1930)
*The Volga Bargemen*, oil on canvas
*Die Wolgatreidler*, Öl auf Leinwand
*De boottrekkers van de Wolga*, olieverf op doek
*Los bateleros del Volga*, óleo sobre lienzo
1870-1873
Russian State Museum, St. Petersburg

**Ilja Repin**
(Chuhuiv 1844 - Repino 1930)
*Procession in the Province of Kursk* and detail, oil on canvas
*Kreuzprozession im Gouvernement Kursk* und Detail, Öl auf Leinwand
*Optocht in de provincie Kursk* en detail, olieverf op doek
*Procesión de Pascua en la región de Kursk* y detalle, óleo sobre lienzo
1880-1883
175 x 280 cm / 68.9 x 110.2 in.
Tret'jakov State Gallery, Moskow

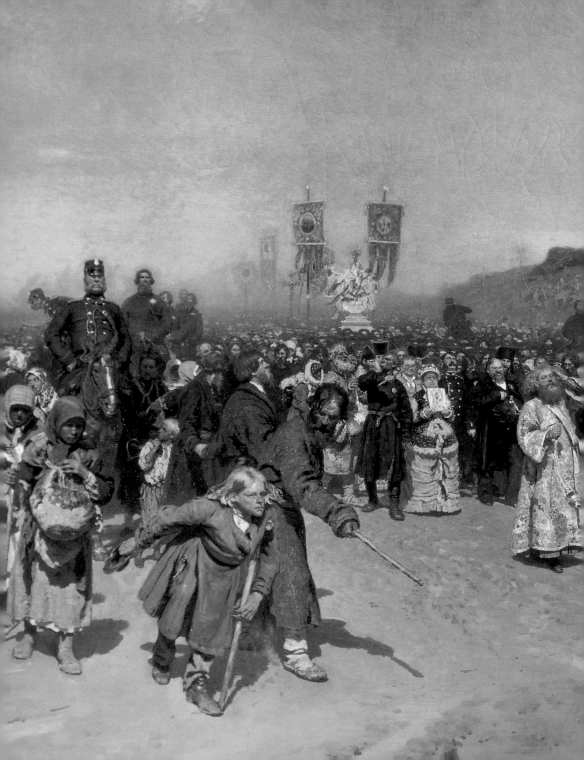

# Glossary

**Aquatint** This technique of intaglio printmaking derived from etching which is more efficient for colour printing because it guarantees bright effects similar to watercolour. A brush is used to apply acid to a metal plate, limiting the corrosive action to the areas that are not treated with resistant material; alternatively, a powder consisting of various materials (bitumen, resin, sand) is scattered on the surface, while the acid will corrode the interstices. After a first "mordant", the plate can be covered with finer powder, protecting with varnish the parts that were previously etched: this results in corrosions of varying degrees, which create different light and dark tones in the final print. This procedure was invented in France in the second half of the 18th century by J.B. Leprince (but was probably already used in Holland in the previous century) and at the end of the century it was one of the most frequently used etching techniques. In the 19th century, aquatint was progressively abandoned, although it is still used in England, where it is valued for its brightness.

**Arts and Crafts** A movement that developed in England in the second half of the 19th century, involving a return to craftwork in order to improve both workers' living conditions and the aesthetic qualities of everyday objects, which are usually mass- produced. The movement was grounded in John Ruskin's utopian socialism, and William Morris, one of its champions, proposed art "of the people and for the people" in which there was a close relationship between art and craftwork. His conception, however, failed to take into account the high cost of the product which, instead of being accessible to ordinary people, could only be purchased by the affluent.

**Burin** A steel cutting tool used for metal engraving. Burin engraving is a printing technique realised by cutting into a copper, steel, or zinc surface. The engraver uses a burin to cut the surface directly. The grooves obtained are inked, followed by the printing phase on paper. Burin engraving, which guarantees clean and regular marks, became widespread in the 15th century both in Italy and in the German-speaking countries, where it was used by many famous painters and sculptors. Marcantonio Raimondi (16th century), Francesco Bartolozzi (18th century), and Raffaello Morghen (beginning of the 19th century) were all excellent engravers. The most important results achieved with this technique were obtained in the Netherlands by Lucas van Leyden in the 16th century, and in France between the 17th and 18th century.

**Eclecticism** A term that identifies a broad movement which shaped the style of Western architecture in the second half of the 19th century: it was based on the rejection of rigid academicism in favour of a mixture of diverse elements derived from archaeology or non-European art forms.

**Etching** Etching, or acquaforte as it is known, from the old name for nitric acid, is the process of using nitric acid to cut into the unprotected parts of a metal surface to create a design in intaglio in the metal. A metal (copper, steel, or iron) plate is covered with a transparent ground, which is resistant to the acid. The artist then scratches off the ground and traces the design with a pointed etching needle. The plate is then immersed in a solution of water and nitric acid, which corrodes the part of the plate that is not covered with the resistant material because it has been scratched away, leaving the areas covered by the ground intact (this phase is called the "mordant", which can be "directed" if the acid is applied with a brush). After removing the ground, the plate is ready to be inked, which is followed by the printing phase. This technique guarantees natural lines and a perfect transmission of the image. Due to these characteristics, etching was the most widespread means of reproduction and spreading of images until the advent of photography, used by artists in different periods and schools, which valued the technique due to its highly expressive results. The most well-known etchers included Dürer and Parmigianino, who were among the first to make use of the technique, as well as Rembrandt, an indisputable master. This technique, whose success continued for the entire 18th century, through Florentine impressionist painters as well as the Impressionists, is still in use in our day (cfr. Picasso, Chagall, Morandi).

**Grand tour** An educational trip (that could even last a year) that used to be undertaken by the children of noble families under the guidance of educated tutors in the most beautiful European cities. An already widely diffused practice in previous centuries, it became particularly popular during the 18th century; Italy was the preferred destination, with visits to Florence, Rome, and Naples, where the excavations in Pompeii and Herculaneum were especially admired.

**Lithography** A particular type of printing technique among the methods of engraving defined as planographic printing, in which a limestone base is used, or since the first half of the 19th century, a porous metal plate (zinc or aluminum): on this surface, the artist traces the drawing with a greasy material (crayon, pencil, or ink) and ink is rolled onto the image.
The ink is picked up by the parts where the design was made and it not picked up by the other parts. Next, a sheet of paper is pressed onto the base using a lithographic press and the print is obtained.
For a colour print, chromolithography is used. The first lithographs were made around 1796 by German printer Alois Senefelder and they began to become widespread in the early 19th century, thanks to the relative ease of the process, which, while not requiring any sort of technical preparation, guaranteed results very close to those obtained from drawing, with deep blacks and a vast array of greys.

**Palladianism** An architectural style inspired by the work of Venetian architect Andrea Palladio (1508-1580), which began to spread in the 16th century, soon extending throughout all of Europe and especially in England where, thanks to the work of Inigo Jones, it became more popular than the Baroque. Palladianism and Neo-Palladianism continued to develop until the end of the 18th century, when it merged with Neoclassicism, thus contributing to the formal definition of the latter and in particular encouraging its spread to North America with the work of Thomas Jefferson.

**Picturesque** A category of aesthetic taste generally including landscapes, gardens, and natural imagery which are characterised by a wild and irregular quality rather than perfection and a classical notion of beauty. Conceived in England in the 18th century, picturesque works focused mainly on storms, ruins, precipices, ruined abbeys, and medieval castles.

**Polish** A term in the field of art that indicates imparting a finish to a sculpture by giving the details definition and smoothing the surfaces.
Canova was famous for his treatment of the "skin" of his sculptures: to obtain this effect of translucency and shine, which made his work unique, he used pumice stones of varying dimensions, wax, and special patinas.

**Revival** An English word meaning "rebirth"; in the world of art it indicates the return to popularity of a style already used in the past.

**Ruins Painting** A style of painting depicting the ruins of ancient buildings. Already practiced in the 16th century, it became widespread in the 18th century. Among the most celebrated painters of ruins were G.P. Pannini and G.B. Piranesi.

**Sublime** An aesthetic category defined by Edmund Burke in the first half of the 18th century and also later by Kant. "Sublime" is that which is able to produce strong emotions in the human soul. The most important aspects of the Sublime are a sense of the terrifying, the tragic, the monstrous, the fantastic, and the infinite; these aspects are expressed in the paintings of William Blake and Heinrich Füssli. The Sublime is a typical Romantic concept, which reassesses the irrational and fantastic elements of art.

# Glossar

**Aquatinta** Eine aus der Radierung entstandene Drucktechnik, die für den Farbdruck effektiver ist, weil sie ähnliche Lichtwirkungen wie die des Aquarells garantiert. Mit einem Pinsel wird die Säure auf eine Metalltafel aufgetragen, wobei die Ätzung nur auf die Stellen beschränkt ist, die nicht mit resistentem Firnis behandelt sind. Man kann die Oberfläche auch mit Körner aus unterschiedlichen Materialien (Bitumen, Harz, Sand) bestreuen, wobei die Zwischenräume von der Säure angegriffen werden. Nach einer ersten Ätzung kann man die Platte mit anderen, feineren Körnen bestreuen und dabei mit der Firnis die bereits eingeritzten Stellen schützen: So erhält man Korrosionen verschiedenen Grades, die beim Druck unterschiedliche Hell- und Dunkeltöne verursachen. Dieses Verfahren wurde in Frankreich in der zweiten Hälfte des 18. Jahrhunderts von J.B. Leprince perfektioniert (aber wahrscheinlich wurde es bereits im vorigen Jahrhundert in Holland angewendet) und gehörte Ende des Jahrhunderts zu den meist verwendeten Drucktechniken.
Seit dem 19. Jahrhundert kam man zunehmend von der Aquatinta ab, auch wenn sie heute in England noch verbreitet und aufgrund ihrer Werte im Licht sehr beliebt ist.

**Arts and Crafts** Arts and Crafts ist eine Bewegung, die sich in der zweiten Hälfte des 19. Jahrhunderts in England entwickelt hatte und die Rückkehr des Handwerks vorschlug, um sowohl die Lebensbedingungen der Arbeiter als auch die ästhetische Qualität der gewöhnlich industriell hergestellten Gebrauchsgegenstände zu verbessern. Als theoretischen Bezug hatte die Bewegung den utopischen Sozialismus von John Ruskin und wurde in erster Linie von William Morris vertreten, der eine Kunst "des Volkes für das Volk" verlangte, in der eine enge Bindung zwischen Kunst und Handwerk herrschte. Seine Auffassung musste sich jedoch mit den hohen Kosten der gefertigten Produkte auseinander setzen, die anstatt für das Volk zugänglich zu sein, nur von den reichsten Gesellschaftsschichten erworben werden konnten.

**Eklektizismus** Dieser Begriff identifiziert eine breite Bewegung, die in der zweiten Hälfte des 19. Jahrhunderts den Stil der westlichen Architektur beeinflusst hat: Der Eklektizismus beruht auf der Verneinung der strengen akademischen Vorgaben zugunsten einer Vermischung von verschiedenen Elementen, die aus der Archäologie oder aus außer-europäischen künstlerischen Formen stammen.

**Grand Tour** Bildungsreise (von der Dauer bis zu einem Jahr), die von den Sprösslingen adliger Familien in die schönsten europäischen Städte unter Anleitung von Privatlehrern unternommen wurde. Obwohl die Grand Tour bereits in den vorhergehenden Jahrhunderten verbreitet war, kam sie besonders während des 18. Jahrhunderts in Mode. Das beliebteste Ziel war Italien mit Abstechern nach Florenz, Rom und Neapel, wo vor allem die Aus-grabungsstätten von Herculaneum und Pompeji bewundert wurden.

**Lithografie** Ein weiteres Druckverfahren: Es handelt sich um eine bestimmte Druckmethode, die als Flachdruckverfahren gilt, bei welcher man als Matrix einen Kalkstein verwendet oder seit der ersten Hälfte des 19. Jahrhundert eine poröse Metallplatte (Zink oder Aluminium). Auf diese Oberfläche skizziert der Künstler die Zeichnung mit einem fetthaltigen Material (Kreide, Bleistift oder Tinte) und geht danach mit einer eingefärbten Walze darüber. Die Farbe hält nur auf den gezeichneten Stellen und wird von den anderen abgewiesen. Daraufhin wird ein Blatt Papier auf die Matrix gelegt und zusammen in einer Druckerpresse gepresst. So erhält man den Druck. Für den Farbdruck verwendet man die Chromolithografie. Die ersten Lithografien sind gegen 1796 von dem deutschen Drucker Alois Senefelder gemacht worden und begannen nach den ersten Jahren des 19. Jahrhunderts eine größere Verbreitung zu finden. Dies vor allem dank seines einfachen Verfahrens, das obwohl es keine technische Vorbereitung erforderte, Ergebnisse gewährleistete, die ähnlich denen der Zeichnung waren: mit tiefem Schwarz und einer Bandbreite an Grautönen.

**Palladianismus** Der an den Werken des Architekten Andrea Palladio (1508-1580) angelehnte Baustil begann bereits seit dem 16. Jahrhundert Verbreitung zu finden, wobei er sich schnell in ganz Europa und vor allem in England ausbreitete, wo er dank Inigo Jones populärer als das Barock wurde. Der P. oder der Neopalladianismus entwickelte sich bis Ende des 18. Jahrhunderts weiter und floss dann mit dem Neoklassizismus zusammen: Er trug zu seiner gestalterischen Definition bei und begünstigte vor allem seine Verbreitung bis nach Nordamerika, mit dem Werk von Thomas Jefferson.

**Pittoreske** Eine Kategorie des Kunstgeschmacks, in die im Allgemeinen die Landschaftsmalerei,

die Ausarbeitungen von Gärten und die Darstellungen der Natur gehören, die von Rauheit und Unregelmäßigkeit, anstatt von Perfektion und klassischer Schönheit der Formen charakterisiert sind. Das Pittoreske wurde im 18. Jahrhundert in England entworfen und hat in der Regel als Bildgegenstand Unwetterszenen, architektonische Trümmer, Abhänge, Ruinen von Abteien und von mittelalterlichen Burgen.

**Politur** Auf dem Gebiet der Kunst bestimmt der Begriff das Nacharbeiten bei einer Skulptur durch die Bestimmung der Details und das Abschleifen der Oberfläche. Berühmt für die Sorgfalt, mit der er seine Statuen behandelt hat, ist vor allem Canova: Der Bildhauer verwendete
Bimsstein in verschiedenen Größen, Wachs und besondere Patina, um jenen Effekt der Transparenz und des Glanzes zu erhalten, der seine Werke so einzigartig macht.

**Punze** Stahlnadel, die für das Gravieren von Metall verwendet wird. Die Gravierung ist eine Drucktechnik, die durch Aushöhlen einer Kupfer-Stahl- oder Zinkmatrix durchgeführt wird. Der Kupferstecher arbeitet mit der Punze direkt auf der Matrix. Die erhaltenen Rillen werden eingefärbt und dann auf ein Blatt Papier gedruckt. Die Gravierung, die klare und regelmäßige Linien verspricht, verbreitete sich seit dem 15. Jahrhundert sowohl in Italien, als auch in den deutschen Ländern, wo sie von vielen berühmten Malern und Bildhauern verwendet wurde. Ausgezeichnete Kupferstecher waren Marcantonio Raimondi (16. Jahrhundert), Francesco Bartolozzi (17. Jahrhundert) und Raffaello Morghen (Anfang des 19. Jahrhunderts). Die besten künstlerischen Resultate in Verbindung mit dieser Technik wurden in den Niederlanden von Lucas Hugensz van Leyden im 16. Jahrhundert und in Frankreich zwischen dem 17. und 18. Jahrhundert erzielt.

**Radierung** Drucktechnik auf Metall, deren Name von dem alten Namen der Salpetersäure stammt, die als ätzende Substanz verwendet wurde. Man bedeckt mit einem säureresistenten transparenten Firnis eine Metallplatte (aus Kupfer, Stahl oder Eisen) und ritzt darauf mit einer Spitze die Zeichnung ein. Danach taucht man die Platte für einige Zeit in eine Lösung ein, die aus Wasser und Salpetersäure zusammengesetzt ist, welche die Stellen der Platte, die vom Einritzen unbedeckt geblieben sind, verätzt und die von der Firnis bedeckten Stellen intakt lässt (Diese Phase ist die Ätzung, die gesteuert werden kann, wenn man die Säure mit Hilfe eines Pinsels aufträgt). Sobald der Firnis entfernt ist, ist die Platte bereit für die Einfärbung und daher auch für den Druck. Diese Technik gewährleistet eine hohe Natürlichkeit der Linien und eine genaue Wiedergabe der malerischen Werte. Wegen dieser Merkmale war die Radierung das beliebteste Mittel zur Reproduktion und Verbreitung von Bildern bis zur Fotografie. Sie wurde von Künstlern aus unterschiedlichen Epochen und Schulen verwendet, die an ihr die besonders ausdrucksstarken Ergebnisse geschätzt haben.
Zu den bekanntesten Radierern zählen Dürer und Parmigianino, die sie auch zu den ersten zählen, die sie angewendet haben, sowie Rembrandt, der unumstrittene Meister. Diese Technik, die das ganze 18. Jahrhundert und damit die Macchiaioli und die Impressionisten überlebt hat, wird noch von den zeitgenössischen Künstlern (Picasso, Chagall, Morandi) genutzt.

**Revival** Ein englischer Begriff, der "Wiedergeburt" bedeutet und auf dem Gebiet der Kunst den erneuten Ruhm eines in einer vergangenen Epoche bereits angewendeten Stils.

**Ruinen** Ein Genre der Malerei, in den Ruinen von antiken Gebäuden dargestellt werden. Es wurde bereits im 16. Jahrhundert praktiziert, aber erst im 18. Jahrhundert verbreitete es sich. Zu den gefeierten Malern von Ruinen gehören G.P. Pannini und G.B. Piranesi.

**Sublime** Über die ästhetische Kategorie sprach Edmund Burke in der ersten Hälfte des 18. Jahrhunderts und später Kant. "Sublime" ist das, was in der menschlichen Seele starke Gefühle hervorruft. Die bedeutendsten Aspekte des Sublime sind der Wunsch nach dem Schauerlichen, dem Tragischen, dem Monströsen, dem Fantastischen, dem Unendlichen; diese Aspekte finden in den Gemälden von William Blake und Heinrich Füssli Ausdruck. Das Sublime ist ein typisches Konzept der Romantik, das die irrationalen und fantastischen Elemente der Kunst aufwertet.

# Woordenlijst

ART IN THE 19TH CENTURY

242

**Aquatint** Van etsen afgeleide graveertechniek die effectiever is voor het afdrukken in kleur, omdat er lichteffecten ontstaan die vergelijkbaar zijn met die van de aquarel.

Met een kwast wordt zuur aangebracht op een metalen plaat, waarbij corrosie wordt van de niet-behandelde delen met zuurbestendige lak wordt voorkomen of door het oppervlak te bestrooien met diverse materialen (bitumen, hars, zand), zodat alleen de tussenruimten met het zuur in aanraking komen.

Na een eerste "ets" kan de plaat met een nog fijnere korrel bestrooid worden, waarbij de al behandelde delen worden beschermd door de lak: zo ontstaat een verschil in corrosie en worden in de afdruk verschillende licht- en donkertinten gecreëerd.

Aquatint werd in de tweede helft van de achttiende eeuw in Frankrijk ontwikkeld door J.B. Leprince (maar waarschijnlijk werd het al de eeuw daarvoor in Nederland gebruikt) en aan het einde van de eeuw was het de meest gebruikte etstechniek. Vanaf de negentiende eeuw raakte aquatint minder in zwang, behalve in Engeland, waar deze techniek nog zeer gewaardeerd wordt om de lichteffecten.

**Burin** Stalen naald die wordt gebruikt voor het etsen in metaal. De ets met burin is een druktechniek gemaakt door een matrix uit te hollen in koper, staal of zink.

De graveur bewerkt de drager met de burijn, waarna de verkregen holtes worden gevuld met inkt en er op een vel papier gedrukt kan worden.

Deze graveertechniek creëert strakke en regelmatige lijnen, en raakt vanaf de vijftiende eeuw in Italië en in de Germaanse landen in opkomst, waar veel schilders en beeldhouwers er gebruik van maken. Zeer goede etsers waren Marcantonio Raimondi (16e eeuw), Francesco Bartolozzi (18e eeuw) en Raffaello Morghen (begin 19e eeuw). Het artistieke hoogtepunt werd in Nederland in de zestiende eeuw bereikt, door Lucas van Leyden, en in Frankrijk tussen de zeventiende en achttiende eeuw.

**Eclecticisme** Term die een sterke beweging aanduidt die in de tweede helft van de 19e eeuw de stijl van de westerse architectuur domineert.

Het is gebaseerd op de afwijzing van starre academische waarden ten gunste van een mix van verschillende elementen uit de archeologie, of vormen van kunst buiten Europa.

**Etsen** Graveertechniek voor metaal, zo genoemd vanwege de oude naam van salpeterzuur die als als bijtende stof werd gebruikt. Met een transparante, zuurbestendige lak wordt een plaat van metaal (koper, staal of ijzer) bestreken, waarna het ontwerp wordt ingesneden met een punt. Vervolgens wordt de plaat gedurende enige tijd in een oplossing van water en salpeterzuur gedompeld, waarbij het ingesneden gedeelte van de plaat corrodeert en het door de lak bedekte gedeelte intact blijft (dit is het "etsen" en het wordt "direct"genoemd als het zuur wordt aangebracht met een borstel). Na het verwijderen van de lak is de plaat klaar voor inkt en vervolgens voor het afdrukken. Deze techniek garandeert natuurlijke lijnen en perfecte resultaten in reproducties.

Vanwege deze eigenschappen is de ets de meest voorkomende wijze van reproductie- en distributiemethode van afbeeldingen, tot de komst van de fotografie, en is populair bij kunstenaars van verschillende periodes en scholen, die de hoge expressieve resultaten ervan waarderen. Enkele van de bekendste etsers zijn Dürer en Parmigianino, van een van de eerste etsers is Rembrandt de onbetwiste meester. Etsen bleef tot lang na de achttiende eeuw een succesvolle techniek, overleefde daarmee Macchiaioli en de impressionisten, en is nog door contemporaine kunstenaars (Picasso, Chagall, Morandi) gebruikt.

**Grand tour** Educatieve reis (van maximaal een jaar) naar de mooiste steden van Europa, die werd ondernomen door telgen van adellijke families, onder leiding van opgeleide docenten. Het hoogtepunt van de populariteit van de Grand Tour lag in de achttiende eeuw en de favoriete bestemming was Italië, met steden als Florence, Rome en Napels, en de opgravingen in Herculaneum en Pompeji die vooral veel aantrekkingskracht uitoefenden.

**Arts-and-craftsbeweging** In de tweede helft van de negentiende eeuw in Engeland ontstane beweging, die een terugkeer naar het vakmanschap beoogde om zowel de leefomstandigheden van de werknemers als de esthetische kwaliteit van alledaagse, meestal industrieel vervaardigde voorwerpen te verbeteren.

De theoretische basis van beweging werd gevormd door het utopisch socialisme van John Ruskin, en een van haar vooraanstaande leden was William Morris, die een kunst "van het volk en voor het

volk» voorstond, met een nauwe relatie tussen kunst en ambacht. Zijn beweging had te kampen met de hoge kosten van de geproduceerde producten, die in plaats van toegankelijk voor alle mensen te zijn, alleen door de rijkere klasse konden worden gekocht.

**Lithografie** Een bijzondere graveertechniek die wordt gedefinieerd als "plat" en waarbij als drager kalksteen of, in de eerste helft van de negentiende eeuw, een poreuze metalen plaat (zink of aluminium) werd gebruikt. De kunstenaar tekent met een vet materiaal (krijt, potlood of inkt) op dit oppervlak het ontwerp en gaat er dan met een inktroller overheen. De inkt zal zich alleen hechten aan de getekende delen en zal op de overige delen worden afgestoten. Daarna wordt er met een lithografiepers een stuk papier aangebracht op de drager en ontstaat de afdruk. Voor een kleurenafdruk wordt chromolithografie gebruikt. De eerste litho's werden rond 1796 gemaakt door de Duitse drukker Alois Senefelder en vanaf het begin van de negentiende eeuw raakte de lithografie alom in zwang, dankzij het eenvoudige proces dat, hoewel er geen technische voorbereiding vereist was, resultaten opleverden die bijna tekeningen leken, met diepe zwarttinten en een breed scala aan grijstinten.

**Palladianisme** Architecturale op het werk van de Venetiaanse architect Andrea Palladio (1508-1580) geïnspireerde stijl die al in de zestiende eeuw ontstond, en zich snel in heel Europa en vooral Engeland verspreidde, waar hij, dankzij het werk van Inigo Jones, populairder werd dan de barok. Het palladianisme of neopalladianisme bleef zich ontwikkelen tot het einde van de achttiende eeuw en vloeide toen samen met het neoclassicisme. Het droeg bij tot de formele definitie en de verspreiding ervan in met name Noord- Amerika, met het werk van Thomas Jefferson.

**Pittoresk** Een vorm van artistieke smaak waartoe in het algemeen landschapsschilderijen, uitwerkingen van tuinen en afbeeldingen van de natuur behoren die worden gekenmerkt door ruwheid en onregelmatigheden in plaats van perfectie en schoonheid van de klassieke vormen.

Het ontstond in het achttiende-eeuwse Engeland en heeft meestal als onderwerp stormscènes, schipbreuken, architectuur, kliffen, middeleeuwse abdijruïnes en kastelen.

**Polijsten** Term die in de kunst het afwerken van een beeldhouwwerk aanduidt door het definiëren van details en het polijsten van oppervlakken.

Met name de beeldhouwer Canova, die beroemd was om de zorg waarmee hij de "huid" van zijn beelden bewerkte om de transparantie en glans te bereiken die zijn werken uniek maakte, bediende zich van puimsteen in diverse afmetingen, was en speciaal patina.

**Revival** Engels woord, dat "wedergeboorte" betekent en dat in de kunst de herleving van een stijl uit een reeds vervlogen tijdperk aanduidt.

**Ruïnes** Een genre in de schilderkunst waarin ruïnes van oude gebouwen worden afgebeeld. Het werd al in de zestiende eeuw beoefend en was in de achttiende eeuw wijdverbreid. Beroemde schilders van ruïnes zijn G.P. Pannini en G.B. Piranesi.

**Sublime** Een in de eerste helft van de achttiende eeuw door Edmund Burke en later door Kant gedefinieerde esthetische categorie.

"Sublime" is datgene wat sterke emoties kan oproepen bij de mens. De belangrijkste aspecten van het sublieme zijn een voorliefde voor het angstaanjagende, tragische, monsterlijke, fantastische en het oneindige. Dergelijke aspecten komen tot uitdrukking in de schilderijen van William Blake en Heinrich Füssli.

Sublime is een voor de romantiek karakteristiek concept, dat de irrationele en fantastische elementen in de kunst opnieuw evalueert.

# Glosario

**Aguafuerte** Técnica de grabado sobre metal llamada así por el antiguo nombre del ácido nítrico, utilizado como sustancia corrosiva. Se cubre con un barniz transparente resistente al ácido una plancha de metal (de cobre, acero o hierro) y se la graba trazando el dibujo con una punta. La plancha se sumerge luego por un tiempo en una solución compuesta de agua y ácido nítrico, que corroe la parte de la plancha que quedó descubierta por el grabado y deja intactas aquellas cubiertas por el barniz (esta fase se denomina "mordido", que puede ser "directo", si se aplica el ácido con la ayuda de un pincel). Después de haber eliminado el barniz, la plancha está lista para el entintado y la impresión. Esta técnica garantiza una gran naturalidad de las líneas y una perfecta reproducción de los valores pictóricos. Debido a dichas características, el aguafuerte ha sido el medio más difundido de reproducción y divulgación de imágenes hasta el nacimiento de la fotografía, usado por artistas de períodos y escuelas distintas, que han apreciado sus grandes resultados expresivos. Entre los aguafuertistas más famosos se encuentran Dürer y Parmigianino, entre los primeros a utilizar la técnica; y Rembrandt, maestro indiscutido. Esta técnica, cuya fortuna ha continuado durante todo el siglo XVIII, a través de los manchistas (del italiano, "macchiaioli") y los impresionistas, ha llegado hasta los artistas contemporáneos (Picasso, Chagall, Morandi).

**Aguatinta** Técnica de grabado derivada del aguafuerte, más eficaz para la impresión a color porque garantiza efectos de luz similares a los de la acuarela. Con un pincel se aplica ácido sobre una plancha de metal, limitando la acción corrosiva a las partes no tratadas con barnices resistentes, o se espolvorea la superficie con granulados de distintos materiales (betún, resina, arena), cuyos intersticios serán corroídos por el ácido. Después de un primer "mordido" se puede espolvorear la plancha con otro granulado aún más fino, protegiendo con el barniz las partes ya grabadas: se obtienen así corrosiones de diferente grado, que en la impresión crean distintos tonos de claros y de oscuros. Este procedimiento fue desarrollado en Francia, en la segunda mitad del siglo XVIII, por J.B. Leprince (pero probablemente ya había sido usado en Holanda en el siglo anterior) y a finales de siglo ya estaba entre las técnicas de grabado más utilizadas. A partir del siglo XIX el aguatinta comienza a entrar en desuso, si bien incluso actualmente es utilizada en Inglaterra, donde es muy apreciada por sus valores de luminosidad.

**Arts and Crafts** Movimiento desarrollado en Inglaterra en la segunda mitad del siglo XIX que proponía un regreso al trabajo artesanal para mejorar tanto las condiciones de vida de los trabajadores como la cualidad estética de los objetos de uso común, por lo general producidos industrialmente. El movimiento tenía como referente teórico el socialismo utópico de John Ruskin y tuvo entre sus principales exponentes a William Morris, que proponía un arte «del pueblo y para el pueblo», en el cual arte y artesanado estén en estrecha relación. Pero su concepción debía enfrentarse al alto costo de los productos realizados, que en lugar de ser accesibles al pueblo podían ser comprados sólo por los sectores más ricos de la sociedad.

**Buril** Instrumento de acero usado para el grabado del metal. El grabado con buril es una técnica de impresión realizada tallando una matriz de bronce, acero o zinc. El grabador, con el buril, actúa directamente sobre la matriz, en las tallas obtenidas se deposita la tinta y seguidamente se procede a la impresión sobre una hoja de papel.
El grabado con buril, que garantiza impresiones de líneas definidas y regulares, se difundió a partir del siglo XV tanto en Italia como en los países alemanes, donde fue usado por muchos pintores y escultores famosos. Se pueden citar como eximios grabadores a Marcantonio Raimondi (siglo XVI), Francesco Bartolozzi (siglo XVIII) y Raffaello Morghen (comienzos del siglo XIX). Los mejores resultados artísticos ligados al uso de esta técnica fueron obtenidos en los Países Bajos, por Luca di Leida en el siglo XVI; y en Francia, entre los siglos XVII y XVIII.

**Eclecticismo** Término que identifica un vasto movimiento que en la segunda mitad del siglo XIX ha orientado el estilo de la arquitectura occidental: se basa en el rechazo de los academicismos rígidos en beneficio de una combinación de diferentes elementos, tomados de la arqueología o de formas artísticas provenientes de países fuera de Europa.

**Grand tour** Viaje de instrucción (que podía durar incluso un año) que era realizado por los jóvenes provenientes de familias nobles, bajo la guía de institutores cultos, por las más bellas ciudades europeas. Ya generalizado

en los siglos anteriores, se puso particularmente de moda durante el siglo XVIII; el destino preferido era Italia, con visitas a Florencia, Roma y Nápoles, donde se visitaban fundamentalmente las excavaciones de Herculano y Pompeya.

**Litografía** Procedimiento de impresión que forma parte de las técnicas de grabado: se trata de un tipo particular de grabado definido "en plano", en el cual se utiliza como matriz una piedra calcárea o, a partir de la primera mitad del siglo XIX, una plancha de metal poroso (zinc o aluminio): sobre esta superficie el artista dibuja la imagen con un material graso (tiza, lápiz o tinta) y le pasa por encima un rodillo entintado. La tinta es retenida sólo en las partes dibujadas, y es rechazada en el resto. Luego se adhiere una hoja de papel sobre la matriz a través de una prensa litográfica y se obtiene la impresión. Para la impresión en colores se usa la cromolitografía. Las primeras litografías fueron realizadas alrededor de 1796 por el artista y cartógrafo alemán Alois Senefelder y comenzaron a tener gran difusión a partir de los primeros años del siglo XIX gracias a la facilidad del proceso que, aun no requiriendo de gran preparación técnica, garantizaba resultados muy cercanos a los obtenidos con el dibujo, con negros profundos y una vasta gama de grises.

**Palladianismo** Estilo arquitectónico inspirado en la obra del arquitecto véneto Andrea Palladio (1508-1580), comenzó a difundirse ya a partir del siglo XVI, propagándose rápidamente por toda Europa y sobre todo en Inglaterra, donde gracias a la actividad de Inigo Jones, ganó más popularidad que el Barroco. El P. o Neopalladianismo siguió desarrollándose hasta fines del siglo XVIII, confluyendo luego en el Neoclasicismo: contribuyó a su definición formal y, sobre todo, favoreció su expansión hasta América del Norte, con la obra de Thomas Jefferson.

**Pintoresco** Categoría de gusto artístico en el cual se incluyen generalmente las pinturas de paisaje, la realización de jardines, las representaciones de la naturaleza, caracterizadas por la rudeza y la irregularidad, en lugar de la perfección y la belleza clásica de las formas. Concebido en Inglaterra en el siglo XVIII, el p. tiene por lo general como objeto de representación escenas de tormenta, restos arquitectónicos, escombros, ruinas de abadías o castillos medievales.

**Pulido** Término que en el campo artístico indica el acabado de una escultura a través de la definición de los detalles y el alisado de las superficies. Famoso por el esmero con el cual trataba la "piel" de sus estatuas es sobre todo Canova: el escultor, para obtener ese efecto de transparencia y de brillo que hace únicas sus obras, se servía de piedras pómez de distintas dimensiones, de cera y de pátinas especiales.

**Revival** Término inglés que significa "renacer" y que en ámbito artístico indica la vuelta en auge de un estilo ya utilizado en una época pasada.

**Ruinas** Género de pintura en la que se representan ruinas de edificios antiguos. Ya practicada en el siglo XVI, ganó mucha popularidad en el siglo XVIII. Entre los pintores célebres de ruinas se encuentran G.P. Pannini y G.B. Piranesi.

**Sublime** Categoría estética de la que habla Edmund Burke en la primera mitad del siglo XVIII y más adelante Kant. "Sublime" es lo que logra producir en el espíritu humano fuertes emociones. Los aspectos más relevantes de lo sublime son el gusto por lo terrorífico, lo trágico, lo monstruoso, lo fantástico, lo infinito; dichos aspectos se plasman en las pinturas de William Blake y de Heinrich Füssli. El s. es un concepto típico del Romanticismo, que revaloriza los elementos irracionales y fantásticos del arte.

# Biographies
# Biografien
# Biografieën
# Biografias

## Robert Adam
Kirkcaldy 1728 - London 1792

**1754-1758** Roma. During this period of time he also visits Herculaneum, Pompeii, and Split, where he is fascinated by the ruins of Diocletian's Palace / In diesen Jahren besucht er auch Herculaneum, Pompeji und Split, wo er von den Ruinen des Diokletianspalasts sehr beeindruckt ist / In deze jaren bezoekt hij ook Herculaneum, Pompeji en Spalato waar hij onder de indruk komt van het paleis van Diocletianus / En estos años visita también Herculano, Pompeya y Spalato donde queda muy impactado por las ruinas del palacio de Diocleciano

**1758** Returns to England / Er kehrt nach England zurück / Terugkomst in Engeland / Vuelve a Inglaterra

**1765-1780** He receives numerous commissions to restructure and decorate private homes: among the most notable are Osterley Park and Syon house (Middlesex) / Zahlreiche Aufträge zur Restaurierung und Ausstattung von Privathäusern: zu den bekanntesten gehören Osterley Park und Syon House (Middlesex) / Talrijke opdrachten voor renovatie en decoratie van pprivéwoningen, zoals het opvallende Osterley Park en Syon House (Middlesex) / Numerosos encargos para reestructurar y decorar viviendas privadas, entre las más destacadas, Osterley Park y Syon House (Middlesex)

**1768** Now famous, he receives urban commissions: The Adelphi Buildings in London, on the Thames / Mittlerweile hat er Berühmtheit erlangt und erhält städtebauliche Aufträge: der Wohnkomplex Adelphi in London über der Themse / Hij is inmiddels beroemd en krijgt stedebouwkundige opdrachten: het wooncomplex Adelphi, aan de Thames / Habiendo alcanzado ya notoriedad, recibe encargos urbanísticos: complejo residencial Adelphi en Londres, sobre el Támesis

**1789** Public housing commission: University of Edinburgh / Auftrag für öffentliche Bauten: Universität von Edinburgh / Opdracht voor openbare gebouwen: Universiteit van Edinburgh / Encargo de obra pública: Universidad de Edimburgo

## William Blake
London 1757 - 1827

**1780** Leaves the Royal Academy of London after attending for several years / Er verlässt die Royal Academy in London, die er mehrere Jahre besuchte / Verlaat de Royal Academy van Londen, na een aantal jaren onderwijs te hebben gevolgd / Después de haber tomado clases por algunos años, abandona los cursos de la Royal Academy de Londres

**1789-1793** A highly emotional poet and artist, he publishes his own self-illustrated texts in the form of illuminated manuscripts: Songs of Innocence and The Marriage of Heaven and Hell / Als Dichter und Zeichner von großer gefühlsbetonter Wirkung veröffentlicht er eigene Texte und illustriert sie selbst, wobei er die Bände wie Miniaturmanuskripte konzipiert: Lieder der Unschuld und Die Hochzeit von Himmel und Hölle / Als uiterst gevoelige dichter en tekenaar, publiceert en illustreert hij zijn eigen teksten, en creëert zo prachtige manuscripten: Liederen van onschuld en Het huwelijk van de hemel en de hel / Poeta y diseñador de gran carga emotiva, publica sus textos ilustrándolos él mismo, concibiendo los volúmenes como manuscritos miniados: Cantos de la inocencia y el Matrimonio del Cielo y el Infierno

**1824-1827** He illustrates The Divine Comedy / Er illustriert die Divina Commedia / Illustreert de Divina Commedia / Ilustra la Divina Comedia

## Antonio Canova
Possagno, Treviso 1757 - Venezia 1822

**1768** He enters the workshop of Giuseppe Bernardi and moves with him to Venice / Er beginnt in der Werkstatt des Bildhauers Giuseppe Bernardi, mit dem er nach Venedig zieht / Werkt in

het atelier van beeldhouwer Giuseppe Bernardi, met wie hij naar Venetië verhuist / Entra no ateliê do escultor Giuseppe Bernardi, com o qual se mudará para Veneza

1775 Giovanni Falier, his first patron, commissions *Orpheus* and *Eurydice*. He opens a studio in the cloister of Santo Stefano in Venice / Er führt für Giovanni Falier, seinen ersten Förderer, die *Eurydike* und den *Orpheus* aus. Er eröffnet ein Atelier im Kloster Santo Stefano in Venedig / Voltooid de *Orpheus en Eurydice* voor zijn eerste beschermheer, Giovanni Falier. Opent een studio in het Santo Stefanoklooster in Venetië / Realiza para Giovanni Falier, su primer protector, *Eurídice* y *Orfeo* (Venezia, Museo Correr). Abre un estudio en el claustro de Santo Stefano en Venecia

1779 He travels to Rome with the money earned from *Dedalus and Icarus*. He stays in Bologna and Florence. Ambassador Girolamo Zulian becomes his new patron / Er geht mit dem Geld, das er mit *Dädalus und Ikarus* verdient hat, nach Rom. Er hält in Bologna und Florenz an. Der Botschafter Girolamo Zulian wird sein neuer Förderer / Gaat naar Rome,van het geld dat hij verdiende met *Daedalus en Icarus*. Verblijft in Bologna en Florence. De ambassadeur Girolamo Zulian wordt zijn nieuwe beschermheer / Va a Roma, con el dinero ganado con *Dédalo e Ícaro* (Museo Correr, Venezia). Estancias en Boloña y Florencia. El embajador Girolamo Zulian se convierte en su nuevo protector

1781-1783 *Theseus and the Minotaur / Theseus auf Minotaurus / Theseus op de Minotauro / Teseo y el Minotauro* (Victoria & Albert Museum, London)

1798 He returns to Possagno, then travels to Vienna, Prague, Dresden, Berlin, and Munich / Er kehrt nach Possagno zurück und reist dann zwischen Wien, Prag, Dresden, Berlin und München / Keert terug naar Possagno, reist vervolgens naar Wenen, Praag, Dresden, Berlijn en München / Vuelve a Possagno, luego viaja entre Viena, Praga, Dresde, Berlín y Múnich

1798-1805 *Funeral monument for Maria Cristina of Austria / Grabmal für Maria Cristina von Österreich / Grafmonument voor Maria Christina van Oostenrijk / Monumento fúnebre a Maria Cristina de Austria* (Augustinerkirche, Wien)

1802 He is made a Knight of the Golden Spur and Inspector General of Fine Arts and Antiquities of the Papal States. He travels to Paris to model the bust of Napoleon / Er wird zum Ritter des Goldenen Sporns und zum Oberaufseher der Kunstschätze des Kirchenstaates ernannt. Er begibt sich nach Paris, um die Büste von Napoleon zu modellieren / Benoemd tot ridder in de Orde van het Gulden Spoor en inspecteur-generaal van de Oudheden en Schone Kunsten van de kerkelijke staat. Reist naar Parijs om een buste van Napoleon te maken / Nombrado caballero del Speron d'oro e Inspector general de las Antigüedades y Bellas Artes del Estado de la Iglesia. Se instala en París para modelar el busto de Napoleón

1815 As head of the delegation of the Holy See at the Congress of Paris, he obtains the restitution of artworks appropriated by the French after the Treaty of Tolentino. London: he examines the Parthenon marbles acquired by Lord Elgin / Als Leiter der Delegation des Heiligen Stuhls beim Pariser Kongress werden ihm die von den Franzosen nach dem Vertrag von Tolentino eingeforderten Kunstwerke zurückerstattet. London: Er prüft die Marmortafeln des Parthenon, die von Lord Elgin erworben wurden / Als hoofd van de delegatie van de Heilige Stoel op het Congres van Parijs, weet hij de na het Verdrag van Tolentino door de Fransen meegenomen kunstwerken, terug te krijgen. Londen: bestudeert de marmeren Parthenonbeelden die zijn meegenomen door Lord Elgin / Como jefe de la delegación de la Santa Sede en el Congreso de París obtiene la devolución de las obras de arte requisadas por los franceses después del Tratado de Tolentino. Londres: admira los mármoles del Partenón comprados por Lord Elgin

1819 *The Penitent Magdalene / Die ohnmächtige Magdalena / De flauwgevallen Magdalena / La Magdalena yacente* (Gipsoteca, Possagno)

## John Constable
East Bergholt, Suffolk 1776 - Hampstead 1837

1799   He moves to London to attend the Royal Academy / Er zieht nach London, um Kurse an der Royal Academy zu besuchen / Verhuist naar Londen om onderwijs te volgen aan de Royal Academy / Se traslada a Londres para asistir a los cursos de la Royal Academy

1802   He returns to the village where he was born and pursues his study of nature and local landscape, breaking away from classical models. *Dedham Vale* / In den Geburtsort zurückgekehrt intensiviert er seine naturalistischen Landschaftsstudien seiner Region und entfernt sich von den klassischen Vorbildern. *Das Tal von Dedham* / Intensiveert na terugkeer in zijn geboortedorp de bestudering van het landschap aldaar en breekt zo met de klassieke voorbeelden. *De vallei van Dedham* / De vuelta a su pueblo natal, intensifica los estudios naturalistas del paisaje de su región, alejándose de los modelos clásicos. *Valle de Dedham* (Victoria & Albert Museum, London)

1821   *The Hay Wain* / *Der Heuwagen* / *De hooiwagen* / *El carro de heno* (London, National Gallery)

1820 -1822   He dedicates himself especially to "the study of clouds" / Er widmet sich im Besonderen den "Wolkenstudien" / Wijdt zich vooral aan "wolkenstudies" / Se dedica en particular a los "estudios de nubes"

1829   He is accepted as a full member of the Royal Academy / Er wird als ordentliches Mitglied in der Royal Academy aufgenommen / Wordt aanvaard als volledig lid van de Royal Academy / Es aceptado como miembro titular de la Royal Academy

**248**

---

## Gustave Courbet
Ornans 1819 - La Tour-de-Peilz, Vevey 1877

1839   He moves to Paris to study law, but becomes the student of the painter Carl August von Steuben. Later he attends the Academy Charles Suisse / Er zieht nach Paris, um Jura zu studieren, wird aber Schüler des Malers Carl August von Steuben. Danach besucht er die Académie di Charles Suisse / Verhuist naar Parijs om rechten de studeren, maar wordt leerling van schilder Carl August von Steuben. Volgt daarna les aan de Academie van Charles Suisse / Se traslada a París para estudiar derecho, pero se convierte en alumno del pintor Carl August von Steuben. Asistirá luego a la Academia de Charles Suisse

1844   *Self-Portrait with Black Dog* becomes his first work to be accepted by the Paris Salon / Zum ersten Mal wird eines seiner Werke im Salon angenommen, *Selbstbildnis mit schwarzem Hund* / De Salon aanvaardt voor de eerste keer een van zijn werken, *Zelfportret met zwarte hond* / En el Salón de París se acepta por primera vez una obra suya, *Autorretrato con perro negro* (Petit Palais, Paris)

1846   He travels in Belgium and the Netherlands / Er reist nach Belgien und Holland / Reis naar België en Nederland / Viaja a Bélgica y Holanda

1847   He befriends socialist philosopher Pierre-Joseph Proudhon / Der sozialistische Philosoph Pierre-Joseph Proudhon und er freunden sich an / Raakt bevriend met de socialistische filosoof Pierre-Joseph Proudhon / Entabla amistad con el filósofo socialista Pierre-Joseph Proudhon

1849-1850   He paints *After Dinner in Ornans*, *The Stone Breakers* and *A Burial at Ornans* / Er malt *Nach dem Essen in Ornans*, *Die Steinklopfer* und *Ein Begräbnis in Ornans* / Schildert *Na de maaltijd in Ornans*, *De steenhouwers en Begrafenis in Ornans* (Lille, Musée de Beaux-Arts), *Los picapedreros* y *Un entierro en Ornans* (Musée d'Orsay, Paris)

1855   Following the rejection of several of his works by the Paris Universal Exhibition, he organizes the *Pavillon du Réalisme* / Nachdem einige seiner Werke bei der Weltausstellung in Paris zurückgewiesen wurden, organisiert er den *Pavillon du Réalisme* / Na de afwijzing van enkele van zijn werken op de Wereldtentoonstelling in Parijs, organiseert hij het *Pavillon du Réalisme* / Tras el rechazo de algunas de sus obras en la Exposición Universal de París, organiza el *Pabellón del Realismo*

1861 He makes a speech in Antwerp on education in art, which is later incorporated into his Realist Manifesto / Er hält in Antwerpen eine Ansprache über das Lehren von Kunst, die später im Manifest des Realismus wieder aufgegriffen wird / Hij houdt in Antwerpen een toespraak over kunstonderwijs, die nadien wordt opgenomen in het Manifest van het realisme / Pronuncia en Anvers una alocución sobre la enseñanza del arte, luego retomada en el manifiesto del realismo

1868 He travels in Spain / Er reist nach Spanien / Reist naar Spanje / Viaja a España

1871 He takes part in the Paris Commune / Er tritt der Pariser Kommune bei / Wordt lid van de gemeente Parijs / Ingresa al Ayuntamiento de París

1873 Exile to Switzerland / Exil in der Schweiz / Ballingschap in Zwitserland / Exilio en Suiza

---

**Jacques-Louis David**
Paris 1748 - Bruxelles 1825

1775-1780 He lives in Rome after having been awarded the *Prix de Rome*, becoming acquainted with the theories of Winckelmann and Mengs / Aufenthalt in Rom Dank des *Prix de Rome*. Er lernt die Theorien von Winckelmann und Mengs kennen / Verblijf in Rome dankzij de *Prix de Rome*. Maakt kennis met de theorieën van Winckelmann en Mengs / Permanece en Roma gracias al *Premio de Roma*. Conoce las teorías de Winckelmann y Mengs

1783 *Andromache Mourning Hector / Der Schmerz der Andromaca / Pijn van Andromache / El dolor y los lamentos de Andrómaca* (École des Beaux-Arts, Paris)

1784-1785 He travels to Rome again. *The Oath of the Horatii* / Reist opnieuw naar Rome. *Der Schwur der Horatier* / Reist opnieuw naar Rome. *Het oordeel van de Horatiërs* / Nueva estancia en Roma. *El juramento de los Horacios* (Musée du Louvre, Paris)

1789 The French Revolution breaks out: David actively participates, dedicating numerous works to the actors and events of the time / Die Französische Revolution bricht aus: David nimmt aktiv teil und widmet Begebenheiten und Personen dieser Zeit zahlreiche Werke / De Franse revolutie breekt uit: David neemt er actief aan deel, hij wijdt veel werken aan gebeurtenissen en personen uit die tijd / Estalla la Revolución francesa: David participa activamente, dedicando numerosas obras a hechos y personajes del momento

1796 His admiration for Napoleon leads him to paint numerous portraits / Seine Bewunderung für Napoleon keimt auf. Von ihm fertig er unzählige Porträts an / Zijn bewondering voor Napoleon ontstaat, voor wie hij talrijke portretten schildert / Nace la admiración por Napoleón, de quien realizará numerosos retratos

1804-1807 *The Coronation of Napoleon I, 2 December 1804 / Die Krönung von Napoleon I. am 2. Dezember 1804 / De kroning van Napoleon I op 2 december 1804 / La consagración del emperador Napoleón y la coronación de la emperatriz Josefina el 2 de diciembre de 1804* (Musée du Louvre, Paris)

1814 With the collapse of the Napoleonic Empire and the Restoration, he is exiled to Brussels / Mit dem Fall des napoleonischen Reiches und der Restauration wird er nach Brüssel verbannt / Na de val van Napoleons rijk en het begin van de Restauratie, wordt hij verbannen naar Brussel / Con la caída del imperio napoleónico y la restauración, se exilia en Bruselas

---

**Ferdinand-Eugène-Victor Delacroix**
Charenton-Saint-Maurice, Paris 1798 - Paris 1863

1806 He returns to Paris after his father dies / Nach dem Tod des Vaters kehrt er mit der Familie nach Paris zurück / Na de dood van zijn vader, keert hij met het gezin terug naar Parijs / Después de la muerte del padre, vuelve a París con su familia

1815 -1822 He enters Pierre-Narcisse Guérin's studio at the École des Beaux-Arts and receives his first commissions / Ausbildung im Atelier von Pierre-Narcisse Guérin und an der École des Beaux-Arts. Erste Bestellungen / Opleiding in het atelier van Pierre-Narcisse Guérin en aan de École des Beaux-Arts, de kunstopleiding. Eerste opdrachten / Formación en el taller de Pierre-Narcisse Guérin y en la École des Beaux-Arts. Primeros encargos

1822 First exhibition at the Paris Salon with *The Barque of Dante* / Debüt im Salon mit *Dante und Vergil in der Hölle* / Debuut op de Salon met *De boot van Dante* / Debut en el Salón de París con la *Barca de Dante* (Musée du Louvre, Paris)

1832 Travels in North Africa and Spain / Er reist nach Nordafrika und Spanien / Reis naar Noord-Afrika en Spanje / Viaja al norte de África y a España

1833-1846 Mural cycles in the Salon du Roi and the Library at the Palais Bourbon, the seat of the National Assembly, and the Library of the Palais du Luxembourg, the seat of the Senate / Dekorative Zyklen in der Bibliothek des Palais de Bourbon, Sitz der Assémblée Nationale, und in der Bibliothek des Palais du Luxembourg, Sitz des Senats / Decoratie van de Salon du Roi en de bibliotheek van het Palais Bourbon, de zetel van de Assemblée Nationale, en van de bibliotheek van het Palais du Luxembourg, zetel van de senaat / Ciclos decorativos del Salón del Rey y de la Biblioteca del Palacio Borbón, sede de la Asamblea Nacional, y de la Biblioteca del Palacio de Luxemburgo, sede del Senado

1844 He resides at Champrosay, in the Fontainebleau countryside / Es beginnen die Aufenthalte in Champrosay, auf dem Land von Fontainebleau / Verblijf in Champrosay, op het platteland van Fontainebleau / Comienzan sus estancias en Champrosay, en la campiña de Fontainebleau

1849-1861 Decoration of the Chapel of the Holy Angels at Saint-Sulpice / Ausstattung der Engels-Kapelle in Saint-Sulpice / Decoratie van de Kapel van de Heilige Engelen in Saint-Sulpice / Decoración de la Capilla de los Santos Ángeles en Saint-Sulpice

1850-1851 Ceiling of the Apollo Gallery in the Louvre / Deckenmalerei der Apollogallerie im Louvre / Plafond van de Apollogalerij in het Louvre / Cielorraso de la Galería de Apolo en el Louvre

---

## Caspar David Friedrich
Greifswald 1774 - Dresden 1840

1794-1798 He completes his studies in Denmark at the Academy of Copenhagen / Studium in Dänemark an der Akademie Kopenhagen / Studeert aan de Academie van Kopenhagen in Denemarken / Lleva a cabo los estudios en Dinamarca, en la Academia de Copenhague

1798 Dresden. He does the major part of his work here / Hier führt er den Großteil seiner Tätigkeit aus / Hier ontplooit hij het grootste gedeelte van zijn activiteiten / Aquí desarrolla la mayor parte de su actividad

1808 *The Cross in the Mountains* creates controversy due to its unconventional representation of a landscape / *Das Kreuz im Gebirge* ruft Polemiken zum antiakademischen Wagemut in der Landschaftsdarstellung hervor / *Het kruis op de berg* veroorzaakt controverse door zijn antiacademische uitbeelding van een landschap / *La cruz en la montaña* (Galerie Neue Meister, Dresden) suscita polémicas por la audacia antiacadémica en la representación del paisaje

1810 He devotes himself to education and begins to earn recognition / Er widmet sich dem Lehren und erhält die ersten Anerkennungen / Wijdt zich aan zijn opleiding en begint erkenning te oogsten / Se dedica a la enseñanza y comienza a recibir los primeros reconocimientos

1818 *Wanderer above the Sea of Fog* / *Wanderer über Nebelmeer* / *Reiziger op een zee van mist* / *El viajero contemplando un mar de nubes* (Hamburg, Hamburger Kunsthalle)

c. 1822 *Wreck of the Hope* / *Wrack im Eismeer* / *Het wrak van de hoop* / *Naufragio* (Hamburger Kunsthalle, Hamburg)

1835 After suffering a heart attack, he ceases painting and dedicates himself exclusively to drawing / Nach einer Herzattacke hört er mit der Malerei auf und widmet sich ausschließlich dem Zeichnen / Na een hartaanval stopt hij met schilderen om zich volledig te wijden aan het tekenen / Tras un ataque cardíaco deja de pintar para dedicarse exclusivamente al dibujo

**Johann Heinrich Füssli**
Zürich 1741 - Putney Hill, London1825
  1763  Following his literary and artistic training in Zurich, he moves to London / Nach seiner literarischen und künstlerischen Bildung in Zürich zieht er nach London / Na zijn opleiding in literatuur en kunsten in Zurich verhuist hij naar Londen / Tras realizar estudios de formación literaria y artística en Zúrich, se establece en Londres
1770-1778  Roma
1778-1780  *The Artist's Despair Before the Grandeur of Ancient Ruins / Der Künstler verzweifelt angesichts der Größe der antiken Trümmer / De wanhoop van de kunstenaar tegenover de grootsheid van de antieke ruines / La desesperación del artista ante la grandeza de las ruinas antiguas* (Kunsthaus, Zürich)
  1779  He returns to England, carrying out extensive literary and artistic work that will influence Blake and English Romanticism / Er kehrt nach England zurück und ist in großem Maße als Literat und Maler tätig, womit er Blake und die romantische englische Kultur beeinflussen wird / Terugkeer in Engeland, waar zijn schilder- en literaire activiteiten Blake en de Engelse romantische cultuur zullen beïnvloeden / Vuelve a Inglaterra, desarrollando una amplia actividad literaria y pictórica, que tendrá gran influencia sobre Blake y la cultura romántica inglesa
  1781  *The Nightmare / Der Nachtmahr / De nachtmerrie / La pesadilla* (Goethe Museum - Freies Deutsches Hochstift, Zürich)

---

**Théodore Géricault**
Rouen 1791 - Paris 1824
  1798  He moves to Paris with his family / Er zieht mit der Familie nach Paris / Hij verhuist met zijn gezin naar Parijs / Se establece con su familia en París
1808-1810  He becomes Horace Vernet's student, then studies under Pierre-Narcisse Guérin / Schüler von Horace Vernet und danach von Pierre-Narcisse Guérin / Wordt leerling van Horace Vernet en vervolgens van Pierre-Narcisse Guérin / Alumno de Horace Vernet y luego de Pierre-Narcisse Guérin
  1812  He exhibits at the Paris Salon for the first time with *The Charging Chasseur* / Debütiert im Salon mit *Offizier der Gardejäger beim Angriff* / Debuteert op de Salon met *Officier van de garde* / Debuta en el Salón con *Oficial de cazadores a caballo de la guardia imperial, a la carga* (Musée du Louvre, Paris)
  1814  *The Wounded Cuirassier / Verwundeter Kürassier verlässt das Schlachtfeld / Gewonde kurassier verlaat het strijdveld / Coracero herido* (Musée du Louvre, Paris)
1816-1817  Italia. In 1817 he paints the series, *Race of Wild Horses* (Baltimore, Lille, Rouen, Paris), then returns to Paris / 1817 fertigt er die Serie *Rennen der Berberhengste* (Baltimore, Lille, Rouen, Paris), dann kehrt er nach Paris zurück / In 1817 volgt de reeks *Berber Paardenrace* (Baltimore, Lille, Rouen, Parijs), vervolgens keert hij terug naar Parijs / En 1817 ejecuta la serie de *La carrera de los caballos Barberi* (Baltimore, Lille, Rouen, París), luego regresa a París
1818-1819  *The Raft of the Medusa.* His first official religious commission, *The Virgin of Sacre-Coeur*, he will pass to Delacroix / *Das Floß der Medusa.* Erste offizielle Bestellung eines religiösen Bildes, *Die Jungfrau von Sacre Coeur*, die aber an Delacroix geht / *Het vlot van Medusa.* Eerste officiële opdracht voor een religieus beeld, *De maagd van het Heilige hart*, die echter naar Delacroix gaat / *La balsa de la Medusa* (Musée du Louvre, Paris). Primer encargo oficial de un cuadro religioso, *La Virgen del Sagrado Corazón*, que pasará a Delacroix
  1821  Short trip to Brussels to visit David in exile / Kurze Reise nach Brüssel, um David im Exil zu besuchen / Korte reis naar Brussel om de verbannen David te bezoeken / Breve viaje a Bruselas para visitar a David en el exilio
1822-1823  He does a series of portraits of mentally ill patients for Dr. Georget / Serie der *Geisteskranken* für Doktor George / Serie *De waanzinnigen* voor dokter Georget / Serie de los *Alienados mentales* para el doctor Georget
  1823  A terrible fall from a horse immobilizes him / Ein schrecklicher Pferdeunfall macht ihn bewegungsunfähig / Raakt verlamd door een vreselijke val van een paard / Una terrible caída del caballo lo obliga a estar postrado

## Francisco Goya y Lucientes

Fuendetodos, Zaragoza 1746 - Bordeaux 1828

1771   While returning from a trip to Italy, he receives his first important commission: the frescoes in the Church of Our Lady of Pilar in Saragossa / Nach Rückkehr von einer Italienreise erhält er die erste wichtige Bestellung: die Fresken in der Kirche Nuestra Señora del Pilar in Zaragoza / Na terugkeer van een reis naar Italië, krijgt hij zijn eerste belangrijke opdracht: de fresco's in de Nuestra Señora del Pilarkerk in Zaragoza / De regreso de un viaje a Italia, recibe su primer encargo importante: los frescos en la iglesia de Nuestra Señora del Pilar en Zaragoza

1774   Madrid. He begins working as a portrait artist for wealthy individuals / Er beginnt seine Tätigkeit als Porträtmaler von Persönlichkeiten der High Society / Begint met het portretteren van personen uit de hogere klasse / Inicia su actividad de retratista de personajes de la alta sociedad

1798   Now deaf, he executes the beautiful frescoes in the sanctuary of Saint Anthony of la Florida in Madrid / Mittlerweile taub erstellt er die prächtigen Fresken von San Antonio de la Florida in Madrid / Hij is inmiddels doof, maar hij maakt schitterende fresco's in de San Antonio de la Florida in Madrid / Ya sordo, realiza los espléndidos frescos en el santuario de San Antonio de la Florida en Madrid

1799   In the series of engravings *Los Caprichos*, he condemns superstition, iniquity and oppression. He is appointed principal painter to the Spanish court / Mit den Radierungen *Los Caprichos* zeigt er seine ganze Aversion gegen den Aberglauben, die Niedertracht und die Unterdrückung. Er wird zum ersten Hofmaler ernannt / Uit zijn *Los Caprichos*-gravures blijkt zijn afkeer van bijgeloof, kwaadaardigheid en onderdrukking. Hij wordt benoemd tot eerste hofschilder / A través de la serie de grabados *Los Caprichos* demuestra toda su aversión por la superstición, la maldad, la opresión. Es nombrado primer pintor de la corte

1797-1803   *The Naked Maja* and *The Clothed Maja* / *Die nackte Maja* und *Die bekleidete Maja* / *De naakte Maja* en *De geklede Maja* / *La Maja desnuda* y *La Maja vestida* (Museo del Prado, Madrid)

1810-1814   He condemns all war and violence with the prints *The Disasters of War* and the painting *The Third of May 1808* / Mit den Radierungen *Die Schrecken des Krieges* und der Leinwand *Die Erschießung der Aufständischen 3. Mai 1808* verurteilt er jede Form von Krieg und Gewalt / Veroordeelt elke vorm van oorlog met zijn gravures *Verschrikkingen van de oorlog* en met het doek *3 mei 1808: executie van prins Pius op de heuvel* / Condena toda guerra y violencia con los grabados de los *Desastres de la guerra* y con el lienzo *El tres de mayo de 1808*, o *Los fusilamientos en la montaña del Príncipe Pío* (Museo del Prado, Madrid)

1824   Bordeaux

---

## Francesco Hayez

Venezia 1791 - Milano 1882

1804   He begins to attend courses on the nude at the Academy of Venice / Er beginnt Aktkurse an der Accademia di Venezia zu besuchen / Volgt cursussen naakten schilderen aan de Academie van Venetië / Comienza a frecuentar los cursos de desnudo en la Academia de Venecia

1809   He wins a competition for one year of study in Rome, which he completes at the studio of Canova, who becomes his tutor and teacher. During his travels, he stops in Florence, where he visits Pietro Benvenuti's studio / Er gewinnt den Wettbewerb um ein Stipendium in Rom: dort verkehrt er im Atelier von Canova, der sein Tutor und Meister wird. Während der Reise hält er in Florenz, wo er das Atelier von Pietro Benvenuti besucht / Wint een stipendium in Rome: daar bezoekt hij de studio van Canova, die zijn begeleider en meester wordt. Tijdens zijn reis verblijft hij in Florence, waar hij de studio van Pietro Benvenuti bezoekt / Gana el concurso para el pensionado en Roma: aquí asiste al estudio de Canova, que se convierte en su tutor y maestro. Durante el viaje, hace un alto en Florencia, donde visita el estudio de Pietro Benvenuti

1812   He wins first prize in the competition of the Academy of Milan with Laocoonte / Er gewinnt

den von der Akademie Mailand ausgeschriebenen Wettbewerb mit Laokoon / Wint met de Laocoonte de eerste prijs bij een wedstrijd van de Academie van Milaan / Gana el primer premio en el concurso organizado por la Academia de Milán con el Laocoonte (Accademia di Brera, Milano)

1817 Venezia

1820 He moves permanently to Milan and paints *Pietro Rossi Imprisoned by the Scaligeri* (Milan, private collection) / Er zieht endgültig nach Mailand. Er malt *Pietro Rossi Gefangener der Scaligeri* (Mailand, private Sammlung) / Verhuist definitief naar Milaan. Schildert de *Pietro Rossi gevangene van de Scaligeri* (Milaan, privécollectie) / Se establece definitivamente en Milán. Pinta el *Pietro Rossi prisionero de los Scaligeri* (Milán, colección privada)

1844 He travels to Naples and Sicily to paint *The Sicilian Vespers*. He is now an established painter / Er fährt nach Neapel und Sizilien, um *Die Sizilianische Abende* zu malen / Reist naar Napels en Sicilië om de *Siciliaanse Vespers* te schilderen. Hij is inmiddels een gevestigd schilder / Viaja a Nápoles y Sicilia para pintar *Las vísperas sicilianas* (Roma, Galleria Nazionale di Arte Moderna). Ya es un pintor prestigioso

1850-1860 He is named professor of painting and then president of the Brera Academy / Er wird zum Professor für Malerei und schließlich zum Präsidenten der Akademie in Brera ernannt / Wordt benoemd tot professor in de schilderkunst en tot directeur van de Academie van Brera / Es nombrado profesor de pintura y luego presidente de la Academia de Brera

1869 He dictates his *Memoirs* / Er diktiert seine *Memoiren* / Schrijft zijn *Memoires* / Dicta sus *Memorias*

## Jean-Auguste-Dominique Ingres
Montauban 1780 - Paris 1867

1797 He moves to Paris and enters the studio of Jacques-Louis David / Er zieht nach Paris. Er beginnt im Atelier von Jacques-Louis David / Verhuist naar Parijs. Begint in de studio van Jacques-Louis David / Se establece en París. Ingresa al estudio de Jacques-Louis David

1801 Wins the *Prix de Rome*, but cannot leave until 1806 because of war / Er gewinnt den *Prix de Rome*, kann aber bis 1806 aufgrund der Kriegsgeschehnisse nicht reisen / Wint de *Prix de Rome*, maar kan tot 1806 niet afreizen vanwege de oorlog / Gana el *Premio de Roma*, pero no partirá hasta 1806 debido a la guerra

1806 *Napoleon I on his Imperial Throne*. He leaves for Rome and stops along the way in Florence / *Napoleon I. auf dem Thron*. Er reist nach Rom und hält in Florenz an / *Napoleon I op de keizerlijke troon*. Vertrekt naar Rome en reist via Florence / *Napoleón en su trono imperial* (Musée de l'Armée, Paris). Parte hacia Roma, pasando primero por Florencia

1808 He sends *The Bather of Valpinçon* and *Oedipus and the Sphinx* to France as proof of his artistic qualifications / Als akademische Prüfungen schickt er die *Die Badende von Valpinçon* und *Ödipus und die Sphinx nach Frankreich* / Maakt in Frankrijk de proefstukken *De baadster van Valpinçon* en *Oedipus en de sfinx* / Envía a Francia como pruebas académicas *La bañista de Valpinçon* y *Edipo y la Esfinge* (Musée du Louvre, Paris)

1813 For the project of transforming the Quirinal Palace into Napoleon's Roman palace, he paints *The Dream of Ossian* / Für das Umgestaltungsprojekt des Quirinals im napoleonischen Palast führt er *Den Traum des Ossian* durch / Maakt *De droom van Ossian* voor de renovatie van het Quirinaal tot paleis van Napoleon / Para el proyecto de transformación del Palacio del Quirinal en palacio real napoleónico realiza *El sueño de Ossian* (Musée Ingres, Montauban)

1819 Firenze

1834-1840 Director of the French Academy in Rome / Direktor der Accademia di Francia in Rom / Directeur van de Academie van Frankrijk in Rome / Director de la Academia de Francia en Roma

1841 Paris

1854 *The Virgin with the Host* / *Die Jungfrau mit Hostie* / *De maagd en de hostie* / *La Virgen de la Hostia* (Musée d'Orsay, Paris)

1856 *The Spring* / *Die Quelle* / *De bron* / *La fuente* (Musée d'Orsay, Paris)

**Anton Raphael Mengs**
Aussig 1728 - Roma 1779

1741 Roma

1746 He returns to Saxony and is appointed court painter / Nach der Rückkehr nach Sachsen wird er zum Hofmaler ernannt / Terug naar Saksen, waar hij wordt benoemd tot hofschilder / De regreso a Sajonia, es nombrado pintor de corte

1761 He completes the *Parnassus* fresco on the central part of the ceiling of the Villa Albani, openly inspired by Winckelmann's principles / Er beendet das Fresko mit *Dem Parnass* auf dem Gewölbe der Galerie der Villa Albani, wobei er sich erklärtermaßen an den Leitsätzen von Winckelmann inspiriert / Voltooid het fresco *De Parnassus* in het gewelf van Villa Albani, dat duidelijk is geïnspireerd op de principes van Winckelmann / Termina el fresco *El Parnaso* sobre la bóveda de la galería de Villa Albani, inspirándose declaradamente en los principios de Winckelmann

1761-1771 Madrid. He completes frescoes at the Royal Palace / Er führt Fresken im Palazzo Reale aus / Maakt fresco's in het Koninklijk Paleis / Realiza frescos en el Palacio Real

1762 He publishes *Thoughts concerning Beauty* in Zurich / In Zürich veröffentlicht er die *Gedanken über die Schönheit* / Publiceert in Zurich *Gedachten over schoonheid* / Publica en Zúrich el libro *Reflexiones sobre la belleza y el gusto en la pintura*

1771-1773 He works on the Papyrus Room in the Vatican / Er arbeitet an der Ausstattung des Papyruskabinett im Vatikan / Werkt aan de decoratie van het papyruskabinet in het Vaticaan / Trabaja en la decoración de la Sala de los Papiros en el Vaticano

---

**Bertel Thorvaldsen**
Copenhagen 1770 - 1844

1797 Roma. He travels to Malta, Palermo, and Naples / Er reist nach Malta, Palermo und Neapel / Reis naar Malta, Palermo en Napels / Viaja a Malta, Palermo y Nápoles

1800 He begins *Jason with the Golden Fleece* / Er fängt mit den *Jason* an / Begint met de *Jason* / Comienza el *Jasón* (Thorvaldsens Museum, Copenhagen)

1804 Napoli, Firenze, Livorno

1808 He completes mythological bas-reliefs for Christiansborg Palace in Copenhagen / Fachreliefs mit mythologischen Sujets für das königliche Schloss Christiansburg in Kopenhagen / Bas-reliëfs van mythologische onderwerpen voor het koninklijk paleis Christiansborg in Kopenhagen / Bajorrelieves de tema mitológico para el Palacio Real de Christiansborg en Copenhague

1812 He finishes *Alexander the Great's Entry into Babylon* for the Quirinal Palace and takes a teaching post for sculpture at the Academy of Saint Luke in Rome / *Alexanders Einzug in Babylon* für den Quirinalspalast in Rom. Lehrstuhl für Bildhauerei an der Accademia di San Luca in Rom / *Intocht van Alexander de Grote in Babylon* voor het Quirinaal. Wordt docent beeldhouwen aan de Academie van San Luca in Rome / *Triunfo de Alejandro Magno en Babilonia* para el Palacio del Quirinal. Cátedra de escultura en la Academia de San Luca en Roma

1816 He begins a disputed restoration, now removed, of the statues of the Temple of Aphaia in Aegina, commissioned by Ludwig of Bavaria / Er beginnt die umstrittene, heute wieder abgetragene Restaurierung der Marmorskulpturen des Aphaia-Tempels auf Aegina im Auftrag von Ludwig von Bayern / Begint de controversiële, inmiddels ongedaan gemaakte restauratie van de beelden van de Aphaeatempel in Egina, in opdracht van Ludwig van Beieren / Inicia la discutida restauración, a día de hoy eliminada, de las estatuas del Templo de Afaia en Egina, por encargo de Ludwig de Baviera

1820 He receives commissions for the Vor Frue Kirke in Copenhagen (the monumental statues of *Christ* and the *Apostles*) and for Christiansborg Palace / Aufträge für die Vor Frue Kirke in Kopenhagen (die monumentalen Statuen von *Christus* und der *Apostel*) und für das Schloss Christiansburg / Opdrachten voor de Vor FrueKerk in Kopenhagen (monumentale beelden van *Christus* en van de *Apostelen*) en voor het Paleis van Christiansborg / Encargos

para la Vor Frue Kirke de Copenhague (las estatuas monumentales de *Cristo* y de los *Doce apóstoles*) y para el Palacio de Christiansborg

1837 He decides to donate his works and his collection to the city of Copenhagen and becomes the head of the project for the Thorvaldsen Museum / Er beschließt seine Werke und seine Sammlung der Stadt Kopenhagen zu schenken: Das Projekt für das Museum Thorvaldsen wird durchgeführt / Besluit zijn werken en zijn collectie te doneren aan de stad Kopenhagen: hij leidt het project voor het Thorvaldsens Museum / Decide donar sus obras y su colección a la ciudad de Copenhague: se pone en marcha el proyecto del Museo Thorvaldsen

1838 He leaves Italy / Er verlässt Italien / Hij verlaat Italië / Abandona Italia

## Joseph Mallord William Turner
London 1775 - 1851

1789 He enters the Royal Academy in London / Er fängt an der Royal Academy in London an / Begint aan de Royal Academy van Londen / Entra en la Royal Academy de Londres

1796 Having dedicated himself to engraving and watercolour, he begins oil painting / Nach der Radierung und der Aquarellmalerei wendet er sich der Ölmalerei zu / Na zich te hebben gewijd aan gravures en aquarellen, richt hij zich op schilderen met olieverf / Luego de haberse dedicado al grabado y a la acuarela, se vuelca hacia la pintura al óleo

1803 *The Passage of the Saint Gothard* is an example of his taste for depicting natural disasters in his early works / *Der St. Gotthard-Pass*: Ein Beispiel für seine Vorliebe für die Darstellung von Naturkatastrophen in seinen jungen Werken / *De Gotthardpas*: voorbeeld van de voorliefde voor de uitbeelding van natuurrampen in zijn vroegere werken / *El paso de San Gotardo* (British Museum, London): ejemplo de su predilección por la representación de cataclismos naturales en las obras de su juventud

1819 He travels to Italy, a decisive event in the evolution of his artistic style / Er unternimmt eine Reise nach Italien, die die Entwicklung seines Stils bestimmen wird / Onderneemt een reis naar Italië om zijn stijl te ontwikkelen / Efectúa un viaje a Italia determinante para la evolución de su estilo

1834-1835 *The Burning of the House of Lords and Commons, 16 October, 1834*: in this period his research into light and color becomes central and shapes lose their consistency and outlines / *Der Brand des Houses of Lords and Commons am 16. Oktober1834*: In dieser Zeit erforscht er das Licht und die Farben, die Formen hingegen verlieren Konsistenz und Umrisse / *Brand in de Houses of Lords en Commons op 16 Oktober 1834*: in deze periode experimenteert hij met licht en kleur en verliezen de vormen hun consistentie en vaste omlijningen / *El incendio de la Cámara de los Lores y de los Comunes el 16 de octubre de 1834* (Philadelphia Museum of Art): en este período, la experimentación con la luz y el color toman un papel central, y las formas pierden consistencia y contornos

1844 *Rain, Steam, and Speed. (The Great Western Railway)* / *Regen, Dampf und Geschwindigkeit (Great Western Railway)* / *Regen, stoom en snelheid (De grote westelijke spoorweg)* / *Lluvia, vapor y velocidad (El gran ferrocarril del Oeste)* (National Gallery, London)

© 2011 SCALA Group S.p.A.
62, via Chiantigiana
50012 Bagno a Ripoli
Florence (Italy)

Text and picture research: Emily Grassi

Printed in China 2011

ISBN (English): 978-88-6637-039-0
ISBN (German): 978-88-6637-038-3
ISBN (Dutch): 978-88-6637-040-6

Created and distributed in cooperation with Frechmann Kolón GmbH
www.frechmann.com

Project Management: E-ducation.it S.p.A. Firenze

Picture credits
© 2011 Archivio Scala, Florence, except:
p. 23, 36, 45, 205, 191 (© Image copyright The Metropolitan Museum of Art/Art Resource/Scala, Florence); p. 40, 41, 42, 46, 48 left, 48 right, 49, 50, 56, 112, 126, 128, 129, 132, 133, 135, 136, 137, 138, 140, 141, 142, 143, 164, 188, 226 top, 226 bottom, 227, 228, 229, 230, 231 (© Photo Scala, Florence/BPK, Bildagentur fuer Kunst, Kultur und Geschichte, Berlin); p. 13, 19, 111, 186, 187, 190, 196, 221 (© Photo Scala, Florence /V&A Images/Victoria and Albert Museum, London) p. 24, 31, 57, 58, 66, 78, 79, 82, 89, 147, 151, 153, 180, 181, 184, 189, 192, 193, 194, 195, 200, 204, 208, 209, 212, 213, 215, 219, 220, 222  (© White Images/Scala, Florence); p. 121 (© Photo The Philadelphia Museum of Art/Art Resource/Scala, Florence); p. 51 (© Museum of Fine Arts, Boston. All rights reserved/Scala, Florence); p. 32, 33, 34, 35, 90, 95, 107, 178, 185, 197  (© Photo Scala Florence /Heritage Images); p. 115, 120, 124 (© The National Gallery, London/ Scala, Florence); p. 56, 84, 85, 86, 87 left, 87 right (© DeAgostiniPictureLibrary/Scala, Florence); p. 97 (© Photo Art Resource/Scala, Florence); p. 11, 134 (© Photo Austrian Archive/Scala, Florence) p. 110 (© Photo Pierpont Morgan Library/Art Resource/Scala, Florence); p. 31 (© Photo Scala, Florence /Luciano Romano); p. 150 (© Photo AnnRonan/ HeritageImages/Scala, Florence); p.122 (© Photo ArtMedia/HeritageImages/Scala, Florence); p. 43 (© NTPL/Scala, Florence); p. 182, 183 (© Wadsworth Atheneum Museum of Art /Art Resource, NY/Scala, Florence); p. 44 (© Yale University Art Gallery/Art Resource, NY/Scala, Florence)

The SCALA images reproducing artworks that belong to the Italian State are published with the permission of the Ministry for Cultural Heritage and Activities.

Every effort has been made to trace all copyright owners, but if any have been inadvertently overlooked, the Publishers will be pleased to make the necessary arrangements at the first opportunity.

Appendix to image credits:

The Metropolitan Museum of Art, New York:
John Everett Millais, Portia (Kate Dolan), 1886, Oil on canvas, 1886. Catharine Lorillard Wolfe Collection, Wolfe Fund, 1906. Inv.06.1328; Benjamin West, Omnia Vincit Amor, or The Power of Love in the Three Elements, 1809, Oil on canvas, 70 3/8 x 80 1/2 in. (178.8 x 204.5 cm).Maria DeWitt Jesup Fund, 1923. Acc.n.: 95.22.1; Honoré Daumier, The Third-Class Carriage, ca. 1862–64, Oil on canvas, 1864. H. O. Havemeyer Collection, Bequest of Mrs. H. O. Havemeyer, 1929. Inv.29.100.129; Jacques-Louis David, The Death of Socrates, 1787, Oil on canvas, 51 x 77 1/4 in. (129.5 x 196.2 cm). Inscribed: Signed, dated, and inscribed: (lower left) L.D / MDCCLXXXVII; (right, on bench) L. David; (right, on bench, in Greek) Athenaion (of Athens).Catharine Lorillard Wolfe Collection, Wolfe Fund, 1931. Acc.n.: 31.45